*Leonardo's*
*Equestrian Statuette*

*To my husband*

# Leonardo's Equestrian Statuette

*Mária G. Aggházy*

*Akadémiai Kiadó*
*Budapest 1989*

Translated by

*Ágnes Simon*

Translation editor

*Mrs Helen Tarnoy*

ISBN 963 05 3951 9

# Contents

"... I shall have to repeat the same things several times; for which, O Reader! do not blame me, for the subjects are many and memory cannot retain them (all) and say: "I will not write this because I wrote it before". And if I wished to avoid falling into this fault, it would be necessary in every case when I wanted to copy (a passage) that, not to repeat myself, I should read over all that had gone before; and all the more since the intervals are long between one time of writing and the next."

Leonardo da Vinci addi 22 di marzo 1508
(Cod. Arundel 263. London, British Museum;
Richter, I, pp. 112ff, no. 4.)

# Our research methods.
# A description
# of the statuette

The aim of this monograph is to discuss the world famous statuette attributed to Leonardo, which is justly regarded as one of the most important pieces in the Budapest Museum of Fine Arts. As well as examining the small bronze statuette itself, we intend to place it within the context of contemporary history and outline the social background to its creation.[1] Historical events, the attitudes and behaviour of the people, their interest in literature are all facts which affected our masterpiece. Its appearance in Leonardo's oeuvre is not surprising. It was maturing and being prepared partly consciously, partly instinctively. Its precedents in terms of both formal elements and content can be clearly traced in Leonardo's life-work.

First of all we shall give a thorough description of the statuette and draw attention to every minute detail, even if it seems irrelevant. Even the slightest marks must be given attention because everything may prove to be significant and meaningful with regard to the choice of subject or form. It would be appropriate to mention here that it was Simon Meller who first determined the authorship of the statuette. Shortly after its arrival in the Museum of Fine Arts he had already placed it within Leonardo's oeuvre.[2]

Our very first task, that of finding a starting point for the description of the statue, is a problem: where should we start? For the statue has no frontal view; it is a preliminary study, a model for an equestrian monument in the round, designed to be free-standing. It does not require a niche or any other architectural background and indeed, some of its beautiful details would then be lost. It does not submit easily to inspection and can only be fully apprehended if walked round,[3] when it becomes comprehensible and gives us all the pleasure of enjoying a masterpiece. From every angle, certain important details stay hidden and this impels us to walk round it, to find new surprises.

The most natural approach would be from the front of the statuette, somewhat to the left, in order to be able to view, between the horse's bent neck and the horseman's shield, the face of the rider, smiling happily, self-confident, rather small but full of character. A face such as this is strange indeed in the context of a "warrior seated on a rearing horse" as our masterpiece was initially labelled. Along with certain other details, it is the face wich will help us to identify the rider. From the frontal view we can see that the horse is rearing, but only the side view reveals how. The horse is lifting both his forelegs parallel in front of him. The animal's broad chest

Fig. 1.
Fig. 3.

stands out, while the excited head on its muscular neck is tilted gracefully to the right and a little backwards. As a result, the skin is wrinkled on the left side of the jaw. The arched neck draws us

Fig. 2. further to the right of the statuette. The magnificently modelled face of the startled, noble animal dominates here, forcibly expressing its whole attitude. The horse's mouth is open for a neigh, the distended nostrils tremble from its alarmed intake of breath. The front part of the head is softly modelled, showing the muscles under the skin. The skin over the cheek-bones, on the other hand, is tight. The eyes and the erect ears are eloquent proof of the animal's startled agitation. The disquiet of the stocky, muscular horse is manifest in another detail on this side. Its hind legs are bent at an angle as it recoils and the muscles are not extended in order to enable the horse to

Fig. 4. rush away. The right foot has caught on a stone and this is the cause of the horse's wild kicking.

It would be appropriate here to identify the type of horse shown. In terms of stature it does not belong among the heavily built draught-horses of the medieval North European knights. It seems to be swifter than those, but stockier and more muscular than the Arab thoroughbreds.

Fig. 5. The so-called ram's head on the long, strong neck, the broad chest, the slanting, round croup are reminiscent of the Spanish breeds, which have some Roman and Eastern strains in them as well. This type of horse was popular in the Mediterranean region during the afterglow of the age of chivalry, especially in a select, privileged stratum of society.[4] On Leonardo da Vinci's two studies of horses (Windsor no. 12294: Messer Galeazzo's Sicilian horse; Windsor no. 12319: Messer Galeazzo's big jennet) the following notes can be read: "Ciciliano dj meser Galeazzo" and below: "Fa. questa medesima dj dentro cola mj-sura dj tutta la spalla"; on the second one: "gianecto grosso dj messer galeazzo".[5] These studies were therefore drawn of the magnificent horses in the stables of Giov. Galeazzo da Sanseverino, a Milanese nobleman whom we shall meet again later on. The word "gianecto" could be identical with "ginnetto" which nowadays means a small, swift Spanish horse. Clearly Leonardo's horses differ from these in size and proportions, so that he had to add the "grosso" attribute. Another interpretation of the term relates it to words "giannetta", "giannettata" (meaning lance, lance-thrust) and thus refers to the horse's use in jousts.

Let us turn now to our horseman. He once held a sword in his right hand, but the blade is missing now and only the hilt remains. Because of the way he sits, the "warrior" seems rather small in comparison to the powerful horse, but he has had to contract his limbs and lift his feet in order to be able to ride bareback without losing his balance and slipping backwards off the horse. His muscular body seems naked at first glance but if we examine it thoroughly we find traces of a shirtlike garment on his thighs in the form of small indentations, while between the legs it shows quite clearly. On the upper part of the body no traces of the shirt can be seen and only the brawny muscles are shown. His face cannot be seen from this side but his helmet can be examined in

Fig. 3. detail. The helmet's vizor is tipped up like a peak of a cap. Above it the helmet is encircled by a
Fig. 7. crown of triangular pointed leaves. On the crest a winged, serpent-tailed dragon, its head erect, is climbing up from the rider's neck to this forehead.

The hind legs of the horse are parted. In contrast to the kicking right leg, the left leg is wholly in contact with the ground and the small surface of this hoof supports the whole statuette. The

horse's body is balanced in such a way that the centre of gravity is between its two hind legs. The tail, like the thick mane, seems to be ruffled and untidy, but the position of the tail is important to the rhythm of the statuette as a whole. The tail was not cast with the horse but was inserted later. However, we shall deal with this question later on, along with other technical matters relating to the statuette.

The decorated helmet looks best when viewed from the left side, as does the horseman's physiognomy with its narrow eyes, long nose and firm chin. He appears to have drawn a deep breath which has expanded the muscles of his chest and back, while his stomach is drawn in. His Fig. 7. left leg is relaxed, in contrast to the right one which keeps his balance and is tensed. The shield in his left hand protects not so much the rider, who is already out of danger, but the neck and head of the magnificent charger. The huge, sloping body of the horse, with its homogeneous outline, is patchy, mottled, but the most important muscles are perfectly discernible. The slanting position of the horse's body is echoed by the sideways turn of its strong neck and head, the horseman's small body and lastly the small tail. The splendid general impression created by composition is based on artistic calculation and careful consideration: the smaller details of the statuette repeat the movement of the horse, they are also at an angle. The counter-movement of the bodies and the repeating of the various rhythms present surprises from different viewpoints and an impression of undisturbed harmony.

<p style="text-align:center">★</p>

After outlining the artistic features of our statuette we must now turn to some technicalities with regard to its surface. The piece is unfinished, especially when viewed with a modern eye. The runners and risers which are needed for bronze casting have not been chiselled off and can be found on the upper third of the horse's body, parallel with the spine. Seen from the front, a larger opening on the horse's breast seems to be later damage. On the front of the rider's right foot there is another irregular opening, but no traces of wear, breaking or subsequent repair can be detected, so that the opening might be the result of defective casting.

The surface must originally have been covered with black lacquer patination but only traces of it are discernible and it was covered over later with artificial verd-antique. In the Middle Ages, artificial verdigris was originally black and was produced by coating with oil. This coating dried, the surface cracked, resulting in the so-called craqueleur, and finally flaked off. This must have happened with our piece, because the remains of the original black laquer patination were covered—we do not know when—with verd-antique. This procedure was especially widespread during the Italian Renaissance, and managed to produce the required effect of verd-antique. It was achieved by dipping in nitric acid and afterwards in clear water. Later the nitric acid was replaced by vinegar.[6] The horseman was cast separately. The way he was fixed to the horse and the fact that he can be detached at any time was technically quite new. The base is again a later addition, made of wood, in imitation of Italian Renaissance forms. The tenons in the hind hoofs of the horse which fit into the mortises on the base are made of a different kind of metal from the

main body of the statuette. The stone under the right hind hoof was cast in one piece with the horse, and is therefore of the same material. The unfinished runners and the fairly long metal brace holding the rider, which can be inserted into the body of the horse, provide evidence that the animal's body is hollow and his legs are solid. The body of the horseman is also hollow.

The height of the statuette, measured from the base is 24.3 cm, its lenght 26.5 cm. Its inventory no. in the Museum of Fine Arts is 5362. It was acquired by the Museum in 1914 from the collection of István Ferenczy (1792–1856), a Hungarian academic sculptor. Further details will be given in the chapter dealing with the history of the statuette.

# Written sources, some problems they raise and a criticism of them

Simon Meller was the first to publish papers on the statuette and he attributed it to Leonardo da Vinci. Its importance is evident from the fact that neither handbooks dealing with the Late Renaissance period nor monographs on Leonardo designed to cover all the smallest details of the artist's work have been able to disregard or overlook our small bronze statuette. Either the piece excited admiration, or the opinion that it was the work of Leonardo aroused passionate opposition. As we shall show in the latter part of this volume, a third group of scholars dealing with the statuette accepted it with reservations. They accepted its close connections with Leonardo's drawings but regarded it as the work of a later follower of the master, at best as cast in bronze by a pupil of Leonardo, after a model by the artist himself. In the practice of bronze sculpture, this is equivalent to accepting the master's own authorship.

All these different opinions were based on comparisons with Leonardo drawings. The series of studies for the Sforza and Trivulzio monuments in particular, sculptures commissioned during his two Milanese periods, were closely examined, along with other studies of horses. In the meantime other statuettes also appeared and were regarded as either more closely in keeping with Leonardo's style or far removed from it. Their discoverers all wanted to attribute them to Leonardo, either in conjuction with our statuette or disregarding it completely.

Our present research work has on the main confirmed and reinforced the initial results, by the application of Simon Meller's methods with necessary amendments. The statuette has been allocated to a different place within Leonardo's work and is dated to the last years of the master's life. During our research into the subject of our piece some novel results have also come to light in respect of other works by the artist, notably his drawings. In his anatomical and preparatory detail studies, and likewise in his so-called "allegories", not only the political aspirations of his ambitious clients were symbolized but also their or his own literary culture and personal opinions. The influence of this outstanding and revolutionary masterpiece is seen not least in the fact that its outward appearance was often copied.

All this required historical and literary research into the age of Leonardo. Naturally we had to make choices among the somewhat complicated and divergent events of cultural history and to restrict our field of research. Leonardo was one of the most confident personalities of the Late Renaissance and knew his own value quite clearly. He served the leading personalities of his age

and it is natural, therefore, that we should examine their social position. We find, at the height of its social development, a new ruling class which wishes to profit by its situation and to maintain its privileges by all possible means. Its members' way of life characterized by violent acts which are necessary for them to achieve their aims, and there is a certain nostalgia for ages long forgotten. The only Renaissance feature of our statuette, indeed one which approaches the baroque, is its artistic modelling and this is seen at its best here.

The creation and existence of a masterpiece cannot be an isolated phenomenon. The more perfect it is, the closer its links with the great traditions of past ages and with contemporary artistic features of other genres. It exerts great influence, it is a significant stage, at once the end and the beginning of an era, connected with everything, past, present and future. This is why it is not enough here to examine the statuette only from the stylistic point of view. A complex analysis of the piece, its place within different contexts, such as cultural history and literary history, cannot be avoided.

<p style="text-align:center">★</p>

All written sources dealing with periods of history must be examined thoroughly. These sources are only authentic if they refer to their own age. In the absence of contemporary evidence, later conclusions drawn from written sources must be accepted and applied with reservations. It must be examined whether it is so-called book knowledge, i.e. a theoretical construction devised to support tendentious theory, or an objective, precise publication of historical data. The latter may be adopted literally.[7]

Old and new opinions relating to our historical sources must be consulted in order that we may decide with the help of modern critical methods whether they are reliable and authentic.

In our case the working methods expected of historians as far as the use of original sources is concerned must be taken into consideration as well.

Certain further requirements were felt to be obligatory even though we are dealing with rather a late period.[8] They are the following: textual criticism, linguistic criticism and literary criticism.

Our studies ranged over several written sources. First of all, *Leonardo's* autographic *Notes,* which are indisputably authentic.

Next, works which dealt with his art, especially his sculpture, in detail and were written close to the time when he was active. In addition to these, modern points of view from art historians who based their work on contemporary written sources.

The theoretical works of a sixteenth century mannerist, *G. P. Lomazzo,* (1538–1600) on North Italian art.[9]

Historical works dealing with Francis I, King of France, as a patron of arts.

Passages from the texts of British, English, French, Italian courtly romances, and the spread of their themes. Their influence on the choice of subject in art (beyond the well-known summary).[10] The endeavour to publish not only classical authors but also the works of early medieval writers.

In accordance with the above grouping we shall now dwell briefly on Leonardo's own statements on sculpture as such—ignoring for the moment technical questions, which will be dealt with in another chapter—and on his own sculptural talents. The Cod. Urb. 21.b.–22.b. Tratt.37[11] which contains a variation of his *Trattato,* compares the work of the painter and the sculptor. According to it: "For making a figure in the round the sculptor need only execute two views, one of the front, one of the back. There is no need to take as many views as there are aspects, of which there are an infinite number... But the *Basso relievo* entails incomparably more mental effort than sculpture in the round and comes somewhat nearer to painting in greatness of invention, as it applies the laws of perspective, while sculpture in the round dispenses with this science altogether and simply takes its measures as it finds them on the model." (Richter I, p. 93, no. 38.) *C.* 1482 Leonardo offered his services to Ludovico Sforza (il Moro) in a letter where he emphasized, besides his wide knowledge of engineering and military techniques, his skill in marble and bronze sculpture as well as clay modelling. "Item. I can carry out sculpture in marble, bronze, or clay, and also I can do in painting whatever may be done, as well as any other, be he who he may. (32) Again, the bronze horse may be taken in hand, which is to the immortal glory and eternal honour of the Prince your Father of happy memory, and of the illustrious house of Sforza." (Cod. Atl. f. 391/r. Richter II, pp. 326–327, no. 1340.)[12] A copy of this letter is in the *Codex Atlanticus*.

Both during his life-time and after his death his views on painting and sculpture, quoted above, were often repeated by his contemporaries. They went into raptures either in prose or in verse over the horse model he planned in larger than life-size for the Sforza monument in Milan. It was ready for casting by 1493, the year of the marriage between Bianca Maria Sforza and Emperor Maximilian. All this can be found in L. Beltrami's publication of the source texts,[13] and in P. Barocchi's two latest papers on art.[14] Among the poems and prose texts glorifying Leonardo is one which is rather problematic. It is an excerpt from an unpublished codex of the humanist Paolo Giovio (1483–1552), who was regarded as a *dillettante* historian and poet. He must be quoted here word by word and we shall try to give an explanation for his statement, which is quite contrary to the facts. "Finxit etiam ex argilla colosseum equum Lodovico Sfortiae, ut ab eo pariter aeneus superstante Francisco pater illustri imperatore funderetur: in cuius *vehementer incitati ac anhelantis habitu* et statuariae artes et rerum naturae eruditio summa deprehenditur." This description is at odds with the fact that Leonardo's own drawing for the Sforza monument in the Cod. Atl. f. 216, showing the scaffolded horse model ready for transport and casting, reveals a horse walking at a steady pace. It is doubtful whether Giovio had seen it at the ceremonial presentation, when he was only ten years of age. Had his impressions faded in his mind? On the other hand, if he saw the model only later, around 1504 or 1506, when he went to Milan during his studies at Pavia University, it was already in ruins, although, in 1501 Ercole d'Este had still wanted to acquire it for himself from the French Governor of Milan.[15] At the beginning of the sixteenth century the much admired model could not have been in such a bad state of preservation, even though it was deliberately demaged, that its description should be so misleading. One solution to the problem could be the supposition that Giovio had seen some

later drawings by Leonardo, representing rearing horses planned for the first Milanese monument. Another explanation could lie in Giovio's journey to France where he might have seen the Budapest model without knowing its origin. This question was later thoroughly investigated by Lomazzo. Still, Giovio's above description best fits the Budapest statuette.

The starting point and backbone of our investigation is Leonardo's stay in Milan, during which time he was mainly occupied with the preparatory work for the equestrian monuments to the two generals: Fr. Sforza and G. G. Trivulzio. We looked for information principally in the *Trattato* (published in 1584) by G. P. Lomazzo who was a somewhat later chronicler of the art of the city.[16] This work is regarded by J. von Schlosser in his *Kunstliteratur*[17] as a mine of information concerning Leonardo; he calls it the Bible of mannerism, but advises caution in the acceptance of the information. Taking into consideration the average life expectancy at the time, Lomazzo's work was published nearly two generations after Leonardo. Nevertheless, he received his information, especially about the master's last years, from a reliable witness, Fr. Melzi (1493–1570) the last of Leonardo's pupils, who remained faithful to him until the master's death.

In recent art literature, starting with E. Panofsky's *Idea*,[18] Lomazzo's works have been analysed mainly from the point of view of artistic theory, while the reliability of his data has only been briefly touched upon by his reviewers. A. M. Paris: *Sistema e giudizi nell'Idea del Lomazzo*[19] and later E. Spina Barelli illustrated Lomazzo's theories with the drawings of some Lombard artists.[20] C. Pedretti's study in *Studi Vinciani*, Geneva 1957: "Sull'importanza delle notizie fornite dal Lomazzo, riguardo a Leonardo" is not always consistent in its use of data.[21] R. Klein regards his technical aims and guidance for artists as somewhat narrow-minded. In his opinion Lomazzo's historical facts were uninteresting to his contemporaries and he achieved his fame only in later times. His critical judgment already seems insufficiently well-founded only a few decades after his death.[22] Lomazzo's theory of art was dealt with by G. M. Ackermann in a monograph[23] and later in a study,[24] but "the analytical version intact would have been a useful book in its time, as well as an *informative document* today". R. P. Ciardi published two introductory studies on Lomazzo's theoretical works,[25] while J. B. Lynch Jr. gave a precise identification of a lesser known work of Lomazzo.[26] Growing interest necessitated a new critical edition of his collected works, which was published under the editorship of R. P. Ciardi.[27]

When using the section of Lomazzo Trattato's text which relates to Leonardo, and especially our statuette, we have to bear in mind certain aspects of historical linguistics. This passage has been misinterpreted even by quite eminent art historians, who did not take into consideration certain changes in word meaning.[28] They thus came to a deadlock in their research into Leonardo's plastic horse figures.

Lomazzo very often cites poetic parallels in order to characterize artists or works of art. In Lib. II, Cap. 19. p. 177, which concerns Leonardo, he quotes passages from *Leukippe and Kleitophon* by Achilles Tatios (fourth century) the last of the late Hellenistic novelists, from works by the predecessors of his contemporaries like the *Orlando Innamorato* by Matteo Maria Boiardo (1441–1494) and its continuation the *Orlando Furioso* by Ludovico Ariosto (1474–1533), and

from the work by Bernardo Tasso (1493–1569). This last is actually a translation of the thirteenth century Portuguese romance *Amadis de Gaule*[29] which he expanded by the use of endless, monotonous eight-lined stanzas and by repeating the episodes in innumerable variations. In this chapter Lomazzo mentions only those scenes where startled, rearing horses are described, either frightened during combat or fleeing danger, e.g.:

"Il grave scontro fa chinar le groppe
sul verde prato alla gagliarda alfana."

(*Orl. Fur.* II. 51)

"E finita la battaglia: ma si roppe,
Posero in terra ambi i *destrier* le groppe."

(*Ibid.* XLVI. 117)

"Non sa in un luogo star', ma con un piede
La terra adhor' adhor' percuote e siede."

(*Amadigi* I. 18)

All these tally with the description by Paolo Giovio, which fits our horse. As will be apparent from the French texts which we will use for checking, the word "destrier"—a horse which is led from the right side—could also relate to his description.

The end of this chapter, the last sentence, contains the expressions which require linguistic analysis: "...si come si puo vedere fra l'altre cose *un cavallo di rilievo di plastica, fatto di sua mano* (Leonardo), che ha il Cavalier Leone Aretino (Leoni) statuario" (1509–1590). On the basis of the term "di rilievo di plastica", McCurdy and Malaguzzi Valeri, as mentioned above, were looking for a relief with this very subject which could be connected with Leonardo—but in vain. In modern Italian usage "rilievo" may be also used as an attribute, meaning outstanding, excellent, significant. However, according to information kindly supplied by P. Barocchi, in those days "di rilievo, significa a tutto rilievo, cioe *a tutto tondo,* in antitesi con altri tipi di rilievo (bassorilievo, altorilievo, ecc.)"[30]. In the latest edition of J. P. Richter's great compilation[31] we still find the original explanation along similar lines: "Leonardo applies this term exclusively to wholly detached figures, especially to those standing in free." On the basis of the term "rilievo", therefore, the model of a horse mentioned as being in the possession of Leone Leoni was without any doubt a free-standing statue.

"Plastico" on the other hand "secondo la tradizione pliniana (Plinio, XXXV. 156) vuol dire, di terra, cioe e riferito al modello" (P. Barocchi). According to F. Baldinucci[32] "plasticare = far figure di terra". Lomazzo's "plastica" may be perhaps interpreted in the sense of Leonardo's own words concerning the procedure of bronze sculpturing as the result of the final act of the

process: "...se fa di terra e'ciera, puo leuare, e porre, et quando *e terminata, con facilita si gitta di bronzo,* et quest'é l'ultima operatione e la piu permanente..."[33] "Moreover, the sculptor when working in clay or wax can take off or add on, and when his model is finished it can easly be cast in bronze, and this is the last process and the most enduring form of sculpture; ..." (Cod. Urb. 28/a–28/b. Trat. 38; Richter I, p. 95, no. 39.)

The words *"fatto di sua mano"* may be equated with the remark "di propria mano di Leonardo"[34] to be found in the passage concerning the head of the young Christ, made of clay or terracotta, mentioned as being in the possession of Lomazzo. This piece was identified by Nicodemi and Pedretti with the head of Chirst in the Aglietti Collection in Rome, although it was attributed by Planiscig to Verrocchio.[35] Naturally, there are different interpretations of "fatto di sua mano". In 1416 a notarial contract was drawn up with Jacopo Quercia for the execution of the portal of S. Petronio in Bologna. Here we meet these expressions, the sketches had to be "fatto di sua mano" by the master, and, emphatically, "sottoscritto di sua propria mano". According to the publisher of the document,[36] this expression "need not be interpreted to mean that Quercia drew the drawing, but instead seems to indicate that he in some measure "dictated" its content and method of presentation..."—"...in connection with drawings for Quercia's commission in two cases does not mean that Quercia 'drew' the drawing literally with his own hand; ...was   to be held as morally responsible for it as if had done the drawing entirely himself; this procedure was analogous to notary's 'hand' in drawing up a contract..." In our opinion the same expression occurring as a legal formula in a contract and as information relating to the birth of a masterpiece must be interpreted in two different ways.

Finally, there is another sixteenth century text, the interpretation of which may be problematical. In a subsequent chapter we shall dwell at some lenght on the correspondence of Leone Leoni conducted with the aim of acquiring a statue model from France "venendo da tanto boun antico maestro".[37] Even today, "antique" is only the third meaning of the word "antico". Its first meaning is "former, of old", then "old-fashioned, old-style". This is how this most important part of the letter was interpreted by the above publisher. As will be seen later on, he identified the "tanto buon antico maestro" with Leonardo.

<p style="text-align:center">★</p>

*Textual criticism,* i.e. textology, could not be applied directly here, because we did not have access to original manuscripts. We could examine only a few codices from Northern Italy containing romances in Paris among the Bibl. Nat. Ms. fr. Owing to lack of time, we were only able to take into consideration the illuminations and text illustrations. In addition to these we examined Boccaccio's *De casibus virorum illustrium,* copied in 1422, originally belonging to the Bibliotheca Corviniana (OSzK Cod. lat. m. ae. 425). Our reasons will be explained in Chapter III. It must be added that the checking of mistakes in the published and printed texts does not fall within my province. The need for this was pointed out by J. B. de la Curne de Sainte Palaye (1697–1781),[38] an eighteenth-century French historian who collected

texts from the end of the age of chivalry. We availed ourselves of his work with the necessary critical reservations.

The reservations concern the requirements of so-called literary criticism, i.e. the study of "traditional ideas" and their dissemination needs examination in connection with the works of Sainte Palaye. A modern critic, L. Gossmann,[39] deals with his works in detail and regards him as a reliable but rather boring historian. His text-collecting activities are compared with the archaeological work of his contemporary B. de Montfaucon (1655–1745), who inspired him. Gossmann blames him for not regarding knighthood as a social institution. Sainte Palaye's work is regarded as the basis for Ch. Nodier's (1780–1844) and F. R. de Chateaubriand's (1768–1848) "great romanticism" and the initiator of the new feudal reaction. It is very unlikely that he wrote his works consciously with this aim. Sainte Palaye quoted contemporaries of Francis I as saying that his endeavours to revive knightly virtues and the martial spirit of the nobility proved to be in vain. "... le Chevalerie s'étoit relachée depuis long-temps" (pp. 362–63). On the other hand, even at that time "... l'honneur de la Chevalerie devint si commun, que chacun crut pouvoir s'en arroger le titre de sa seule autorité" (p. 404).

Twentieth century historians have gladly built upon Sainte Palaye's precise data. In 1911 R. Truffi[40] took from him a quotation by E. Deschamps (c. 1340–early fifteenth century) saying that even then everyone already "veult escuyer devenir...". He is quoted by F. Lot in his essay on the prose of Lancelot, written in 1918.[41] Today it seems natural that in his *Herbst des Mittelalters*,[42] which was first published in 1919, Huizinga should have made ample use of his work. Graeme Ritchie, in his commentaries on Longuyon's *Voeux de Paon,* published in several volumes,[43] also relies on Palaye. J. Evans drew upon his data in her work on the history of medieval French art, published in 1948.[44] R. D. Middleton[45] resorted to Sainte Palaye's work because of the coincidence in Western art of early Romanticism and Classicism (and Palaye satisfied his yearning for the past with his collection of literary data). In his concise summary[46] of the age of chivalry and the knightly way of life, especially as far as France is concerned, A. v. Reitzenstein makes use of Palaye's data. Our selected bibliography of books based on Palaye's work is far from complete. Such a collection was not our aim and we have endeavoured to seek traces of his influence mainly in writings dealing with art.

In this chapter we have tried to clarify some of the problematical parts of our sources. The data which did not present problems, the elements which are unambiguous, distinct and relevant to our subject matter, will be used in the appropriate place. They will serve to confirm and explain or provide proof of our observations and the facts conveyed to us by the work of art itself. As our principal task here is an art historical one, we shall attempt above all to persuade the extant objects to yield up their secrets, at the same time availing ourselves of the evidence of the written sources.

In this chapter we have endeavoured to interpret parts of Lomazzo's *Trattato,* which is the most important source of information relating to the statuette. *It throws light on questions regarding its creation, its creator and its subsequent fate.*

In the identification of Paolo Giovio's horse model we have only arrived at the stage of a probable hypothesis. Nevertheless, we may still have come closer to a solution of the contradiction, than did J. P. Richter[47] when he drew a parallel between Vasari's text and Donatello's *Gattamelata*.

La Curne de Sainte Palaye's work will be of great use in providing information, especially in respect of late, already dated courtly customs. This will be particularly useful when we come to defining the subject of our piece.

# Chapter *III*

# *Technical execution of the statuette. "Homo faber"*

The questions of technical execution of the statuette are being dealt with immediately after the discussion of the written sources and before its thematic and material elements are developed. There are good reasons for this, because the authenticity of written sources relating to this aspect is indisputable, as they are by Leonardo himself: partly his notes, partly his drawings for the statue. Although the latter relate to the first Milanese equestrian monument, the Sforza statue, they may be equally well to our statuette and provide conclusive evidence.

These technical questions need to be dealt with in a separate chapter and must be regarded as an alien body, to be separated from the historical part of the study. But they cannot be excluded completely; especially since they relate to Leonardo's personality and working methods. Modern research abroad is making increasing use of various sophisticated instruments in the analysis of bronze statues. With their help ancient processes and written "recipes"[48] can be closely examined and monitored. They provide significant support for our discoveries.

Our preliminary results were confirmed by X-ray examination (carried out by the Institute of Criminology, Budapest), which showed that the figures are hollow but the legs of the horse are solid. In addition, the framework was revealed: the ribs at the wider parts of the horse's skeleton were rounded, resembling one in a drawing in Windsor (no. 12349) with the legend *"queste legature vano di dentro"* (These bindings go inside — Richter II, p. 7, no. 713). As a result of the traditional lost wax method the metal is not of uniform thickness and distribution. For this reason, our examination of the metallic composition of the bronze statuette was restricted to qualitative spectrum analysis (carried out by the research workers of the Spectrographical Laboratory at the Development Department of the United Light and Electricity Company in Budapest). The results of a quantitative analysis would have been accurate because of the uneven thickness of the material. The most important discovery about the statuette was that samples taken from its various parts proved that the basic components of the material throughout were copper (Cu), tin (St) and lead (Pb). Zinc was found in only insignificant quantities, along with other contaminating elements (Sb, Ag, Si). According to researchers, Fe and Ni could be either component metals or contaminating elements. Our statuette is therefore made of *the classic, noble zinc-free lead-bronze*. The material of the horseman and the horse is identical even in respect of

Figs 8, 9, 10.

Fig. 11.

the contaminating elements and it is therefore certain they were cast together. To produce two such identical alloys is impossible and the theory that rider and horse originally did not belong together is thus ruled out once and for all.

The possible reason for the irregularity of the material is that the procedures for eliminating it were not yet known: fast cooling after casting or constant heating, of which the latter could perhaps not have been used in the case of a sculpture. Without these, the slowly cooling metal crystallizes to a rough, irregular texture. We can read about fast cooling in Theophilius Presbyter's[49] work, but only in relation to the smelting of metal from ore and the removal of lead from copper. The other cooling process is mentioned in connection with the obtaining of a black laquer patination, when fine linseed oil is heated but *"refrigratum fuerit, non in aqua, sed per se"*. Apart from him, neither the authors of the Italian Quattrocento nor Pomponius Gauricus[50] in the early Cinquecento, nor Leonardo, Vasari (1511–1574)[51] or B. Cellini (1500–1571)[52] talk about a cooling process between casting and cleaning-chasing. On cooling shrinking is detectable. This is the cause of casting stress, which may lead to fire-cracks, although they do not always spread in the material. X-ray examination of our statuette revealed big cracks, visible even to the naked eye, and numerous smaller ones as well.

The material of the statue proved to be unusually hard when the necessary samples were taken for spectral analysis. This indicated that it has a relatively high tin content, since the characteristics of bronze vary according to the tin content. Its strength is greatest at 6–8 per cent tin content. Leonardo's formula for gun casting is in accordance with this: *"Il metallo si uole fare universalmēte nelle bôbarde co .6. uisino 8 per ciēto, cioe 6 di stagnio sopra ciēto di rame, e quāto meno ve ne metti, piv sicura sia la bôbarda."* (Of alloying the metal. Metal for guns must invariably be made with 6 or even 8 per cent, that is, 6 of tin to one hunder of copper, for the less you put in, the stronger will the gun be. — Triv. 15/b; Richter II, p. 16, no 740).[53] We can find the description of another alloy in the Madrid codices,[54] which were discovered recently, first published in separate parts[55] and then in a facsimile edition, translated and transcribed, with notes. There the quantity of tin prescribed is much greater in the alloy used for axle sockets. This alloy coincides with the much later American Isaac Babbit's (1799–1867) wear-resistant metal. Leonardo gives no prescription for the composition of the alloy to be used in the case of statue casting. He only gives instructions for the method of producing the bronze alloy: he suggests that copper should be mixed with tin when the former is in a liqid state; or else in another instance: "To combine lead with other metal. If you wish for economy in combining lead with the metal in order to lessen the amount of the tin which is necessary in the metal, first alloy the lead with the tin and then add the molten copper." (Triv. 16/a; Richter II, p. 15 no. 739.)[56]

Fig. 12  Sketches of furnaces for melting metal are often found in his drawings: Cod. Atl. f. 32/r
Fig. 13.  and f. 306 r-c, Cod. Triv. 16/a and Windsor no. 12348.[57] There are crucible furnaces and air furnaces in the drawings. A great deal depends on their proper construction and maintenance. He recommends willow and dry, young willow boughs for their firing up, except for one case in the drawing on Cod. Atl. f. 306, where coal is mentioned (*carboni*), although most probably this meant charcoal. Of the above-mentioned metals copper has the highest

melting point: 1083°C. Cellini described the exciting casting of his Perseus, where during the work the metal grew stiff and had to be re-melted. He used oak wood for this procedure but its fire was too hot for him and according to his description the gun-founders used poplar or pine-wood.[58]

Leonardo gives a detailed account of the model, the later core of the mould, of its inner structure and its modelling. "Anchora lo scultore, se fa di terra o'ciera, puo leuare e porre, et quando e terminata, con *facilità* si gitta di bronzo et quest'e l'ultima operatione e la piu permanente..." (Cod. Urb. 28/a–b).[59] Still, the master shows great concern for the execution of the casting: he makes drawings from different views of the future metal layer of the horse model and of the ingates (casting holes) (Windsor nos 12348, 12352, 12351). These drawings always show the walking horse, which Leonardo wanted initially to cast in one piece in spite of its considerable size. No. 12349 in Windsor is the only drawing where rearing horses are sketched and the large holes on their backs are clearly meant for the rider to be placed in position later. The same must have applied in the case of our statuette; as was mentioned earlier, the rider was fixed to the horse later. Most probably, here too a larger opening was filled in later, using more advanced technology, since the sample taken from around the hole where the metal rod holding the rider was inserted slightly different from the rest. The Si, Mg, Al, Ca content has been explained as the result of external surface pollution or the use of a sealing-compound. On pages f. 149/r and 151/v. of the Madrid codex no. 8936-II are sketches for the casting of the walking horse and beside the latter the following note is found, dated December 20, 1493: "conchiudo gittare il cavallo *sanza coda* et adiacere..."[60] This shows that Leonardo gave up the idea of casting it whole and decided to use piece casting (*forma di pezzi*) (Windsor no. 12347). Our statuette is dated much later, to the last years of his life but, as already mentioned above under the description of the piece, he adhered to this earlier decision. The tail and a large section around it was cast separately and then inserted.

To complement our discussion of the technical execution of the statuette we have to study the problems of balance and the influence of classical prototypes. "*L'imitazione delle cose antiche e piv laudabile che quella delle moderne;*" and "*Il trotto e quasi di qualitá di cavallo libero...*" (Cod. Atl. 147/a).[61] In relation to the walking horses the influence of the Marcus Aurelius statue and of the so-called Regisole monument, at Leonardo's time still visible in Pavia, has generally been mentioned rather than the horses of Verocchios Colleoni and Donatello's Gattamelata. These latter represented the palfrey type of horse, in which a pacing gait, using the limbs on the same side of the body together, was artificially induced.

We are concerned here above all with illustrations of rearing horses. In Rome, rearing horses curbed by the Dioscuri were to be seen on Monte Cavallo, today in front of the Quirinal. Leonardo made precise drawings of some of their details, to complement his drawings from nature.[62] The motif of the galloping rider trampling down an enemy, which was always in Leonardo's mind, is only known from three classical pieces—a torso from Delos, so-called Dexileos-stele, and a sepulchral monument from Attica, now in the Villa Albani in Rome.[63] But these came to light only in the 18th and 19th centuries, respectively and any influence on

Fig. 16.

Fig. 14.
Fig. 15.

Leonardo's rearing horsemen may therefore be excluded. The composition of the group may have derived from Hellenistic gems and Roman imperial coins.[64]

Plinths of Hellenistic equestrian monuments with hoofmarks of rearing horses:

1. Priene Agora      2. Delphoi, Aristainos      3. Delos Apollon Temenos
Basis, B.C. 186—85

Some interesting marble slabs have been found, which were later re-used for building walls, but once served as bases for Hellenistic bronze equestrian monuments and thus help us to reconstruct them. The position of the horses may be inferred from the hoofprints remaining in the marble.[65] Rearing horses were also among these — as may be assumed from the fact that only the two hind hoofprints remained on the complete slab. At the front of some of them, traces of a small supporting rod or the larger traces of an enemy fallen under the horse can be detected. There are instances where no traces of a supporting rod are visible. On one slab the hoof-prints are at the very edge of the marble base and the stance could have been quite similar to our horse's straddle position. Another analogy between the two pieces is that in both cases the left hind leg is somewhat ahead of the right one.

We do not intend here to dwell further on the relationship between Leonardo and the classical monuments. In his last Italian years he stayed in the Vatican where he was able to witness the excavation of antique statues and their erection in the garden of the Belvedere. He made small sketches of the Sleeping Ariadne, or Cleopatra (Cod. Atl. f. 283/v).[66] The arrival of this piece in the Belvedere may be dated to 1515, which means that Leonardo might have seen it personally and his sketch of it may already have been connected with the endeavours by Francis I, King of France, to collect copies of antique pieces.

Another classical sculpture which could have been known by the aging master was the Tiberis, one of the so-called river symbol group of statues. It came to light in 1512 and was included in the Belvedere garden collection.[67] Information from the time of the French Revolution refers to this fact: "*A Fontainebleau on a mutilé un fleuve en bronze exécuté sous les yeux de Léonard de Vinci.*"[68]

How the original eventually came to be in Paris is not important here, but Leonardo supervised the casting of this *fleuve*. Contrary to previous opinion, he led a rather active life in France, considering his state of health: he took part in the conversion of the castle of Chambord,[69] made plans for the regulation of the River Loire as far as Romorantin, organized festivities for which he constructed moving animal figures, etc. The most important activity from our point of view was his supervision of the above-mentioned bronze casting. The unfinished state of our statuette, its unchiselled runners are all evidence in favour of Leonardo's authorship. According to Vasari, Rustici was later commissioned to cast the horse, in 1528, but he was not successful (1973, 6th ed., pp. 619—620, was used by the author). Such an untrimmed, "raw" model could not have been presented to the highest benefactor or client by any other artist but Leonardo. Leonardo's last patron, Francis I, King of France nevertheless greatly valued and appreciated the small masterpiece, as we shall see later.

The final conclusion of our next chapter will be that after the numerous unfinished works in Italy Leonardo's idea of a rearing horse with a rider, a motif which followed him throughout his life, could at last be realized, at least in the form of a small plastic model made for the French king.

# The prototypes
# of the formal elements

It is by no means our aim to compare our statuette with that of St. George (1373) by the brothers Kolozsvári, now in Prague. This was an outstanding work of the late Middle Ages, composed to stand in an open space with a single front view, where the rising ground produced the illusion of a rearing horse. Further comparisons with the statues of generals on walking horses are to be avoided. In painting we must disregard the two fresco monuments in Florence Cathedral by P. Ucello (1436) and Andrea del Castagno (1456), and the equestrian battle scenes by Ucello, which are regarded as perhaps the most varied fifteenth-century prototypes. These were painted for the Medici Palace in Florence, for the family which were Leonardo's first patrons. Within Leonardo's own oeuvre we are concerned above all with the motif of the *warrior seated on a rearing horse*. It is one of the few elements which cropped up time and again in his work, were used several times over. He returned to this motif a number of times and included it in other compositions. All these have been dealt with in the many studies by Edith Pogány-Balás.[70]

The first large-scale original painting by Leonardo, showing many figures, was commissioned by the former Augustine monastery of San Donato a Scopeto for the main altar of its church and depicted the *Adoration of the Kings*. In September of the same year he received his last payment for this work, but he left it unfinished and moved to Milan in 1482, entering into the service of Lodovico Sforza (il Moro).

The *Adoration of the Kings* never went further then its underpainting in several shades of brown. Behind the most important figures in the foreground swarm masses of accessory figures. The enlargement of the scene to such an extent is due to its gradually having developed a profane, popular character. Part of the background is especially important from our point of view. In the middle of the background landscape, at a point to which the eye is drawn from the left by the sharply foreshorted ruins of terraced buildings, there are two trees, at the feet of which two nervous members of the retinue have started a fight and their horses can be seen rearing. A third figure has fallen to the ground between them. How often will we meet this same motif in Leonardo's work!

Fig. 17.

A traditional motif in the Adoration of the Magi is the debate between the two kings about the star which led them to Jesus. One of them points to the sky with a sweep of his arm, which may be in one of a variety of positions. This motif can be traced to 14th century French, North-Italian

and Rhenish ivory carvings.[71] This motif appears in Leonardo's picture on the left, in the figure of a follower pointing to the sky. The position of the hand is again a constantly recurring Leonardesque motif, the origin of which may be sought in antique prototypes already known in his time.[72] This question is quite important here because, as we shall see, several other medieval ivory motifs also found their way into Leonardo's works.

In connection with the mounted battle in the background of the *Adoration of the Kings* we may refer to a prototype in French painting of a hundred years earlier. In the Bargello there is an altar panel showing a narrow valley between two hills where two horsemen are fighting and their animals at the same time fiercely biting each other.[73] The painting is dated to around 1390 but no mention is made of the circumstances and time of its arrival in Florence. This means that we are unable to draw any conclusions about its possible influence on the background scene to Leonardo's picture. Epiphany as a church festival commemorated predominantly the baptism of Christ in the Eastern Church, the coming of the Magi in the Western Church. The Marriage at Caana lost its importance in both Churches. The festive processions outside the church and the dramatization of the events were first mentioned in Milan in 1336.[74] In pictorial representations the Journey of the Magi, their hunts in the meantime, etc., gained more ground. A magnificent procession of this kind is represented on the murals of the chapel in the Palazzo Medici, painted by Benozzo Gozzoli in 1459–60 to commemorite the 1439 Ecumenical Council, which is partly designed to depict outstanding personalities of this time. Accordingly, the costumes of the personalities and the caparison of the horses befit the status of the clients and those represented in picture. In Leonardo's picture all the figures are clad in simple, neutral cloaks, which are not typical of any period.

It was still in Leonardo's lifetime, but most probaly completely independently of him, that Hieronymus Bosch painted his beautiful *Adoration of the Kings*, dated 1516 (Madrid, Prado). The composition here is even more complex, since besides the adoration of the shepherds the mystic anti-Christ also appears. The gifts of the kings and the outer surfaces of the boxes containing them are ornamented with biblical scenes, for example the Sacrifice of Isaac, or pointers to Christ's future self-sacrifice: there are pelicans on one of the kings' crowned helmets, laid beside them. The position of the kings, Mary and her Child accords with the liturgy of the mass for the feast of the Epiphany, at least as far as the central part of the scene is concerned.[75] At the same time, in view of the pitched battle beween the two mounted armies in the background, it was interpreted as the future clash between good and evil, between chaste innocence and sinful impurity, according to Ezekiel (38. 1–10. Gog and Magog) and certain parts of the Apocalypse (20.8–10).[76] These parts of the Holy Scripture are not included in the texts for the mass or the psalms—the Augustinian canons in Scopeto used the Romanum— but nevertheless the wishes of those who commissioned the paintings played a very important role in determining the complicated symbolics of the compositions. We have had to dwell on the above in order to show that ancient elements were often employed by Leonardo and indeed other great masters.

<p style="text-align:center">★</p>

In his letter to Ludovico Sforza, in which he offered his services and listed his abilities in engineering, architectural work and the manufacture of tools of war, Leonardo mentions his skill in all branches of sculpture.[77] He acquired his latter ability in the workshop of Verrocchio in Florence, and thus found himself qualified to undertake a monument to commemorate the great general Francesco Sforza.

At the Sforza court he practised a great variety of activities. His Milanese works are well known. We only mention two here, but the difference between them is typical of North Italian courts and of Leonardo's art too, especially as far as our statuette is concerned.

On January 13, 1490 the "Festa del Paradiso",[78] to celebrate the wedding of Ludovico il Moro's nephew Giangaleazzo Sforza and Isabelle of Aragonia from Naples, was held in the Milanese Castello. The text was written by B. Bellincioni (d. 1492), a Florentine humanist who lived in Milan, while the staging of the play was Leonardo's task. Among the figures were the classical gods of the seven planets, the signs of the zodiac, etc. The plan for the magnificent fresco in the Salone dei Mesi of the Schifanoia Palace (1469 and 1476–1484) was provided by Pellegrino Prisciano, an astronomy professor at the University of Ferrara, who was a librarian and historian to the d'Este family. He was inspired by M. Manilius, who lived at the time of Augustus, the early medieval Abû Màšar (Albumazar, 805–885), and his Latin translator, Pietro d'Albano (1250/57–1316). Among other astronomical works one of Albumazar's writings was to be found in Leonardo's library and he could thus apply considerable knowledge in the service of his clients, whose ideas tended towards the astrological. In the ruling generations of the d'Estes the classical humanist rules were succeeded by those advocating the *poesia in volgare,* the courtly culture—Lionello, Borso, Ercole—thus enabling Leonardo to follow in Milan the path of the so-called *umanesimo cavalleresco.*[79]

On January 26, 1491, Leonardo was staying at the house of Giov. Galeazzo da San Severino "a ordinare la festa della sua *giostra* e spoliandosi cierti staffieri per provarsi alchuna veste *d'omjni saluatichi* ch'a detta festa achaderno". "Item. On the 26th January following, I, being in the house of Messer Galeazzo da San Severino was arranging the festival for his jousting, and certain footmen having undressed to try on some costumes of wild men for the said festival..." (C. 15/b I.—Richter II, p. 363, no. 1458).[80]

The traditions of the ancient feudal nobility, the tournaments, were still alive among the new rulers of the Italian city states. These could be eminent tradesmen and financiers, or those who had come to power with the help of the army—e. g. the Sforzas—and tried to imitate the ancient customs of the impoverished nobility. In Florence Leonardo was able to witness two important *giostras* of the Medici family. The first was arranged by Piero the Elder in 1469 for his 19 year old son, later "Lorenzo il Magnifico". The second took place in 1475, in honour of the latter's younger brother, Guiliano. In both cases the ornaments of the weapons, the banners, draperies, etc., were designed by the leading artists of the city, among them Verrocchio, and Leonardo, who worked in his shop.

We know of another *giostra* in Milan, arranged for the wedding of Anna Sforza and Alfonso d'Este in 1491. These joustings in Italy were not real, serious tiltings. The weapons were largely

decorative and the costumes of the young men were what mattered. They fought without inflicting wounds upon their adversaries. Horse races, tourneys and processions completed the ceremony. In the opinion of the sixteenth-century M. E. Montaigne: "les prences et la noblesse d'Italie s'amusaient plus à se rendre ingénieux et scavants que vigoreux et guerriers". Gianfrancesco Gonzaga wrote a letter to his son Federico in 1519, a year before his death, expressing the Italians' opinion of the French. The young man was staying in France at that time and his father warned him against the customs in France, where "demenini" (Tumben, garzune) "noi le indicamo molto pericoloso quando non se vi usi arme e selle solite adoperarse in Italia in le chiostre . . .".

The "wild men" costumes of the festivities at Galeazzo da San Severino's harked back to the so-called "Breton cycle of legends" which were popular in Lombardy and above all in the Alps. The *ludi de homine salvatico* were theatrical customs of the spring-time festivals. Survivals of these customs may still be found among the Southern Slavs in Hungary, who came from Dalmatia via the Balkans. Later we shall be able to trace these magic motifs in Leonardo's other works, in particular his drawings.[81]

Among the Leonardo sketches depicting a rider seated on a rearing horse we find a number of variations. In the early examples the horses are drawn from the side and at least one of their raised front legs is supported. In the beautiful silverpoint drawing in Windsor (no. 12358. r) the rider is seen in profile, his right hand with his staff pointing backwards—although the possibility of a forward-pointing right arm is also indicated in pentimento—and with his left he is pulling at the reigns, thus determining the carriage of the horse's head: its neck is thrown back and the head is turned towards the onlooker. The rider is naked, either because it is only a pose study or because the artist wished to indicate the heroic nudity of antiquity. Later the human figure is drawn in a more impressive position: he is turned towards the onlooker: pointing forward or backward with his staff. Leonardo practices both open and closed composition, i. e., parallel to the horse's movement or in opposition to it. The rider's cuirass is simple, hardly seen, just drawn with a few lines. (E.g. Windsor nos 12343 and 12355, dated to 1508–11 and associated with the Trivulzio project.) The horse is often supported by a human figure, the enemy, either protecting himself with a shield under the front legs of the rearing horse, setting his leg against the animal's belly or crouching and trying to make himself as small as possible, relying on the possibility that the horse will jump over him.   Fig. 19.

During Leonardo's first sojourn in Milan, in 1490, he stayed in Pavia for a time, where in the former Visconti Library he might have seen the late-fourteenth century codices which subsequently went to Paris as the booty of Louis XII, King of France. After the presentation of the clay model of the Sforza Monument in 1493, Leonardo had to give up his plans to cast the horse, because the bronze obtained for the purpose had to be given away in the autumn of 1494 to Ercole d'Este for gun-founding. On their entry into Milan in 1499 the French soldiers used the model as a target for shooting practice and this sealed its fate. Leonardo left Milan. Among other places he went to Mantova where he painted a portrait of Isabella d'Este. On this occasion he most probably had the opportunity of visiting the Pisanello frescoes (1435—1444), which had

recently been discovered. They show an episode from the Arthurian cycle, the tournament at Leverzep, the scenes of which are somewhat brutal.[82]

Fig. 18.     Leonardo's composition of *The Battle of Anghiari* is the depiction of a grim cavalry battle, the swirling, rearing horses biting each other in fearsome fight. It was executed on commission by the town between 1503—1506. It is quite extraordinary that he could paint simultaneously two pictures of such different emotional content — on the one hand this unbridled hatred, on the other the *Mona Lisa*, the personification of peace, balanced emotion and harmony. The head of the latter figure is emphasized by the obscure landscape in the background, with its unusually elevated horizon.[83]

The mural of *The Battle of Anghiari* for the session-hall of the Palazzo Vecchio remained unfinished. The best copy of the cartoon, which accords with contemporary descriptions, was made by Rubens (today in: Paris, Louvre). The fresco was started but never finished and subsequently destroyed. In art historical literature the question has often arisen as to whether the copies by Rubens and other artists only represented the central part of the whole battle scene. There have been attempts to link up the crowded composition of the central part of *The Battle of Anghiari* with Leonardo's other drawings of cavalry fights or battles between horsemen and infantrymen, the composition of which is usually much looser.[84] (Windsor nos 12339, 12340;

Fig. 53.     most of Leonardo's drawings in the Accademia in Venice, e. g. the No. 216. or B. B. 1098.) These attempts have been refuted on two counts. According to Isermeyer the size of the wall surface and the position of the windows in the council-hall were not suited to this purpose.[85] A. Chastel pointed out that we have no knowledge of the complete plan.[86] In my opinion there are other reasons which distinguish the battle scenes — seen from a different perspective — in the above mentioned drawings from *The Battle of Anghiari*. My arguments are based once again on Lomazzo's work.

His *Trattato* (Lib. VI, Cap. 5: Regole de i motti del cavallo...) contains rather ambiguous praise of *The Battle of Anghiari*: "Má avvertiscano i pittori, che ne gl'huomini e ne'cavalli e altri animali, non si doverebbono in tutto esprimere i moti cosi estremi, se non si e sforzato piu che da gran necessita di effetto sforzato e terribile. Impero che apportano spesso piu tosto offensione che diletto alla vista, eccetto se non si fosse piu che eccellente nel dimostrargi, si fece nella sala conseglio di Firenze Leonardo, dove gli espresse con atti stupendi, e scorti maravigliosi, alla concorrenza de quali il Buonarotti fece il suo maraviglioso cartone de'nudi..." This can only refer to the "central" group.

The linking of the drawings in question with *The Battle of Anghiari* is even more improbable, if we look at another description by Lomazzo. It is a very important circumstance, and one which up to now has received little consideration, that the following sentence appears on p. 384 of his *Trattato* (Lib. VI, Cap. 40) in the section "Compositione di giuochi", after the description of antique tournaments and the prizes: "Ma ritornando a professori dell' armi, eccellente appresso a nominati fu Gentile de i Borri, al quale Leonardo da Vinci disegno tutti gl'huomini a cavallo, in qual modo potevano l'uno da l'altaro difendersi con uno a piedi, e l'atro difendere e offendere per cagione delle diverse armi." These descriptions fit the drawings in Venice and in my opinion the

latter can therefore be identified with the drawings made for Gentile de i Borri. Unfortunately there is no information about the time they were made. It is significant that these drawings depict tourneys, the practice of military prowess, which are regarded by Italian historical literature as characteristic of the French.[87] It is therefore more probable that it is the period after the French conquest which is represented here, the military prowess, which received its reward in the service of the French — perhaps even, to use a modern word, manoeuvres, i. e. a harmless, though by no means hazard-free, military exercise. According to the rules of the "classical" tournaments the foot soldiers bearing the armour of the mounted warriors were allowed to intervene in a battle fought with sword, dagger or axe.[88] There are numerous examples in codex illustrations: the fifteenth century marriage ceremony forming part of the scene of St Thomas' mission in a religious codex made for Philipp le Bon, Duke of Burgundy, would have been incomplete without such a spectacle.[89] In a later manuscript which belonged to Francis I, King of France, now in the British Museum, the role of the foot soldiers is mainly that of parting and protecting the mounted warriors if the tournament should degenerate to a free-for-all.[90] Fig. 29. Fig. 30.

Leonardo's drawings of more uninhibited military exercises went to Venice as late as 1822, from the Milanese Luigi Celotti, who acquired them from the collection of Giuseppe Bossi (d. 1815). Bossi himself was a painter and the founder of the Brera Gallery. He acquired the drawings from the heirs of Venanzio de Pagave, who obtained some of them at least from Cardinal Cesare Monti. The earliest known owner was padre Sebastiano Resta at the end of the 17th century.[91] These men were all Milanese residents and it seems highly probable that the drawings had never left Milan.

Chronologically, therefore, the motif of the battle between warriors on rearing horses first appears in the background to *The Adoration of the Kings* and later, with heightened emotion, in *The Battle of Anghiari*.

In 1506 Leonardo left Florence, at first temporarily, at the invitation of Charles d'Amboise the French governor in Milan, later extending the time limit. In 1507, after the death of his father, he returned to settle family issues and the beginning of a new manuscript is dated to March 1508 in Florence: Ms. Arundel. In July, however, he returned to Milan. During his short stay in Florence he helped his pupil Rustici with the casting of three of his bronze statues for the Battistero: St John the Baptist, the Levite and the Pharisee.[92] The St John the Baptist motif of the hand raised in a pointing gesture can be recognized in several of Leonardo's works. From the summer of 1508 he settled again in Milano where he received the same titles, status and honours as at the time of the Sforzas.

In the preparation of the Budapest statuette a number of works represented important stages: the Adoration of the Magi, the studies for the Sforza monument, the drawings for *The Battle of Anghiari* and of other battle scenes. Now we have to examine the next Milanese work, the sketches for the Trivulzio monument. The "great" condottiere Trivulzio, Gian Giacomo, was a native of Milan, but this fact did not disturb him when he entered the city in triumph after his victory in the service of the conquering French. After the death of the first French governor (1511), he assumed power which he shared with the Frenchman Gaston de Foix. Trivulzio's

intention to have his tomb made with an equestrian statue during his life-time was in line with the customs of the time. The exact date of the commission is not known, but Leonardo's estimate of the cost and his description of the monument is extant (Cod. Atl. 179/b). It was planned as a life-size equestrian statue on a plinth. In the drawing in Windsor (no. 12355) we see a square plinth with standing nude figures by the corner pillars. At the four corners of the cornice which crowned the columns he planned seated figures (Windsor no. 12353), while in the middle of this pillared monument the figure of the condottiere was to lie on the sarcophagus. The studies for the monument sometimes show a walking horse but those depicting a rearing one are in the majority, Windsor 12359, 12360, etc., in addition to those mentioned.

Fig. 19.

In the nudes bound to the corner pillars the influence of the slave figures in Michelangelo's first plans (1505) for Pope Julius II's tomb has been detected. One problem for research has been how Leonardo gained access to the sketches for the Julius monument. The strained relations between the two artists, publicised by Anonimo Gaddiano, suggest that he would have had little opportunity.[93] It is obvious that the answer is to be sought in their parallel commissions in Florence (the battle cartoons for the Palazzo Vecchio) which permit us to presume fairly regular meetings as a result of which Leonardo was able to draw on Michelangelo's sketches for the details of the Trivulzio monument.

Among the studies for the Trivulzio monument we find a few where the plinth is round, surrounded by columns. This has been connected with a sketch in Antonio Averlino's *Trattato d'architettura* (1464), dedicated to Francesco Sforza.[94] The most detailed Leonardo studies show the condottiere on a prancing horse, without any support and with the movements of the horse and the rider in opposition. It was planned to stand in the open air, a statue in the round (Windsor no. 12355). In the meantime, the walking horse variant also appeared. Of the final solution even less is known than in the case of the Sforza monument, although as far as details are concerned, we have studies of the face and head of the commissioner of the monument.[95] The life-size statue was finally never executed, a possible reason for this being that the condottiere's son died in 1512 and Trivulzio abandoned his plan of erecting an individual monument. Instead he built a family mortuary chapel with niches for the coffins within a central building, beside the S. Nazaro Maggiore in Milan.[96]

Nevertheless, the numerous preliminary sketches and anatomical studies, the various projects and plans which were never carried through, were not entirely in vain. The idea finally took shape in the form of a small-scale model or models, of which only one survived "... di sua mano ..." with merely slight changes. A presentation and evaluation of these changes is the subject of the next chapter, but the name of the person for whom it was executed appears in Lomazzo's *Trattato* Lib. VI, Cap. 19: "... Con la medesima via riferi Francesco Melzo ... cosa molto mirabile a vedere ... *parimenti i cavalli che fece per donare a Francesco Valesio Re di Francia...*". After so many futile studies, plans, destroyed and unfinished projects, Leonardo gave the superb plastic model to Francis I, King of France.

★

The war situation in Milan forced Leonardo to move to the home of his above-mentioned pupil, F. Melzi, near Vaprio and later he left with him and other pupils in 1513 for Rome, where he was given a home at the papal court of Leo X by Giuliano de Medici, the Pope's brother, in the Vatican Belvedere. From then until 1516 he was preoccupied with theoretical studies and writings; artistically these years were unproductive. Then, although he had turned sixty three, he happily seized the opportunity and accepted an invitation from the young French king, who just succeeded to the throne. The date of Leonardo's departure from Italy is still rather uncertain. Most probably he set out in the autumn of 1516 across the Alps and arrived in the castle of Cloux before winter came. Taking into consideration the fact that the French New Year started at Easter, Leonardo is estimated to have spent 30 months at the king's court. In spite of his ill health, his artistic activities were extremely varied. At his death he was "I.er peinctre et ingenieur et architecte du Roy, meschanischien d'estat et anschien directeur de peincture..." (Beltrami, L., *op. cit.* in note 12, pp. 156, no 246).

The 21 year old, highly cultured king was deeply loved but strictly educated by his cleverly calculating mother, Louise of Savoy and his sister, the witty writer, Margaret of Navarre. He revived the Italian aspirations of his predecessor and uncle Louis XII. After having assumed power he crossed the Alps with his army and, to the utter amazement of the world, won a victory in 1515 over the enemy army which was reinforced with Swiss mercenaries. His ambitions never let him rest and he spent practically his whole life on the battle-field or hunting. In the year of Leonardo's death, in January 1519 Maximilian I died and Francis I aspired to the throne of the Holy Roman Empire for which he already made some diplomatic moves. His intentions may have been known to Leonardo in the last months of his life (he died in May 1519). The king failed in his bid for the throne and instead of him the Habsburg Charles V came to power.[97] Leonardo's invitation to France gave a spur to the activities of many Italian artists in France. The influence of the Italian Renaissance was felt strongly there although the advance of mannerism had already begun.

# *Questions of subject and content. "Homo ludens"*

On the basis of the previous chapters we may now conclude that the descriptions fitting our Budapest "rilievo di plastica" show that it is Leonardo's autograph work. The statues he made in Italy which resembled this one either remained unfinished or have been lost. He made some remarkable models of horses for Francis I, King of France. We shall now attempt to prove that our statuette in Budapest is identical with one of those meant for the young king. When compared with the monuments made for the Italian generals, the slight formal alterations he made changed the essence of the whole piece.

Attention should be drawn here to those features which are rather unusual in the case of a "warrior seated on a rearing horse": (a) our horseman's confident, happy face, which reflects a pronounced personality; (b) the absence of protective armour on the horseman and of saddle and reins on the horse; (c–e) the crown-ornamented and dragon-crested helmet.

All these have persuaded us to believe that our statuette was never a model for the monuments commissioned by the Milanese generals. We have to add that the origins of the motifs cannot be investigated in every detail, but it is not necessary. More important will be information about people's knowledge at the time of Leonardo and his last patron, in the period before them and for a while after them. It will be interesting to see what they knew of earlier, ancient things, why they reached back to them and what they tried to express by them at the time and in the place where the little masterpiece was made.

Literary sources for the motifs are investigated mainly within the social stratum and circle with which Leonardo was familiar, from which he received his commissions. Literary works popular among the lower classes are only referred to if their influence on Leonardo can be proved.

(a) *The horseman.* If we compare him with the fiercely fighting warriors of the Battle of Anghiari and the sketches for the monuments to the generals, the main difference which strikes us as we look at the statuette is that instead of a staff and the reins he carried a sword in his right hand, of which only the hilt is extant. In his raised left hand the shield is still to be seen; thus he is unable to direct his horse with reins or bridle. In view of all this, there is a direct link between our statuette and a detail in an earlier drawing in Windsor (no. 12283). The small figure with sword and shield, sitting with his legs drawn up on a rearing horse, is on a sheet which includes other

Fig. 20.

drawings, such as the half-figure of an old man in classical garb, plants connected with the *Madonna of the Rocks* and geometrical figures, etc. Either it was drawn later on this sheet independently of the others, or else Leonardo went back to this earlier idea. We cannot be sure. There is another drawing in Windsor (no. 12354) which is regarded by scholars as sufficiently complete to serve as a direct model for the statuette. The face of our rider is not that of a soldier or a hard-featured general.[98] He has a merry, self-confident countenance, he is not fighting and is not going into a battle. He is not the leader in a serious fight, but is only playfully defending himself from an adversary attacking from the left or perhaps already defeated. His shield is protecting his startled horse, or at least the animal's head, rather than the horseman himself. The horse is a stocky type, the so-called "destrier", which was used in jousts and tournaments and he rides it bare-back. The movement of the horse and the use of the sword suggest that the horseman has been taking part in a joust or is the winner of a tournament (*torneo, tournoi*) where movements in several directions were allowed. From Italian sources we know that this was an especially popular sport in France, the Italians regarding it as too dangerous.[99] During such a tournament—as seen in a late fourteenth-century codex from Milan, now in Paris[100]—the units of the opposing parties readily split up into smaller groups, and after the weaker ones had been eliminated the rest of the participants fought duels.[101] The confidence on our horseman's face indicates that he is out of danger but the alertness of the horse shows that they are still excited, the tension has not yet evaporated.

Fig. 21.

Fig. 31.

Fig. 30.

Fig. 29.

The facial expression of the rider, in spite of his small size, perfectly expresses his character. The confident smile, the strong chin, the narrow eyes and above all, in the words of Lomazzo: the "grandissimo naso" make it indisputable that the hero of this French-style tournament is "Francesco I. Valesio, re di Francia" himself.[102] Portraits of his youth—a drawing by a French master from c. 1515 in the Hermitage, Leningrad, or a picture by an unknown artist in Chantilly, Musée Condé—lack the furrows around his smiling mouth. They may be found, though, in his later portraits, both the one by a painter from the circle of Corneille de Lyon in the Lyon Museum and the bust with a feathered hat among the statues decorating Chateau Sansac.[103] The portraits of his old age—a portrait by J. Clouet and a bronze bust by an unknown sculptor in the Louvre, a profile portrait by Titian, thought to be based on a medal by Benvenuto Cellini—also perfect, a confident, cheerful personality.[104]

Figs 22, 24.

Fig. 25.
Fig. 23.

The detection of similarities is at least partly influenced—as is shown by the results of comparisons with Leonardo drawings, begun by Simon Meller—by subjective considerations. We shall therefore endeavour here to find other arguments besides the apparent physiognomical similarities to justify our hypothesis that the statuette is a portrait of the French king during a special tournament. The subtitle of this chapter is thus necessarily "Homo Ludens".

It is a fact that Leonardo was preoccupied with the portrait of Francis I. He made a separate study of the head of the king: "...testino di Francesco I. re di Francia..."[105] The genre of the portrait is not known but its subsequent fate can be traced: it was mentioned as part of the Veronese Curtoni Collection in 1662, then in 1668 the whole collection was acquired by

Alessandre II Pico della Mirandola and the last duke of the family, Pierfrancesco Maria, took it to Bologna. After that, however, all sign of it was lost.

Let us turn now to the details of the horseman that show the elements of a special tournament, rather than an every-day event.

(b) *The rider's clothing*. As already mentioned he is wearing a shirt-like garment which is indicated by small indentations on his thighs and is more discernible between his legs. It is a close fitting, light shirt, no longer to be detected on the upper part of his body. His muscles are clearly visible. The absence of a saddle is another important peculiarity which deserves our attention. We have already mentioned the Gonzaga letter from the beginning of the sixteenth century, according to which the French way of jousting was regarded by the Italians as too dangerous. In fact, the French did not use the saddles and arms (presumably defensive arms) which were customary in Italy but fought with different ones. We have more data on the subject. In 1450 Jacques Lalaing organized a tournament in Châlon-sur-Saon, called "Pas de la fontaine aux Pleurs" with the consent of Philip the Good, Duke of Burgundy. There were a great number of participants and in order to avoid the danger of tediousness or boredom he asked the knights to discard now this part, now that of their armour.[106] Furthermore, in 1454 in Lille at the tournament organized by Philip the Good for the knights departing for the crusades, Philip Pot made a vow that he would take part with his bare right arm in the potentially serious fights.[107] Thus it was to be expected that Francis I would wish to excel all former bravery, in a time when knighthood and chivalry were being rather artificially revived. The king was presumably familiar with Jacques de Baisieux's *Des trois chevaliers et del chainse* (chemise), an excessively, "hyperchivalrous" tale. In thirteenth century literature, in Lancelot's Book in the so-called "Vulgata cycle", or in the compilation made by Rustichello da Pisa in Italy at the end of the century, there was an insignificant knight, Meldon l'Envoisié, who fought for a period of one month in only a shirt. He is depicted thus in Pisanello's Mantova frescoes between 1436 and 1444. In the second half of the fifteenth century in Sir Thomas Malory's Morte d'Arthur similar heroic deeds are performed by Tristan and Lancelot.[108] The rise of this motif into noble circles continued with Francis I and ended with King Arthur.

In Leonardo's work we find horsemen without a saddle in drawings for the Milanese equestrian monuments e. g., no. 12354 in Windsor and no. 12360, the so-called sheet with five horses, in the upper left sketch. Two naked horsemen riding bareback and fighting a dragon are to be seen on the beautiful sheet in the Louvre (Rothschild Collection), which is definitely not a St George. Similar fights with dragons are to be seen in no. 12331 in Windsor, especially in the group in the upper right. In my opinion it is not a St George motif but one of the legendary knight and dragon adventures. In the same sheet in the middle on the left is a horse, drawn from the rear, which is reminiscent of the Budapest horse. This similarity was noticed by Simon Meller. The sheet cannot be dated to the time of the Anghiari cartoon, but was produced in the last years of Leonardo's life.[109]

(c) *The horseman's helmet*. Huizinga cites from Sainte Palaye's book, the contemporary chronicler, according to whom Francis I took great pleasure in the personification of figures

appearing in the "Neuf Preux" (we shall dwell upon this in a subsequent chapter), which was still popular in his time, in clothing *à l'antique*.[110] In our case *à l'antique* could have referred only to the helmet with vizor up as opposed to the classical-chivalrous *heaume fermé du tournoi*, closed helmet. According to Millin (1759–1818), a younger contemporary of Sainte Palaye and one of the representatives of Classicist archaeology, this had to be rejected, because the helmet with vizor up does not conceal the feelings and passions which are reflected on the face of the man.[111] He failed to take into consideration the fact that the Greeks had their vizors up only as long as they rested. During fights it was used properly, i. e. it was closed and protected the face and head of the warrior.

The helmet of our rider imitates the Greek form, as used during resting, but some new parts have been attached to it: the cheek-pieces used from the end of the fifteenth century, and the helmet-shade. It has no nasal, either of the rigid type or the moveable one which was fixed by a screw. Among Leonardo's drawings we can find some representing this latter type, e. g. the profile sketch of an old warrior in fantastic armour in the British Museum. On the vizor of our   Fig. 31. rider, above the cheek-pieces, there are traces of parts which enable the vizor to be lifted. Francis I is wearing this kind of raised nasal in an engraving depicting him in the 1525 battle of Pavia (engraving by Martin Heemskerck and Cornelis Bos).[112] On medieval closed helmets only a   Fig. 40. narrow opening facilitated vision while at the same time in special cases it served to preserve the knight's incognito. The perforated *bretèche* on the sides and at the bottom permitted breathing. It was further developed later into a grill-like, movable vizor, a *visière*. A good example is the figure of King Arthur on the tomb of Maximilian I in Innsbruck, which was cast in the workshop   Fig. 38. of Peter Vischer in 1513 after the sketch by Dürer.[113]

(d) *The helmet crown.* Lomazzo,[114] who is well versed in the antique tournaments, regards the chaplets that were given to the winners of classical tournaments and contests as prototypes of the later helmet crowns. Later, from the end of the fifth century, especially after military successes, these crowns around the helmet were made of precious gold or silver laminate.[115] The radiated crowns resembling diadems depicted on the Roman imperial coins might also have had some   Figs 22, 24 influence on these medieval helmet crowns. The kind of crown our rider wears, with its open golden or silver, triangular or semi-circular plaques was originally the headdress of the Byzantine women at the imperial court. Men wore helmet-shaped, arched crowns with a fillet.[116] In medieval Western Europe the once necessary, strict regulations were forgotten. We know quite a number of fifteenth-century representations of loosely or tightly woven floral wreaths *à l'antique:* in the *Scipio* relief (Paris, Louvre) which was commissioned for King Matthias of Hungary from Verrocchio, the Roman hero's helmet is wreathed with only one laurel branch; the Neapolitan Ferdinand of Aragon is wearing a tightly woven floral wreath on the frontispiece of the codex containing Cicero's speeches once in his possession (Vienna, Nat. Bibl. Ms. No. 4.).[117]   Fig. 35. In later courtly literature these floral wreaths acquired symbolic meanings and mystic qualities. In Anjou René's *Cuer d'Amour épris* (c. 1465), which followed such works as the thirteenth century *Roman de la Rose,* and writings by Guillaume de Lorris and Jean Clopinel de Meung, the floral wreath on the hero's helmet has been interpreted as meaning that his thoughts were always

centered on love (Vienna, Nat. Bibl. Ms. no. 2597).[118] Francis I had the *Le Roman d'Amadis de Gaule* translated from Portuguese-Spanish into French and this work had a fundamental influence on the whole life of his court. In the reconstructed original text[119] the revival of a faded floral wreath in the hands of a lady became the test of faithfulness.

We have a number of fine renderings of 14–15th century royal helmets decorated with precious stones and crowns. In the funeral procession of the Holy Roman Emperor Charles IV in 1378 his crowned helmet was carried behind his coffin. The scene is represented on the tower of the Old Town bridge in Prague.[120] On the so-called *Goldenes Rössl*, a beautiful example of ronde-bosse enamel-work which was given by Isabeau, Queen of France, as a New Year present to her husband Charles VI, the king's crowned, closed helmet with its French *fleur-de-lis* decorations is carried by a senior member of the court.[121] Philip le Beau (1478–1506) is wearing a Burgundian sallet with a crown of rich goldsmith's work[122] in a picture which has a companion piece representing his wife Johanna the Mad. These two pictures constituted the wings of an altar. In literature it is the crowned helmet of Richard III, King of England, which is the most widely known. He lost it at the Battle of Bosworth (1485) and his successor, the first Tudor, Henry VII, was crowned with it there on the spot.

In the discussion of our next thesis we shall have to deal with the role of the animal figures in heraldry. Be it said incidentally that on the Maximilian monument in Innsbruck King Arthur (designed by Dürer) has a crown on his helmet. More than a hundred years earlier, *c.* 1400, the legendary king had most frequently a three crowned coat-of-arms, sometimes he had even more crowns, depending on how many countries he had conquered, as seen on his tunic *(Waffenrock)* on a tapestry series formerly in the possession of the Count of Berry (now in the Metropolitan Museum of Art, New York, Cloister Collection). In the Boccaccio codex of Jean sans Peur (Paris, Bibl. de l'Arsenals, Ms 5193.f.349 v) the king is seated among the knights of the Round Table, he is distinguished by the drapery on his throne which is ornamented with crowns.[123]

In the *Adoration of the Kings* by H. Bosch (Madrid, Prado) the king kneeling in front has placed beside him as a symbol of his admiration his rather fantastic crowned helmet.[124] The last crowned helmet was ordered in 1543 in Augsburg for Gustav Wasa, King of Sweden. The *bretèche*, which served to facilitate breathing, is clearly discernible.[125]

(e) *The dragon-shaped crest to the helmet.* To illuminate the origin of this we have to go far back in history. Classical mythology would have us believe that the deities of the many nations, and the national heroes enjoying the benefit of their patronage, all have some sort of connection with the dragon.

The ornaments of the weapons in Renaissance pictures of warriors were determined not only by the emblematics and symbolism of classical antiquity but also by early and late medieval practice. On the "capitani affrontati" reliefs by Verrocchio, which were intended for King Matthias,[126] the monster and animal figures clearly had a dual role: on the one hand they filled the enemy with terror, while on the other they represented the benevolent protector of the wearer of the helmet. Frightful roaring lion heads are to be seen on the Dareios representation and in the above-mentioned Leonardo drawing in the British Museum. A similar effect is achieved by the

Fig. 39.

Fig. 38.

Fig. 61.
Fig. 62.

Fig. 31.

Medusa head on Scipio's breast-plate and on that of Donatello's Gattamelata.[127] Belief in their apotropaic power played an important part in their use. The benevolent protection of these legendary animal figures is an ancient totemic motif, seen, for example, on the North German wild boar helmets and in rich variety on medieval *escutcheons*. By the 13th century these animals had moved back to the helmets, to the so-called *Waffenrock*, a sleeveless, shirt-like garmet which was worn over the wire armour, to the *couverture*, the drapery covering the horse, to the banners, to the garments of the armourbearers, etc.[128]

In the Verrocchio reliefs Alexander and Scipio are justified in wearing the protective dragon on their helmets. This dragon belongs to Zeus, who was brought up on Crete, and escaped in the shape of a dragon from his father, Cronos. When he eventually seized power he took the configuration of the dragon to the sky.[129] This is the origin of the protective dragon which was the symbol of the heroes who trace their descent back to the supreme god, Zeus. In the case of Alexander we have our information from Plutarch, while Scipio is mentioned by his contemporary, Polybios, and this was taken up by Livy. It should be mentioned here that both Greek authors in Latin translation and Roman authors began to appear in print, especially around 1470. Codex copies of their works were well known and highly appreciated by Lorenzo Medici's Neoplatonic circle, those from the East through the good offices of cardinal Bessarion and those from the West in the wake of the activity of humanist researchers after Petrarch, Boccaccio and Poggio Bracciolini who were ardent seekers of antique texts.

In his *Trattato*[130] Lomazzo means the "capitani affrontati", though not in the above context, and deals especially with their facial characteristics: the broken nose of Dareios, the shaven face of Alexander the Great, the youth of Scipio, and his benevolent look. Later he mentions another legendary hero: ". . . fra i Re d'Inghilterra Arturo famosissimo, soleva portare una corazza e un elmo d'oro, nel quae era scolpito *un drago* e farsi portar inanzi un scudo d'oro, nel quale era scolpito la Vergine Maria; in battaglia soleva usare una lancia armata di ferro. . ." Where did Lomazzo obtain his information?

In Italian texts dealing with the Arthurian tradition—as far as I have been able to obtain indirect information from works of literary history—the king's dragon only appears later. For example, in a 1468 "Tavola ritonda o l'istoria di Tristano" manuscript, Tristan's father, Meladius, appears "a guisa di dragone"[131] at the great May tournament of Arthur's father, Uther Pendragon. Most probably Meladius was dressed in this garment in honour of his host. Earlier, following W. Pleister, I also regarded the 1544 Augsburg, Ziegler edition as an enlarged variant of the "De casibus virorum illustrium" and I have cited the data on Arthur's helmet from there: "*in qua draco* sculptus videbatur".[132] Recently, after reviewing Pleister's book, in particular with the aid of G. Ricci's study,[133] and on the basis of the texts of the enlarged version of the 1544 Ziegler edition, I have come to the following conclusion: both shorter and longer variants of Boccaccio's "De casibus" already existed in manuscript, but the original dual variant was not printed until 1973. The enlargements to the 1544 edition were different in character and not made by Boccaccio, but were interpolated by the publishers. The parts taken from known

authors have been successfully identified. Here we are only interested in the dragon helmet and the other arms mentioned by Lomazzo.

In his "prepositi tübigensis Chronicon...", first ed. Melanchton 1516,[134] Nauclerus Johannis (c. 1430–1510), referring to his source as Galfredus (Monemotensis, Geoffrey of Monmouth), enumerates and describes Arthur's arms: his sword, spear, shield, helmet, etc. Among others "... in capite aurea galea, *in qua draco* insculptus videbatur ... clypeum ... in quo Dei genitricis depicta erat...", etc. From this enumeration the 1544 Boccaccio edition contains only the following: "... in capite gestabat galeam, in qua draco scpulptus (sic!) videbatur..." Consequently, Lomazzo, who mentioned not only Arthur's helmet but also the Madonna picture on his shield and his spear, might have used the chronicle of Nauclerus directly, most probably in the later 1564 edition.

Researchers now think that Lomazzo made a journey to the North. Moreover, they think that he was familiar with some of the works of Johannes Trithemius (1462–1516), the Benedictine about of Spanheim, later of Würzburg, another eminent historian to the Emperor Maximilian.[135] We cannot advert here even briefly to the possible role of Trithemius in the planning of the Maximilian monument in Innsbruck and we would merely note that the "Compendium ... de origine gentis francorum", first ed. Insprug 1515,[136] also refers, among others, to Galfredus Monemotensis as his source of information. But here, there is no mention of Arthur's dragon. For Nauclerus and Trithenius the most accessible edition of Monmouth must have been the 1508 Paris first edition. Lomazzo was most probably familiar with the works of both authors and on his putative journey to the North might have seen the statue of Arthur, executed after the plans by Dürer, in the Vischer workshop. On the helmet of the statue, already mentioned earlier, and also on the armour and shield the dragons really are "*in*sculptus", i. e., engraved reliefs.

However, it is assumable that the two authors belonging to the circle of Emperor Maximilian's "humanists" made an allusion to Monmouth as an old source which they made only use of to give the impression of authenticity. They could have read in extenso the description of the arms of King Arthus in the world chronicle by Hartmann Schedel of Nürnberg (1440–1514)) which appeared in 1493 entitled *Liber Chronicarum* p. CXLIII/v. On the other hand, Schedel took over the above quotations—following in retrograde order—at least the passage referring to King Arthus, from the work by Jacobus Philippus Foresti Bergomensis entitled *Supplementum Chronicarum* published first in 1490 in Venice, on page 149. and later in a good many editions as well. It has to be thought over that this publication was to be found in Leonardo da Vinci's enlarged library. (Cf.: Reti, L.: *op. cit.* in Note 53 and 231 part II. *ibid.* col. 83. no. 13.)

It has also to be taken into consideration that the house of Schedel and that of Dürer were neighbouring and situated among the homes of influential patricians, ambitious merchants, humanists and famous artists. (Cf.: Fr. von Schnelbögl: Das Nürnberg Albrecht Dürers. A. D. Umvelt. Festschrift zum 500. Gebursttag. 1971. pp. 72—75.)

Going back to the times when the Innsbruck *Arthur* statue was planned and executed, there seem to have been close connections between Dürer and Leonardo through Galeazzo da Sanseverino (d. 1525), Lodovico il Moro's son-in-law, and Willibald Pirckheimer (1470–1530),

a friend of Trithemius and one of Maximilian's most famous humanists.[137] If we add to these northern humanists of Maximilian's Konrad Celtis (1459–1508) or Konrad Peutinger (1465–1547), ardent researchers of "German Antiquity", i. e., the early Middle Ages, publishers of literary and historical texts—Hroswitha, Jordanes, Paulus Diaconus—then we arrive in a circle in which in addition to classical humanist education, the romantic revival of national history began in the sixteenth century.

In a certain sense their Italian equivalent is Polydorus Vergilius (1470–1555) who spent most of his life in England and worked on the history of that country. He adopted his method from Flavio Biondo (1392–1463), the Latin linguist and historian of the Roman period, who collated sources and discovered elements in the Middle Ages which were the precursors of humanism. Polydirus Vergilius also went back to early sources. In 1525 he published Gildas' sixth-century "De calamitate excidio et conquestu Britanniae". His own 1534 *Anglica Historia* was designed to be an "objective" English and not British history in honour of the Tudors. Except for William of Malmesbury and the thirteenth-century Mathew Paris he had nothing but contempt for monastic annals, rejecting the legend of descent from the Trojan Brutus and the legends of King Arthur, which generally aroused the repugnance of sixteenth-century English writers.[138]

As opposed to Polydorus Vergilius, the above-mentioned Germans, Nauclerus and Trithemius had to go back to the legends in spite of their reservations when preparing the genealogy of Maximilian's family, above all to Geoffrey of Monmouth (Monemotensis), since the true chronicles could not provide them with sufficient information. Of the earlier sources we will only mention here Nennius, Abbot of Bangor in the eighth century, whose *Historia Brittonum* was the first to mention the Madonna picture in connection with Arthur, though there is a slight misunderstanding, because it says that he carried the Madonna on his shoulders. In reality the picture was painted on the inside of his shield, in order that he might gain strength by looking at it during battle. He further mentions fights between red (British) and white (English) dragons.[139] The following text by Monmouth is of interest to us here: ". . . auream galeam *simulacro draconis* insculptam capiti adaptavit", or ". . . inponens . . ." (Lib. IX. 2, *c.* 1136).[140]

Chronologically there follows the poem *Le roman de Brut* (*c.* 1155) by the Anglo-Norman Robert Wace who wrote in French.[141]

9283—9288 "Helme ot en sun chief cler luisant,
        D'or fu tut li nasels devant
        E *d'or li cercles envirun,*
        *Desus ot purtrait un dragun.*
        El helme ot mainte piere clere,
        Il ot esté Uther, sun pere. . ."

Wace's work were not published in full until the nineteenth century, but there are twenty-four known codex copies, what indicates that he must have been quite popular.[142]

In the *Le Chevalier de la Charrete* by Chrétien de Troyes (*c.* 1180) the tournament at Noauz is described as follows:[143]

5777—5782 "Et veez vos celui aprés,
        Qui an son escu pres a pres
        A mise une aigle et *un dragon?*
        C'est li filz le roi *d'Arragon*
        Qui venuz est an ceste terre
        Por pris et por enor conquerre..."

In the volume on Merlin in the so-called Vulgata version from the first half of the thirteenth century[144] we find "Et Merlins donna au roy artu une baniere ou il ot moult grant senefiance. Cal il i auoit *ı* *dragon* dedens si le fist fremer en une lance & il ietoit par samblant *fu & flambe par la bouce*..."

From now on the depictions in the manuscripts will be of greater importance to us, and we shall therefore not follow the chronological sequence of the literary sources. For example, in the *Guiron le courtois* (1230–40) or *Palamedes* novel, in a North Italian manuscript dating from *c.* 1380, which came to Paris with the above-mentioned booty from Pavia,[145] on f. 7 and 7/v we see "Artu'" with a dragon-crested helmet, but this dragon is holding a ring in its mouth. The idea of the warding off evil is represented here by the ring, in the same way as the lion's head motif on antique and early medieval door-knockers, which was later applied to parts of the protective armour as well. The practical meaning is quite lost but these motifs can be seen on Hector's hip, on the frontispiece of the Vienna copy of Longuyon–Mamerot–Briart: *Les Neuf Preux,*[146] and on Judas Maccabaeus' knees. We shall return later to one of the miniatures in the Arthurian part of the text.

A *c.* 1415 copy of *Le livres dou Trésor* by Brunetto Latini, who wrote his works in "d'oil" and lived in political exile in France in the thirteenth century, is decorated with illuminations executed by painters from the workshop of the Boucicaut Master.[147] The text mentions Arthur only briefly: "di cui le romanzi parlano...", but in the picture representing his final battle with Lucius, ethereal lights are shining.[148] This corresponds to the fuller text by Wace:

8293—8296 "Uns feus, ki de cel rai eisseit,
        Figure de *dragun* faiseit,
        De cel dragun dui rai veneient,
        Ki par la gule fors eisseient..."[149]

The above-mentioned *Neuf Preux* must be examined here in greater detail, because it will be of great importance to us. This short characterization of the nine heroes as part of the *Voeux de Paon* was written by Jaques Longuyon in 1310, but was enlarged several times, e. g., by Eustache Deschamps in the second half of the fourteenth century and beginning of the fifteenth century.[150] Their history may be regarded as a history of the world as depicted by three figures representing

pagan antiquity, the Old Testament and Christianity. They presented both an *exemplum bonum* and an *exemplum malum* to the rulers. For a long time their history was extremely popular reading both the shorter and the longer version. As figures they provided a theme for festive costumed processions, as seen for example in Francis I's time, and they were represented in beautiful series of tapestries and wall-paintings. They only occur in France or in regions under French influence, such as Northern Italy. Examples from the rest of Italy are mixed up with other heroes and develop into "uomini famosi" series.[151] The most important hero among the Christians is Arthur. His story is described in greatest detail and is most richly illustrated in the codex in Vienna dated to 1482–86 and attributed to Jean Colombe.[152] On f. 38/v we see the ancient battle of the white and red dragons.

Figs 61, 63.

Fig. 64.

Fig. 65.

Finally we would like to mention here a compilation from the end of the Middle Ages, Le Morte d'Arthur (first ed. London Caxton, 1485)[153] by Sir Thomas Malory (†1471). Here the explanation of "King Arthur's marvellous dream" is as follows: "... the *dragon*, that thou dreamedst of betokeneth thine own person...".

There is no doubt that the person of Arthur is most closely connected, indeed identified, with the dragon which protects him and scares off his enemies. After Monmouth and the fourteenth-century German historian Nauclerus, on the Arthur statue in Innsbruck we can see an "insculptam", engraved dragon relief. The dragon of "Prince Arragon" in Chrétien de Troyes' work is literally Pendragon, i. e., it was interpreted as dragon's head and appeared later on a helmet of the humanist Spanish ruler, Martin I (Madrid, Armeria).[154] The Neapolitan Aragon rulers adhere to it, as seen on the *c*. 1448 Pisanello coin design for Alfons I (Paris, Louvre),[155] or on the frontispiece of Ferdinand I's codex containing the speeches of Cicero (*c*. 1480–90).[156] Thus Neapolitan influence is probably to be detected in the dragon-headed helmet in the Bargello in Florence, which is dated to the 1470s, and the mid-fifteenth century helmet crest in the shape of a dragons' head made of leather and plastered linen in the Museo Bardini, Florence.[157] Both the latter and the Madrid piece were based either on the Monmouth tradition of "simulacro draconis" or "a guisa di dragone" as Meliadus in the 1468 Italian codex. Arthur's helmet in Wace's description:

Fig. 38.

Fig. 36.

Fig. 35.

Fig. 33.

"D'or li cercles envirun,
Desus ot purtrait un dragun..."

supplied Francis I with a good model for his own helmet when played the part of Arthur. It was made by Leonardo. He was depicted in a similarly ornamented helmet, but with his family emblem, the flaming salamander instead of the dragon, in the lost battle of Pavia (1525) by M. van Heemskerck and C. Bos (*c*. 1555) in a portrait commissioned by Hieronymus Cock, the publisher. On his way back to The Netherlands from Italy C. Bos visited the French court and thus could have become aquainted with Francis I's apparel. The above-mentioned portrait is the first piece in a series of engravings which commemorated Charles V's successful deeds in battle. It is worth mentioning here a beautiful example of Charles' "chivalry": contrary to historical fact, Francis is still sitting on his horse after having lost only his sword and thus fallen into

Fig. 40.

Spanish captivity.[158] The events shown on one of the seven tapestries executed in Brussels (1525–1531) and designed by Bernard van Orley (Naples, Pinacoteca), actually reflect true historical fact: the French king lost his horse and had to surrender.[159] The viceroy of Naples came to his rescue and was taken prisoner with him. This tapestry series represented the victorious battles of the Marchese di Pescara, Charles V's general.

The nine heroes were popular among other members of Francis I's court. Francois Moulin, the king's tutor owned a work by Albert Pioghe: "Commentaires des guerres galliques" which contained an imaginary dialogue between Caesar and Francis I. It was ornamented with illuminations depicting the nine heroes.[160]

All the details of the Budapest statuette, the characteristic features, the shirt-like garment, the exclusive use of defensive arms such as the shield and helmet and the iconographical identification of the helmet's ornamentation lead us to conclude that it represents the French king himself, as the hero of a tournament in the role of the legendary King Arthur. Historical circumstances explain this choice of subject. According to legend King Arthur also crossed the Alps from the North in order to become the ruler of Rome. Thus he is the chosen *exemplum bonum* for the young French king, whose ardent wish after his victory in 1515 at Marignano was to become Holy Roman Emperor, during Leonardo's life-time.

We have earlier data concerning Francis I's gallant duels. When the second wife of his predecessor, Louis XII—sister of the English King Henry VIII—arrived in France, Francis I, who was a member of the delegation sent to greet her, challenged a member of her retinue to a duel. But when his hand was injured he abandoned the fight, which in modern terms was fought until blood was drawn.[161]

The "impossible" way Francis chose his attire—as opposed to the rules of a classical tournament—is not unfamiliar from other later representations of the King. In a painting
Fig. 26. attributed to Jean Clouet he is depicted as St John the Baptist,[162] a work we have already mentioned among the portraits of the King. It rather reminds us of one of the last Leonardo pictures which has the same subject (Paris, Louvre): its influence on the reputed Clouet picture is
Fig. 27. obvious.—In a tapestry made after Rosso Fiorentino (c. 1535) the unity of the state is symbolized by his figure in Vercingetorix's costume (Vienna, Gobelinsammlung).[163] Written documents tell us of the King's liking for costumes of France's legendary heroes. At the beginning of the 16th century the universal belief was that at the time of the Creation and in the Gallic golden age all men were giants. Charlemagne's legendary hero, Roland was also thought of as a giant. Francis I was especially curious to know whether this was true or not and had his grave opened at Blaye. On finding his bones and armour in good condition he tried the latter and found that it fitted him perfectly, hence Roland had been no taller than Francis himself.[164] The most fantastic costume
Fig. 28. picture of the King was painted c. 1545 by a Niccolo Belin (da Modena), where Francis, by now no longer young, is Mars, Minerva, Diana, Mercury and Cupid in one person (Paris, Bibl. Nat.). All the attributes of these gods are represented in him.[165]—*Homo ludens!*

To provide proof of the foregoing I shall complete my book with chapters on the career of the Arthurian legend in Italy and on the chivalrous subjects which appear in Leonardo's art.

# The influence of the statuette and its later history

From our point of view it would be superfluous to discuss here the activities of Italian artists in France before the reign of Francis I, because they have no connection with Leonardo whatsoever. The architect Fra Giovanni Giocondo lived between 1495 and 1506 in Amboise and he became the first promoter of Renaissance art. Earlier rulers also commissioned sculptors to make equestrian monuments, such as Guido Mazzoni, who went to France in 1495 with Charles VIII. The monument, planned to be erected in St Denis, was destroyed but a picture of it is extant. This shows the praying figure of the dead king separated from the object of his worship, the chapel of the Virgin Enthroned. Equestrian monuments erected in churches were very rare north of the Alps at that time. The equestrian statue of Louis XII is still extant, but it was commissioned for the castle in Blois, i.e. for a secular building. Mazzoni returned in 1516 to Modena and the same year Leonardo arrived at the court of the victor, Francis I.

The Juste (Giusto) brothers had already settled in France around 1504. They began to work on the St Denis monument of Louis XII and his first wife, Anne de Bretagne, in 1516 and finished it in 1531. Only two sculptures have remained by the less famous elder brother in Gaillon, all his other works are lost. Another sculptor called Andrea Solari(o) worked in Gallion in 1507—1509, but no works of his are extant. In 1518, while Leonardo was still alive, Andrea del Sarto came to Fontainebleau but after nine months he returned to Florence.[166]

Leonardo stayed in France from the end of 1516 until his death in the spring of 1519. Vasari and Lomazzo mention only one work by him from this period, a mechanical lion made for a feast: when it was opened, lilies fell out of it. In October 1517 Cardinal Louis d'Aragon visited Leonardo in his small castle at "Clu" (Cloux), near Amboise. According to Antonio de Beatis, the cardinal's secretary, they saw three pictures in the master's studio. These are identified today as St John the Baptist, St Anne and the Mona Lisa, the latter on the basis of a report by Cassino del Pozzo on his journey to Fontainebleau in 1625.[167] Leonardo was preoccupied with the regulation of the Loire and with architectural problems: he made a drawing of the staircase of Blois castle and he had an important part in the rebuilding of the castle at Chambord.[168] He supervised the casting of bronze copies made after antique sculptures. This also reinforces our opinion that Leonardo supervised the casting of the Budapest statuette himself. Francis I

probably brought Leonardo over to copy antique statues found in Italy, which the King so greatly appreciated. He employed a number of Italian artists to enrich his precious collection.

Before turning our attention to the above artists we have to mention here some problems concerning the King and his various ambitions in the field of art. In 1525 Francis I again carried war into Lombardy to regain the power which he had lost to Spain. His rule after the victory at Marignano in 1515 was transitory and Charles V took it back in 1521. After the battle he lost in 1525 the King was taken as a prisoner to Madrid from where he was only released after the forced peace treaty of 1526. Not much later he was again in contact with Italian artists. In 1528 Leonardo's former pupil, Giovan Francesco Rustici (1474—1554) was invited to Paris[169] where he was granted a proper annuity. His main task was to cast the King's twice life-size equestrian statue after the models by Leonardo, which were much admired by Francis I. In E. Plon's biography of Leoni,[170] Vasari's information is supplemented by data acquired from L. de Labore.[171] According to this, Rustici started with the casting in a house given to him by the King "ès faulxbourgs de Sainct Germain des Prez lez Paris". After the casting of the horse they had enough molten bronze left (*assez de cuivre*) to cast the figure of the royal horseman as well. E. Plon claims that this can refer only to a small bronze model, not to the huge monument. Otherwise in 1549—1550 Leone Leoni would not have urged Antoine Perrenot Granvella (1517—1586) to send him the statuette. Granvella was Bishop of Arras between 1541 and 1561, an ardent follower of Charles V and for a while his political representative in the Netherlands.[172] Moreover, we know from Vasari that Rustici failed to cast the large monument.[173] The above sources supply the latest possible date for the casting of the bronze statuette after Leonardo's model. This amounts to an acknowledgement of Leonardo's authorship of the model on the basis of his treatise on bronze casting and indeed general practice today. After careful consideration, these circumstances settle the dispute in favour of the opinion that the casting was executed in Leonardo's life-time. He was the only person who could afford—in a similar way to many others of his works—not to finish the bronze statuette and for it still to remain a favourite, highly appreciated piece of its owner, the King. Later it was the fervently desired and then joyfully owned property of Leone Leoni (1509—1590), court sculptor to Charles V.[174] The young French King was not a person to be offended by one of the greatest artists of the period for offering him an unfinished work of art. During a court performance of a certain "Neuf Preux" he did not take amiss a slip of the tongue by one of the court-ladies, who wanted to flatter the King with a compliment: ". . . qu'elle croyoit voir an sa personne un des neuf lépreux"[175].

Figs 63, 64.

The French King made use of the model at the end of his life, in the 1540s, when he had some plans made for armour by an unknown master. On one of these, on a defence for the horse's forehead, there is a relief with "Rollwerk" decoration and in the middle the well-defined outlines of our statuette are discernible. With the other previous arguments, *this is the final and decisive proof that the Budapest statuette is identical with one of the models intended for the French King.*[176] (According to Lomazzo's *Trattato* as already cited, in Lib. VI, Cap. 19.)

Fig. 41.

As far as Rustici is concerned, according to recent opinion he worked on the building of the castle in Écouen for the disgraced Anne de Montmorency and is thought to have made an

equestrian statue above the main entrance. The statue itself is not extant but is known from an engraving.[177] Rustici's activity in Écouen is not documented by written data and opinions differ about the statues decorating the main entrance.[178] We shall deal with their relation to our statuette in a later chapter.

Pietro Strozzi, an opponent of the Medicis, went into the service of Francis I and became one of his most successful generals. After the death of the king, according to Vasari,[179] Rustici's former palace in Paris (*un gran palazzo*) was given to Strozzi. He in turn provided for Rustici who lived to old age. He placed him in an abbey and all his personal property remained with Stozzi. Florentine notabilities, during voluntary exile or banishment, always supported artists from their home town abroad. In 1434 Palla Strozzi, who was banished by Cosimo de'Medici, had a large share in finding commissions for Donatello in Padova.[180] Later, when Bernardo Rucellai spent a longer period abroad, partly as an envoy of the Medicis and later during the reign of Pietro Soderini, as his adversary in voluntary exile, he was instrumental in paving the way for Leonardo.[181]

In order to clarify Leone Leoni's role in relation to Leonardo's equestrian model, we have to settle a few problems as regards the antique copies commissioned by Francis I. We have already mentioned the fact that Leonardo was into this. In the coming years not only Francesco Primaticcio (1504–1750) received such a commission from the king in 1540–41, but before him, Leoni too. He received this order most probably in 1537, on moving to Rome during the papacy of Paul III as the papal coin engraver. After Francis I's third Milanese battle in 1536, Paul III was the mediator. Leoni did not have to move permanently to France in order to make antique copies for Francis I. His activities are recorded by plentiful data, in particular cardinal Federico Borromeo's 1625 contributions,[182] and Plon's biography of Leoni,[183] in which a letter dated 1549 to Ferrante Gonzaga is cited, giving Leoni's report on a brief four day visit to Paris. He examined the antique plaster-casts, which contrary to Plon's opinion, could not possibly have been made by Primaticcio, since Primaticcio was still fulfilling commissions from Henry II and Catherine de Medici. It is not very likely that he assigned his own copies to Leoni with the intention that Leoni should make further copies for himself and for Ferrante Gonzaga, governor of Milan. On the other hand, Primaticcio would not have let his own casts become dilapidated to the extent described by Leoni. In his letter to Ferrante Gonzaga, cited by Plon, Leoni is making excuses for himself, saying that he had good reason to visit Paris, and that he went only for a short time, with the knowledge and approval of Granvella and Mary, the widowed Hungarian Queen, governor of The Netherlands. Plon's mistake is understandable because Leoni tried to obliterate all traces of his former connections with Francis I. Obviously he was cautious, unlike his friend Pietro Aretino, who showed consummate skill in serving several rival kings and noblemen. Leoni assembled a fine collection of copies at his Milanese house, the Casa dei Omenoni, or as it was called after his copy of the Marcus Aurelius equestrian statue, the Casa Aurelia.[184] Cardinal Borromeo's evidence is reliable, because Leoni copies were undoubtedly acquired later by the Ambrosiana: in 1674 one made after Michelangelo's early Pietà and in 1688 a copy of the Laokoon group, both donated by

the Calchi family.[185] The Calchis were later the owners of the Casa dei Omenoni as Leoni's heirs.[186]

Leone Leoni wanted to apply his practice in casting copies of plaster-casts to the much admired horse model which he saw in the summer of 1549 in Paris: "venendo da tanto nuon antico maestro", and—as he wrote—he badly needed it to make Charles V's equestrian statue. Between December 1549 and May 1550 Leoni wrote six letters, first requesting, then insisting that the statuette be sent from Paris to Milan by Granvella, and promised to send it back to wherever the bishop requested after the making of the mould (*una forma–moule*-letter dated December 2, 1549). He also named the person, a certain Père Vivone, whom Granvella should commission to arrange the transport of the fervently desired horse model from Paris to Milan. Granvella, the bishop of Arras, had an antipathy to the French despite having French as his mother tongue and his task of approaching Pietro Strozzi, who served the French rulers, cannot have been an easy one. On the other hand, he was a painstaking collector of beautiful books and rare antiquities, for which he employed a number of learned agents and antiquarians to track down for him. "Père Vivone" might have been one of these trusted men.[187]

Certain members of French Court society were probably relatives of Father Vivone: Anne de Bourdeille, née Vivonne, was one of the protagonists of the famous Heptameron by Margarete of Navarra.[188] In Catherine de Medici's portrait collection, drawn by Clouet, of members of her extensive retinue, Jeanne de Dampierre, née Vivonne is depicted twice and Francois de Vivonne, son of André, who was lord of Chataigneraye in 1510—1547,[189] also appears.

Leone Leoni never finished Charles V's equestrian statue and did not keep his promise to send back the model to Granvella. This was why Lomazzo could write in his Trattato the information already quoted, according to which Leonardo made "... *un cavallo di rilievo di plastica, fatto di sua mano, che ha il Cavallier Leone Aretino statouario*".

Leone Leoni and his sculptor son, Pompeo (c. 1533—1608) possessed other Leonardo treasures. Their machinations with the Codex Atlanticus and other Leonardo manuscripts have been described by C. Pedretti and A. Corbeau.[190] The fortunes of the *St Anne* cartoon and other Leonardo paintings were also traced by Pedretti.[191] Some of the manuscripts and paintings had parallel wanderings. From Francesco Melzi's (d. 1570) son, his tutor, Lelio Gavardi, obtained books which he intended to offer in 1587 to the Tuscan Grand Duke of that time, Francesco de Medici. The death of the Grand Duke upset these plans. Besides their exploitation of large Melzi collection, the Leonis also acquired a large number of manuscripts at second and third hand. These continued to be greatly treasured by Pompeo's sons, Michele or Michelangelo (d. 1611) and Giambattista (d. 1615), although they were reserved partly for the Spanish ruler. Pompeo's son-in-law, Polidore Calchi and his son sold some of them in 1622 to Galeazzo Arconati, a Milanese patrician and collector. Cardinal Francesco Barberini had some copies of these manuscripts made for his family library in Rome, through his secretary, Cassiano del Pozzo.[192] These same stages are to be detected if we trace the fortunes of the *St Anne* cartoon, the "Leda in piedi" and "una santa del naturale". In 1614 Pompeo Leoni's son offered them to the next Grand Duke of Tuscany, Cosimo II de Medici. This attempt was also unsuccessful. In 1635 the well-

known Galeazzo Arconati turned to Francesco Barberini through Cassiano del Pozzo.[193] None of these sale attempts is of interest to us, because there is no mention made of our "cavallo". Cassiano del Pozzo patronized Poussin (1594—1665) in Rome. His Meleagros and Atlanta (later in Madrid) was influenced according to X. de Salas by our statuette.[194] The appearance of the Budapest statuette in Rome at such an early date is only a supposition. Even if Leone Leoni's grandchildren preserved it too, at the dispersal of the collection in 1620 all trace of it was lost.

With regard to Leone Leoni's wish to copy it and his practice of doing so, as mentioned above, we may well attribute to him the first copies of the Budapest statuette: one in the Metropolitan Museum of Art in New York and one in the Collection of Pierre Jeannerat in London.[195] In comparison to the horse of the Budapest piece, both these horses are less upright; they are not stallions, and could not therefore have been intended for a monument. Marc Vulson de la Colombière (?—1658), in his work: *Le vray theatre d'honneur et de chevalerie* ..., published in 1648, states that "ne on ne pouvoit ung chevalier plus deshonnorer que faire chevaucher une jument pour le blasme ... les juments étoient déstinées à tirer des charettes et c' étoit un opprobre que d'etre mené sette espece de voiture...".[196] During the 1969 Budapest exhibition it was discovered that there is an indentation on the left side of the New York horse which is not anatomically justified, where a carriage-pole was fixed to the horse. The London horse has proved to be a mirror image of the latter and has a longish incision on the right side which corresponds to the left side of the other horse. Below these there are two triangular indentations on the lower part of the hind limbs. In our opinion these horses might have belonged together, pulling a cart with their heads turned away from each other; they were draught horses and the incisions on the surface are traces of the harness, the reins, the breeching. We know that the New York horse contains zinc in a quantity which is not negligible; the same is true of the London piece. Leoni was a true imitator of Leonardo even as far as technical things are concerned and the New York horse was also cast without its tail, but the subsequent fitting was carried out with greater accuracy. Most probably the New York statuette was made first, freely modelled after the original and not made with the original mould, as is proved by the differences in neck and head bearing which also apply to the London horse. Structurally neither of them is well balanced, differing in this respect too from the masterly balance of the Budapest piece.

The rearing position of harness horses is nothing out of the ordinary. On a bust of a man attributed to Donatello, the cameo on the man's chest represents two rearing draught horses pulling Eros' two-wheeled cart.[197] A richly illustrated codex dated 1446 tells the story of the "search for the Grail" as well. Sir Bors (*Bohort* or in Italian *Gorone*) is being mocked and put on a cart bound hand and foot. Here too the horses are rearing to the whip.[198]

Leone Leoni is not only suspected of casting variations of our horse figure but he probably made a few fighting figures to complete the group. Opinions concerning these small figures differ in both the earlier and the later literature. It will be most appropriate to deal with the problems in the order of the publications.

It was W. v. Bode in his three volume work *Die italienische Bronzestatuetten der Renaissance*[199] who first published a small bronze crouching warrior with his shield raised above his head and

Figs 43, 45.
Figs 44, 46.

Fig. 42.

holding a sword in one arm. This was in the former Trivulzio collection, although now according to Professor J. Pope-Hennessy, it is in the Museo Poldi Pezzoli, Milan (Inv. no. FC 77/68). In Bode's opinion it is the work of a follower of Leonardo from Lombardy. In the works already cited S. Meller linked (note 2) it with our Budapest statuette. His arguments may be augmented by a French design for a mail for a horse's head, on which not only our statuette is to be seen but, above the opening for the eyes, a horseman sitting on a rearing horse and holding a banner, while in front of him a hunched up warrior figure is defending himself. The chronological order of the drawing and the figure has not yet been clarified.

Fig. 50.

In the third volume of his work Bode presented on Plate 257 the bronze figure of a naked, helmeted foot-soldier advancing with his sword and holding a shield, (formerly in Philadelphia). Bode regarded it as the work of a Paduan master in the 1530s. On the basis of Bode's illustrations there is a strong connection between the Milanese defensive warrior and the Widener Collection's advancing figure.

Fig. 48.

More and more figurines cropped up and were dealt with by L. Planiscig,[200] above all the pedestal figures for Leone Leoni's bust of Charles V (Vienna, Kunsthistorisches Museum, Inv. no. 5504, a replica in Madrid, Prado) and the two foot-soldiers in Vienna. One of these fighting figures in Vienna (Inv. no. 5819)[201] was regarded by him as especially similar to the Mars figure on the plinth of the authentic. L. Leoni's Charles V bust, on which in my opinion the infuence of the Budapest rider is to be detacted: the contracted stomach and the powerfully muscular chest are similar on both of them. Planiscig attributed them all to Leone Leoni.

Fig. 49.

Later the Philadelphia piece was acquired from the Widener Collection by the Washington Museum of Art (Inv. no. A-131). In 1967 H. R. Weihrauch reproduced it in his work on the development of 15th—18th century small bronzes and adopted Planiscig's attribution.[202] A. Santangelo: *La collezione Auriti*, 1964, Rome, Palazzo Venezia,[203] produced another example, as did S. Androssow from the collection of the Hermitage in Leningrad (Inv. no. N. rk. 1348) in 1977.[204] In the catalogue for a temporary exhibition[205] M. Leithe Jasper accepted one of the Vienna pieces (Inv. no. 5583) as the authentic work of Leone Leoni. The second with the more perfectly executed surface (Inv. no. 5819) is regarded by him as a later piece, which was reworked. In our opinion this latter piece is more closely connected with the Mars figure on the Charles V bust, especially in respect of the helmet, moustache and beard. Finally, the Minneapolis Institute of Art exhibited a long-known statuette, belonging to the David Daniels Collection. It was attributed after Bode to the Paduan Andrea (Briosco) Riccio.[206]

For my part, I do not agree with this. Two kinds of surface modelling can be detected in the series: some of them have more homogeneous, not very well articulated body surfaces, while the other group's anatomical modelling is much more detailed. Riccio on the other hand, in his other works, goes much further: in the equestrian statue in the Victoria and Albert Museum, London (Inv. no. A.88-1910.) under the skin of the animal's head we can see the veins, while in the *Rape of Europe* in the Budapest Museum of Fine Arts, (Inv. no. 5363.) the wrinkled skin on the bull's neck is perfectly executed. The Leonardo statuette is more concentrated and concise, with monumental force; it was the model for a monument, planned to be executed in at least life-size.

This view of Riccio's authorship is refuted several times. Riccio's stay in Florence in 1504 was short, the alleged model—the Budapest statuette—, or preliminary studies, could not have such a deep impression on the Paduan master. An influence is much more likely to be detected in Leone Leoni's works, since for years he had been the happy owner of Leonardo's model as already described.

The above "additional" figures by Leoni serve as indirect proof of the fact that our rider was regarded as the victorious hero of a joust. As already mentioned, during the late flowering of the age of chivalry the help of such foot-soldiers was allowed, in equal numbers on both sides. The formation of this loose group was greatly influenced by the drawings which Leonardo made for Gentile de i Borri, and were still in Milan at that time (Cf.: No. 216, Venice, Accademia). We have earlier data confirming that Leoni modelled such a group of figures for the monument to Fr. d'Avalos, Marquis del Vasto, the Spanish governor in Milan, who died in 1541.[207]

Fig. 53.

There is another work by Leone Leoni which is considered to have been made under the impact of Leonardo's equestrian statuette: the reverse of the Bernardo Spina coin, showing a foot-soldier defeated by a horseman. Bernardo Spina was secretary to the governor of Milan, Ferrante Gonzaga. In his biography of Leoni, Plon cites several letters which demonstrate the cordial, friendly relationship between Spina and Leoni. One is from Annibale Caro, an accomplished art collector and writer, who wrote to Spina in 1544. The second was by Leoni to Gonzaga in 1549, the third, dated May 3, 1550, was written by Leoni to Granvella and Spina is mentioned in it. All these letters are from the time before Leonardo's horse model was acquired by Leoni. Whether Leonardo's model influenced the coin depends on its dating, but this is not all important. Leoni could have acquired a Roman imperial coin during his stay in Rome or at another time.

A similar motif was employed by Niccolo Tribolo (1500–1550), an Italian who began work at the court of Francis I. His principal work was to have been an equestrian monument planned to be erected in San Marco Square, Florence, which was commissioned by Grand Duke Cosimo de Medici I to commemorate his father, Giovanni delle Bande Nere. Its design is in the Louvre's collection of drawings. (Inv. no. 50.) The concise and clear composition consists of several figures: the main figure is riding a rearing horse, under the horse is a figure lying on his back, while another foot-soldier is attacking the horseman with a sword, who is also advancing with his sword.[208] Tribolo must have become acquainted with the Leonardo composition or the sketches for it when still in France and later made use of his earlier impressions when designing his own monumental composition.

In the mid-sixteenth century several well-known Leonardo motifs appeared all over Europe: for example the influence of his battle scenes can be detected in shield and helmet reliefs.[209] Good examples of dragon helmets are in one of the drawings by Bachiacca, the detail of the Paduan fresco by Domenico Campagnola (Liviano, Sala dei giganti), the portrait of Franc. Maria della Rovere, Prince of Urbino by Tiziano. The two latter date to the 1530s.[210] The Leonardo influence in the case of these latter ones is not absolutely certain. Probably it was still merely the generally accepted "heaume de joute", as was earlier the case with the *Three Marys at the*

Fig. 54.
Figs 55, 56.

Figs 51, 52.

*Sepulchre* (Rotterdam, Museum Boymans) attributed to the Eyck brothers, where the helmet of one of the sleeping soldiers was explained in this way.[211] It would be interesting to find an explanation for the meaning of the dragon helmet worn by the angelic horseman in Raphael's *Heliodorus* fresco in the Vatican, which was executed in 1512–15. Simon Meller linked Leonardo's Milanese equestrian monuments with our statuette and considered that he detected its influence on the Raphael painting. But recent research suggest that the dating is reversed, and since a more complicated iconographical interpretation has been found on one of Raphael's frescoes in Rome (Parnassos),[212] it is likely that the helmet of the celestial horseman also has a deeper meaning.

Fig. 37.

The Leonardo type of horse appeared in a great number of compositions and we shall only mention a few here. In 1536 Domenico Beccafumi erected an equestrian statue to commemorate Charles V's entry into Siena, but it was not made of a durable material.[213] In an engraving by Corn. Cort (*c.* 1578) after the drawing of Stradanus, showing the activities carried out at the "Academy of Art", "sculptura" is demonstrated by the modelling of a horse of the Leonardo type.[214] Francesco Primaticcio's fresco in Fontainebleau (finished in 1543), shows a horse with the same proportions. Its subject is a scene from the life of Alexander the Great.[215] Pietro Tacca's *Philipp IV* of 1640 in Madrid and E. M. Falconet's *Peter the Great* of 1766 are both equestrian statues that attempted to realize the Leonardesque motif; but to eliminate problems of balance the sculptors were compelled to use external or internal, concealed supports. When dealing with the influence exerted by the model we have to keep in mind that it was kept in France until the mid-sixteenth century, and then until the beginning of the seventeenth century in Milan, although probably accessible to visitors in Leone Leoni's collection.

In contrast to the formal elements of our statuette, its inner essence, the playfulness is quite unique. This is unrelated to any prototype, differs from everything else and is not detectable in the imitations.

Most of the medieval and fifteenth century Italian Renaissance equestrian statues are sepulchral monuments. Among the Veronese della Scala (Scaliger) monuments, the ironically laughing statue of the most popular member of the family, Cangrande (d. 1329), is unparalleled, in itself a mocking of death. The monuments to all the other members of the della Scala family are crowned by an equestrian statue on top of a Gothic building but they are all rigid, facing stiffly forwards. They are related to the equestrian statue of the Milanese Barnabo Visconti (d. 1380), made by Bonino da Campione. In one of the pantheons of the Venetian nobility, the Frari, we find a similar monument, to Paolo Savelli (d. 1405). In 1470–76 Antonio Amadeo erected a monument in Bergamo for Colleoni; its wooden horse figure is taking a step with one of its forelegs, but it is still lifeless and stiff.[216] The two most important fifteenth century prototypes: Donatello's *Gattamelata* in Pauda and Verocchio's *Colleoni* in Venice are both monuments erected by city-states in order to pay tribute to military services rendered by these condottieris in the achievement of their foreign policy goals. Leonardo's Sforza and Trivulzio statues were also planned as monuments of this kind, the latter still in the general's life-time. The ideal of the absolute ruler, who determined the inner politics of the city-state as well, was born later. The

first monument to this kind of ruler was erected for the Grand Duke Cosimo de Medici I, by Giambologna, who worked on it from 1560 on. The equestrian statues to Alessandro and Ranuccio Farnese by Francesco Mochi (1580–1654) in Piacenza symbolize both military distinction and the long-awaited calm of peacetime. In France the first monument symbolizing the rule of the king was the one to Henry IV, also executed by Giambologna. It was commissioned by the king's widow, Maria of Medici. Only the model is extant of Louis XIV's equestrian statue by Fr. Girardon (1628–1715). This monument was the opposite of the rule it should have exemplified. The theoretical basis for all these monuments was provided by political writings on absolute rule.[217]

Francis I also embarked on endeavours to unite his state; his engaging personality enabled him to subdue all internal conflicts. This is symbolized in a tapestry made after the cartoons of Rosso Fiorentino (1495–1540), now in Vienna, where the king is wearing the costume of Vercingetorix and is holding the pomegranate in his hand. Unification could only be realized by marriage; like his great predecessor, Louis XII of Orléans, who could only acquire Bretagne through marriage to its heiress, Francis could only retain it by marrying their daughter Claude de France. The literary basis of the Leonardo model, however, is the playfulness expressed by imitation of the "Neuf Preux". Its formal elements are the starting point of a long development, but its content is unique at the dawn of absolutism.

★

Of the many erroneous ideas concerning the Budapest statuette I shall only mention one or two. In his two-volume edition of the Parmigianino Drawings,[218] A. E. Popham regards no. 265 as executed under the influence of our horseman. This is not true, because it corresponds precisely with the back view of one of the horses on Monte Cavallo. Two other publications[219] endeavour to attribute other bronze statues to Leonardo. It is typical of both authors that they do not realize that the formal execution of the same motif here is quite alien to Leonardo's style. The proportions of the horses are different as the relationship between horse and rider. Nothing in them has anything in common with the Leonardo drawings. The equestrian statuette's origin could perhaps be traced back to the figure already mentioned on the castle of Écouen, allegedly the work of Rustici. But the picture of it is rather small and it would be reckless to come to any definite conclusion. The statue in Louisville (USA) and the copy which emerged at a London art-dealer's were made after a seventeenth-century brush drawing by Jan de Bisschop.[220] That the statue was made after the drawing and not vice versa is proved by the fact that the views of the statue which are unrepresented in the drawing, i. e., cannot be seen in it, are obscure and unsatisfactory. The sculptor was left to his own imagination except for the main view. The intersecting movements of both the Leonardo drawings and the Budapest statuette lead us logically from one view to the next. In the "rear view" of the Louisville statuette, the rider and the horse are leaning in parallel to one side, threatening to overturn the whole piece. The statuette is not in balance at all.

★

We have now arrived at a point in the history of the Budapest statuette where we have no data available. We cannot advance any further but if we make certain inferences from what has gone before, this might show the way for future investigations. As we have already seen, the Leonardo manuscripts and some of his pictures were known to Cassiano del Pozzo (d. 1657), secretary to Cardinal Francesco Barberini and patron of N. Poussin (1594–1665). The idea has occurred that the Budapest "cavallo" must have been in Rome at that time, because its influence can be detected in a Poussin picture. On the other hand, we know that Francesco Barberini had a large part in the preparation of the 1651 Paris edition of Leonardo's Trattato and that the inventory of the Cassiano del Pozzo collection (which is extant) includes two half-length portraits of women by Leonardo (to decide whether the attribution is correct, is not our task here). Had the statue from the Leoni collection been in his possession, it is hard to imagine that he would not have mentioned it.[221]

Once again, as in the case of the helmet dragon, we shall attempt to trace backwards from reliable data. Our statuette was bought between 1818–24 along with 82 other small bronzes by István Ferenczy, a Hungarian sculptor who had been in Rome on a scholarship. Ferenczy, who was full of noble ambitions and bold dreams, was a student of sculpture at the Vienna academy and received a scholarship to Rome as a pupil of Thorwaldsen.[222] He had lodgings in one of the tower rooms of the Palazzo Venezia which brought him into contact with Canova, whose atelier was in the Palazzetto. In his heart Ferenczy felt himself closer to Canova, but he could not leave Thorwaldsen because his scholarship tied him to the latter's studio. Ferenczy had a share in the formation of another Hungarian private collection, that of the Marczibányi family. Ferenczy's collection remained intact and in 1914 the Budapest Museum of Fine Arts bought it in its entirety from the sculptor's heirs. The Marczibányi collection, on the other hand, was scattered all over the world and its most famous piece, the St Christopher bronze from a Florentine workshop and dated 1407, found its final home in the Boston Museum of Fine Arts. Two bronze figures, formerly attributed to Fr. da Segala and later to T. Aspetti and intended to ornament a pair of fire-dogs, are in the Budapest Museum of Fine Arts on deposit.[223]

The relationship of the two collections has already been recognized by Géza Entz. Both included a great number of small Italian Renaissance bronzes, but there are some pieces from North of the Alps as well. In the 1846 inventory which Ferenczy compiled with his own hand on the occasion when he offered his collection for sale to the Hungarian state—at that time he was unsuccessful—he regarded classical "Athenian" works as his most precious pieces.

When we look at the two collections together, it is striking that most of the statues are by Venetian, Paduan (Riccio) and other North Italian masters. They must have had some connection with the Palazzo Venezia in Rome; the poor Hungarian sculptor could not have acquired such a collection piece by piece.

The Palazzo Venezia was built by Pope Paul II, the Venetian Pietro Barbo, and always housed its occupants' private archaeological and other art collections. It belonged to the Church and was one of the papal residences until 1564, when it was ceded to Venice and became the seat of the Venetian republic's ambassadors in Rome.[224] Unfortunately we do not know all the ambassadors

and their history, but one of them, F. Erizzo, deserves attention. He was visited in 1706–10 by the Frenchman Blainville, although the latter emphasizes mostly his civility and only mentions among the works of art that he saw there a few large antique sculptures, a sarcophagus with reliefs, etc.[225] Other members of the Erizzo family are known to us, notably the aged Francesco who was Doge in 1631–46 and at the end of the sixteenth century, Sebastiano Erizzo, who was mainly known as an expert on antique coins; Giovanni Battista and Gasparo were well-known as collectors, but only in Venice.[226]

The visits and activities of the Venetian envoys and diplomats were not always undisturbed. As a consequence of conflicts in diplomatic matters and affairs of protocol with the papal courts, a number of them were recalled abruptly or left Rome voluntarily. In 1631 Zuane Pesaro left the city, in 1635–36. Fr. Maria Rosso, in 1678–79 Girolamo Zeno, in September 1707 G. B. Nani and in 1732, after a long and complicated affair, Zaccaria Canal. Nicolo da Canal, who left in 1736, was probably a relative of his. In 1797–98 the position of Pietro Pesaro was even more precarious, because the use of the palace was a question in dispute between the French (Napoleon) and the Austrians (the Peace of Campoformio). The suggestion that an academy of art be established in the building was first advanced by Napoleon, who planned to found the Art Academy of the Italian Kingdom.

The palace later became the seat of the Austro-Italian Academy and from 1812 on it housed the Accademia di Belle Arti, whose head was Canova.[227]

From 1814 it belonged again to the Austrians, which was why István Ferenczy, a former pupil of the Vienna Academy and a protegé of the wife of the ambassador Alois Wenczel Kaunitz, was put up there. The next Austro-Hungarian ambassador, Antal Apponyi also observed the ambitious young sculptor's progress with interest.

It has been necessary to sketch these restless times and the fate of the palace, which was reduced to ruins several times, in order to provide a basis in probability for my hypothesis. Here we may suppose that as a result of the many changes of owners, one of the Venetian ambassadors that had to flee urgently from the city, left a complete bronze statuette collection behind, perhaps even carefully packed, in a remote corner of the huge palace. Was it Canova, his pupil, Cincinnato Baruzzi who helped the eager young Ferenczy to acquire it? Canova's fears regarding the safety of ancient monuments induced him to collect the material which is the basis of the Museo Chiaramonti, part of the Vatican Museum. At the turn of the 18–19th centuries collectors and patrons of art were interested in small bronzes only as far as they were small-scale replicas of ancient sculptures. The popularity of this intim genre of the High and Late Renaissance just as well as of manierism and baroque touched bedrock at that time in Italy.[228]

★

Finally we must devote a few words to the history of the statuette in the Budapest Museum of Fine Arts. At the same time we would like to list the opinions of some art historians on the subject of the statuette. It is not our aim to give a full bibliography, because there is one already,

compiled by Jolán Balogh in her 1975 catalogue of the museum's complete collection. (Katalog der Ausländischen Bildwerke des Museums der Bildenden Künste in Budapest. Vols. I. II. Budapest. 1975. pp. 115–122.-Abb. 185–186.) We shall omit the articles on the statuette which appeared in the daily papers, especially at the time of Simon Meller's "discovery" of the piece. Other such articles appeared during the statuette's 1930 exhibition in London and the 1969 International Congress of History of Art. The small exhibition at the time of the congress enabled us for the first time to make a direct comparison between the Budapest and New York pieces. The results of this have already been discussed. The contributions of journalists and non-professionals have their importance as far as statistics are concerned, but they cannot answer scientific questions.

The first mentions of the statuette in art literature were by Simon Meller in 1916 and 1918, then the 1917 exhibition catalogue of the Ferenczy collection and the 1921 exhibition catalogue of the Old Sculpture Department described the statuette. Before these appeared, the small bronze had been quite unknown to the world for around three hundred years. Simon Meller stuck to his first opinion in the catalogue too. His opinion was confirmed by some: L. von Baldass, 1917,[229] E. Tietze Conrat, 1917 and 1920,[230] Fr. Schottmüller, 1918 and 1925,[231] W. Suida 1920,[232] E. Maclagan, 1923,[233] and refuted by others. Those doubting his opinion: B. Kramer, 1921,[234] Fr. Malaguzzi Valeri, 1921 and 1922,[235] A. M. Brizio, 1925,[236] A. Venturi, 1925,[237] O. Sirèn, 1928 (in his two-volume Leonardo monograph),[238] i. e., mostly the Italian art historians. They regarded it as the later work after Leonardo. In the main they were personally acquainted with the statuette, as they had been to Budapest. Their reserves were mostly based on aesthetic points of view and its baroque features.

The first scholars who said "yes" to Simon Meller's attribution of the Leonardo statuette had already noticed its influence on works by later masters. Other researchers also joined in this opinion and more and more influences were detected. The first were E. Tietze-Conrat in his 1917 article and Fr. Schottmüller in his second paper in 1925. In his great Leonardo monograph of 1929,[239] W. Suida somewhat amended his former view-point and regarded the finishing of the statuette and its preparation for casting as the work of a less talented pupil. However, in his article in the 1929 *Archaeológiai Értesítő* he augmented the list of statues, plaques, coins and paintings that were made under the influence of the Budapest piece.[240] In his 1931 *Belvedere* article[241] he discovered connections with one of the pictures by Palma Vecchio. In 1952 Hoogewerff[242] extended the influence of the statue on Raphael not only to the *Heliodorus* but also the Vatican fresco representing *Attila and Pope Leo*. The picture he published, however, does not show the original statuette but a copy which was sent by the Museum to the 1939 Leonardo Exhibition in Milan. J. Müller Hofstede (1965)[243] registered its influence on an early *St George* by Rubens (Madrid, Prado). It is true that the best copy made of *The Battle of Anghiari* is also by Rubens (Paris, Louvre) but we have no information on the statuette's whereabouts at the beginning of the seventeenth century. X. de Salas had the same problem in his 1968 article,[244] where he discussed the influence of the Leonardo statuette on a Poussin picture in the Prado. He assumed that the piece must have already been in Rome in 1632–37. Finally, E. A. Popham

Fig. 37.

56

maintained (1953 and 1971),[245] that a Parmigianino drawing was made under the impact of our statuette and he thus dated the drawing to the time just before the painter's journey to Rome. This seems to be incorrect, because the drawing is an exact copy of the back view of a horse on Monte Cavallo. Beside this, Parmigianino died in 1540, when our piece was still in France, so he could not possibly have known it.

In his 1927 Leonardo monograph[246] E. Hildebrandt suggested that the Budapest statuette was a plastic model made for the cartoon of *the Battle of Anghiari*. In an article in 1930 he changed his mind and, accepted the pieces as the work of Leonardo.[247] Either under the influence of Hildebrandt's views or on examining the drawings, Kenneth Clark came to the same conclusion.[248] On a Windsor drawing (no. 12328) which relates to the Battle of Anghiari, beside a horse study, the master gave instructions to prepare a small wax model. In Kenneth Clark's concise biography of Leonardo (on p. 132 in the 1958 Baltimore edition and on p. 271 in the 1967 French edition) the Budapest piece is regarded as a model for *The Battle of Anghiari* and attributed to a pupil of Leonardo, J. Pope-Hennessy, in his 1961—62 catalogues[249] of the London, Amsterdam, and Florentine exhibitions, is of the same opinion but shows the London piece as well. In *The Italian High Renaissance and Baroque Sculpture* by the same author (Vol. I, p. 98ff, Fig. 127), the statuette is listed among the studies made for the battle cartoon. This opinion was adopted by J. Montagu: *Bronzen* (1963)[250] and later by A. Radcliffe: *European Bronze Statuettes* (1966[251] who added that it may have been cast by Rustici after a model by Leonardo. As we have already seen, in the light of historical fact this last opinion is quite likely. Finally, we have to mention Ch. Avery's 1970 book on Florentine Renaissance sculpture[252] where the author repeats the opinion that the wax model mentioned on the Windsor drawing no. 12328 was made for the battle cartoon. Nevertheless we have to refute the unanimous opinion of the authors belonging to the "British school". Our belief is based on a written source from 1587 by G. B. Armenini, entitled "De' veri precetti della pittura".[253] The author refers to a conversation he had with a former pupil of Leonardo's, who explained to him that Leonardo disapproved strongly of models which could be used from several angles and could not possibly have employed one. According to him it would have led to the depiction of all the figures in one composition with the same proportions. Leonardo could not have mentioned the most frequently cited example of this, Michelangelo's *Last Judgement*, because it was executed several decades after his death.

In connection with the 1930 Italian Exhibition in London we must mention a mistake which was made in the Exhibition Catalogue.[254] Windsor no. 12680 is a drawing of a plain for the regulation of the Arno. Luckily, from the text of the reference it is clear that the author meant no. 12354, which is an equestrian monument on top of a triumphal arch. Unfortunately, this incorrect numbering was adopted in Jolán Balogh's systematic catalogue. According to Kenneth Clark this drawing was at a more advanced stage than the Trivulzio drawings and was the final stage before the plastic execution of the motif.[255] After the London Exhibition McCurdy revised his former opinion, cited above, and as a result of his direct examination of the piece he ranged himself on the side of Simon Meller.[256]

Others were not so impressed: M. H. Longhurst regarded the statuette as closely related to Leonardo but maintained that it was not his authentic work. There followed a number of opinions with the same reservations and a later dating. These works are sometimes monographs on the master (Bodmer, 1931)[257] or books on bronze statuettes, like the one by L. Planiscig[258] and by G. Nicodemi,[259] although the latter author's opinion is milder. In a recent edition of the earlier, basic monograph by W. Seidlitz,[260] Simon Meller's results are cited, but the statuette is accepted only as "Schule Leonardos". Several scholars emphasize the statuette's importance and its daring innovations but do not venture to attribute it to Leonardo: G. Nicodemi in his 1940 monograph,[261] Venturi in volume X/1 of his monumental work,[262] G. Delogu in his history of Italian sculpture,[263] and finally M. Salmi in his two-volume popular history of Italian art.[264] In the 1951 edition of his book L. Goldscheider repeated his comparison of the statuette with some authentic Leonardo drawings and in the 1959 edition he regarded it as the most "Leonardesque" among other statuettes recently discovered. In the appendix to *The Complete Paintings of Leonardo da Vinci*, L. D. Ettlinger and A. Ottino della Chiesa (1967 and 1969 editions) state that the Budapest piece is "the most widely attributed to Leonardo".[265]

A group of scholars, especially Americans, are inclined to find traces of Leonardo's sculptural activities in some other pieces in addition to or apart from our statuette. R. S. Stites[266] links a terracotta relief in the Bargello representing a whirling group of fighting horsemen with the cartoon for the *Battle of Anghiari*. In an article in 1930 in *The Art Bulletin* the same author discovered traces of some Leonardo features in several works of art: a group of horsemen attacked by a lion (Philadelphia, Museum of Fine Art), the horses drawing the ship of Neptune (Vienna, Kunsthistorisches Museum) and a terracotta group of fighting soldiers (Paris, Cammondo Collection). Finally, in his article in *La Critica d'Arte* (1970) he regarded the rearing horses of the Widener, the former Trott and the Stites Collections to be closely in keeping with Leonardo's types. In his *Rustici in France* W. R. Valentiner detected Leonardo elements relayed by Rustici in the equestrian statue that used to be above the main entrance to the castle of Écouen. This problem has already been discussed above. The large-size equestrian statue in the Louisville Speed Art Museum is attributed by M. Hall to Leonardo.[268] At the same time J. R. Spencer [269] found prototypes for the Milanese equestrian monuments in the coins of Francesco and Lodovico Sforza and, following Ch. Seymour Jr., in one of the drawings in Filarete's 1460–64 Trattato. Finally, V. L. Bush gave a summary of all the views and data concerning the Sforza monument in the 1978 volume of the *Arte Lombarda*.[270] All these scholars, dealing with these many-figured compositions, are astonishingly unaware of their lack of plasticity and good arrangement, which are both clearly present in the Budapest statuette, despite its mobility and "baroque" features. The recently published prancing horses, or horsemen sitting on such, are much farther from the Leonardo drawings than the Budapest piece as far as the type of horse, its movement and its strength are concerned. J. R. Spencer does not realize that the movement of the horse on the medals is one of bolting, breaking into a gallop. The sharp angle of the hind legs is necessitated only by the round shape of the medal. As stated earlier, the horse in the drawings for the monuments and the Budapest piece are both rearing, recoiling horses, in accordance with the quotations from Lomazzo.

In his wholly correct article V. L. Bush summarized all the data relating to the artistic links with the first Milanese plan, for the Sforza monument. His work constitutes a comprehensive integration. As we have known since Simon Meller, the variation with a rearing horse also occurred here, while in the background to the Adoration of the Magi we meet the same fighting soldiers. However, we must mention the fact that the author did not realize the importance of the statuette's absence of saddle, reins and armour and the rider's helmet with its crown and dragon. Finally, the characteristic features of the rider, and Lomazzo's data concerning the models made for Francis I, are all reasons to separate the Budapest piece from both of the condottiere monuments. Why this is so, is explained by the history of the piece. At the time Leonardo was preparing his studies for the Sforza monument, the Budapest statuette did not exist.

Let us now outline some of the attitudes of North European scholars to Leonardo's links with our statuette. H. Friis accepted it as a Leonardo in 1933,[271] as did F. Knapp in 1938.[272] In his two volume monograph, in which he solved some important problems, L. H. Heydenreich regarded the Budapest statuette as the best as far as balance is concerned, but he still denoted it as "Umkreis".[273] H. R. Weihrauch, on the other hand, in his 1956 catalogue[274] of the bronzes in Munich, regards it as the most outstanding of the small-size plastic models. In his fundamental work of 1967 the same author appreciated it as one of the most beautiful Renaissance statuettes. He pointed out that it is the only authentic sculpture by the master, but regarded it as made after the wax model prepared for the Trivulzio monument. Th. Müller[275] values it as follows: in the composition "das Äußerste, was an rundplastischer Darstellung dieses Motives überhaupt möglich war . . . aber auch wenn es sich um eine Gußarbeit aus der nachfolge Leonardos handelt, so kann doch das notwending vorauszusetzende Modell nur Leonardo geschaffen haben." As already mentioned, Leonardo himself regarded the casting of the statue as the last, easiest phase and even today the creator of the model is regarded as the author of any bronze statue. In spite of this, in 1965 A. Chastel held it to be a workshop piece.[276] Both N. V. Lazarev and V. R. Vipper are inclined to think that the Budapest statuette is the work of Leonardo's studio, although they acknowledge its artistic qualities.[277] Much later S. Androssow summarized the partial results in several publications[278] and then identified it as the work of Leone Leoni representing Francis I as rider. (In Leningrad, Hermitage, Inv. N. sk. 2234.) Similary he attributed the small foot soldiers to Leone Leoni (*ibid*. Inv. N. sk. 1348.).

After such divergent opinions, for my part I would keep in mind the concluding words of M. V. Brugnoli in his work of 1954.[279] He said the following of our piece: "un discorso a parte, in tal senso meriterebbe soltanto il bronzo di cavallo impennato col cavaliere del Museo di Budapest." Yes, it has been our aim to open up new vistas for researchers, based on a detailed analysis of the statuette. Our results have already been published in part, but the novelty of the facts may astonish some scholars and it will be difficult to have them accepted. In his chronology of Leonardo's works, C. Pedretti dates the statuette to the end of the master's life, basing his opinion on a French study for a horse's armour.[280]

★

Finally we should touch upon the history of the Leonardo statuette in the Budapest Museum of Fine Arts, and the events relating to its acquisition.

Fig. 57.    In 1917 Béni Ferenczy made a commemorative medal for Simon Meller,[281] with a relief representing our statuette on one side. Ferenczy also prepared a study for it without the rider, possibly under the influence of the view of some people that the rider and the horse did not belong together.

In 1930 the statuette was shown at the Exhibition of Italian Art 1200–1900 in the London Royal Academy of Arts,[282] along with some other works of art from Hungary. It was exhibited as the work of Leonardo and was compared with a drawing from Windsor, mistakenly identified in the catalogue as no. 12680, whereas in reality it is no. 12354.

Since the reorganisation of the permanent exhibition in the Budapest Museum of Fine Arts in 1935, the work has been referred to in the writings of Jolán Balogh, former head of the department, as "Leonardesque". In 1939 the directorate of the Museum sent a bronze cast made after a freely modelled copy of the original to the Leonardo Memorial Exhibition in Milan (no. 137/1939).[283] We have a letter by the bronze–caster G. Vignali, and 110/1939 that acknowledges the receipt of „Lionardo da Vinci's statuette" for the purpose of casting its copy in bronze, but it is quite certain that the bronze copy was not made after the original. The above mentioned copy is to be found in the Castello Sforzesco in Milan. There are other copies in the possession of André Corbeau, the former curator of the Leonardo Manuscripts at the Institute de France, Ladislas Reti, or rather his heirs, and Carlo Pedretti. In addition to these there is one copy—

Fig. 58.    probably a second Vignali casting meant for the Museum—in Budapest in the property of Dr. Gyula Gross. He acquired it from Ödön Marjay, editor of the former periodical *Szépművészet*. These copies are rather poor, with deliberate discrepancies in the details, but it is still worthwhile keeping track of them.

In 1940 the porcelain factory at Herend had a copy made in plaster by the sculptress Katalin Gácser. Since then it has been producing copies of the statuette in white porcelain.

The 1969 C. I. H. A. International Congress held in Budapest signified a new chapter in the history of the statuette. (The same year was the 450th anniversary of Leonardo's death.) On this occasion we had an opportunity of making a direct comparison between the Budapest statuette and the New York piece for the first time. The Dublin statuette that also appeared in public and has been discovered only recently proved to be the latest among the horses.

The present work is the result of comparisons of the statuettes with Leonardo drawings, technical examinations and subsequent research.

# Breton and Carolingian legendary cycles in Italy. Traces of courtly literature in Leonardo's art

This supplementary chapter should certainly begin with those sources which mention books belonging to the artists of the Renaissance period. These shed light from one angle on the artists' intellectual and cultural interests.[284] The picture may be enhanced by the similar and much greater collecting activity of those who commissioned work from the artists, since it often happened that the works were executed according to the wishes of the client and based on a given theme. In Leonardo's case the books in his possession are evidence of his multiple spheres of interest and sources of knowledge.

Our data will not be listed chronologically as the legacy of individual masters, for it can be assumed that there was a connection between the books owned by Verrocchio and Leonardo. In 1479, between the dates of the sources relating to these two artists, Benedetto da Majano died leaving 28 volumes of books in his inventory. The majority were on religious subjects but there were also Livy, Dante, a history of Florence, *Cento novelle*, etc. The latter are considered to be the written versions of legendary events passed on from mouth to mouth and partly derived from Arthurian material taken from the Breton lays.

Recently new documents have been published relating to Verrocchio,[285] notes to his will in which five of his books are mentioned: "...Biblia in volgare, Cento novelle, Trionfi del Petrarcha, Pistole d'Ovigio" and finally a writing mentioned as 'Moscino". According to Kristeller and Panofsky the latter is not the author's name but the title of the work. If this is so—and it seems to be regarded as certain—it is quite likely that they were all produced by the master's great pupil, Leonardo. A library catalogue dating from around 1497 and listing some forty items has long been known and identified from the Cod. Atlanticus. One of the recently discovered codices in Madrid contains the catalogue of a library of Leonardo's comprising 116 items, which has been dated to around 1503–4. Of the earlier books, however, nine are missing from the latter catalogue having been left out of the extended library. Of the missing books, the Petrarch was perhaps Verrocchio's "Trionfi", the one which contained "Tabula Rotunda" material. The *Cento novelle* is not Fr. Sacchetti's work because that is *Trecento novelle* but it may perhaps be identified with Masuccio Salernitano's *Il novellino,* listed as no. 40 in Leonardo's enlarged library. The same may apply to the *Biblia in volgare* mentioned under no. 5, and to no.

64, the *Pistole d'Ovidio,* while the "Moscino" may be identical with a courtly short story entitled *Guerino Meschino,* and entered here as "Guerino" under no. 71, whose author was Andrea da Barberino (1370—1431 or 1433).

In Hungary Tibor Kardos, in his great article *The Humanism of Leonardo,*[286] drew many conclusions about Leonardo's literary culture and knowledge. However, at that time the Madrid codices had not been discovered or published and they may well provide us with much more extensive information. On the other hand, however, during our tracing of the iconography of the statue it seemed logical, in connection with his books on courtly subjects, that we should look at the drawings to see whether there are other traces in his art of his having dealt with the subject. The immediately acknowledged, successful attempt by Peter Meller to relate some of Leonardo's drawings to the *Divine Comedy* undoubtedly provided an impetus.[287]

In our case we are not always concerned with the major drawings, since some of them did not escape the tampering of later students and the authenticity of others is questionable. I have no right to comment on this question or on the problem of the dating of the drawings because I have had direct access to too few Leonardo drawings. Deciphering their iconography, however, may be attempted with a certain literary knowledge. I am still at the initial phase of investigation and further results may be expected when the books from Leonardo's library with a "courtly" theme become available for study. The initially promising experiments may lead to further positive achievements in this task. I should like to stress again that in accordance with the requirements imposed by Schramm in respect of literary sources, I intend to take into consideration primarily these publications and manuscript volumes which are closest to the age under discussion. As we have already seen in the case of the shirts worn by certain knights, for example, the early motifs may be modified later, as they travel further afield. These changes, however, can be very characteristic. This is why, in my opinion, we should attribute such major importance to the Caxton publication of the 1484 Malory, or the first Paris edition of Geoffrey of Monmouth in 1508. The fact, that the information derived from these works was in demand even by later rulers, is seen from the use of the chronicle written for Edward IV by Harding (1378–1465) as the basis for the British Museum's manuscript Lansdowne, 882, which comprised all the coats of arms [288] of King Arthur and was compiled on behalf of Henry VIII. The interest in this direction shown by those of the very highest rank is explained by the dynastic basis to the lives led by kings and their striving for power.

The so-called "Breton lays", with the foremost of knights, King Arthur, at their centre, became exceptionally popular and spread and wide in the whole of European literature. With the help of writings and archaeological remains—in the wake of excavations carried out from 1966–70 on the site at Cadbury (Camelot)—it has emerged that he was a historical figure among the Romanized Celts at the beginning of the sixth century, a representative of the pro-Roman anti-Celtic trend in British politics.

He was one of the tribal petty monarchs who fought against the Scots and Picts when they attacked from the North after withdrawal of the Romans, and against the Saxons who were called in to help by Vortigern, Prince of Kent, "sed ipse dux erat bellorum". (Nennius, abbot of Bangor

at the end of the eighth century: *Historia Britonum,* from the beginning of the ninth century.) Even in his life-time he had already become a legendary hero whose deeds were passed on by oral tradition. Bards such as Taliessin in the late sixth century and Aneurin in the early seventh lamented the passing of Arthur. I have referred several times to Geoffrey of Monmouth's book of around 1138, mainly in connection with its dragon figure. His work is the first summary of the events which had crystallized around the figure of Arthur. The latter had a magnetic power of attracting Irish and Welsh folk tales and traditions. [289] In the course of time Arthur's material in Britain become "anglicised". To escape the Saxons and Angles the Britons withdrew partly to Wales, partly to Armorica, the rocky seacoast of Normandy and Brittany. After Monmouth, as we saw, it was Wace, of Anglo-Norman origin and writing in French, who composed Monmouth's material in verse and this started the flow of Breton lays into European literature in the twelfth century.[290]

In order to remain strictly with our theme, we shall continue by tracing this nascent European "courtly" literature mainly in Italy and France. The reason for this is that the two personalities we are concerned with were Leonardo, an Italian artist, and his patron Francis I, the ruler of France. At times, however, the literary sources from the original site, Britain, have to be scrutinized. The relationships between leading historical personalities can be long lasting or repeatedly renewed. The influences may be mutual and certain motifs may migrate there and back. As an example of this we may cite the names of the heroes' legendary swords: in the ancient Irish legend of the great cow robbery (*Táin Bó Cualnge* written in the eighth century A. D.) the sword of one of the heroes was Caladbolg, in Welsh "Caledvwlch", while Monmouth gives Arthur's wonderful sword as Caliburn and meanhile in the *Gesta Caroli Magni* (of 883) by Notker of St Gallen at the time of "ferreus Carolus" we find "... nam dextera ad invictum calibem semper erat extenta...". In the Vulgate cycle of the Breton lays—the prose version dating from the thirteen-thirties—Arthur's sword is referred to as Escalibor, in Malory as Excalibur. In Malory, however, in the Roman military campaigns the list of Arthur's enemies includes "... then came Caliburn one of the strongest of Pavie..." (Vol. I, p. 139, V. 6). Obviously, this is a contamination of the Charlemagne tradition in the earlier Arthurian material.[291] The merging of the two legend cycles in northern Italy will continue to be a characteristic feature. The sword term which varies in the different but related languages may mean the name of the hero's own sword, or "sword" in general as in Notker's account of Charlemagne because the name of the latter's own sword was "Joyeuse". Finally, however, Caliburn also meant the knight himself, completely armoured in steel, who was Arthur's strongest enemy (Malory). I have dwelt on this at such length because, along with many other weapons which will be dealt with later, we find sketches of various ceremonial sword-hilts among Fig. 66. Leonardo's drawings. (Cod. Atl. f. 133/ra.) These in any case would seem to belong more to fiction than among his studies of technical novelties or more effective murder weapons, such as for that on Windsor no. 12653.

In Italy it was not in literature that the Arthurian theme first appeared. It is now accepted by Italians and others that Arthur and his cortège are depicted on the archway of the Porta della

Fig. 60. Pescheria of Modena cathedral, on which the names of the figures are inscribed indicating that the cathedral's initial phase of construction was between 1099 and 1106. Similarly, Arthur can be found again on the lion gate of the St Nicholas church in Bari from around 1106 A. D. [292] Arthur and Guinevere are depicted on the bell tower, the Ghirlandina, in Modena which dates from 1169–79. However, Roland or here Orlando, with his wonderful horn now appears beside them.

In another branch of art, the figurative decorations of floor mosaics, we also find the figures of Arthur, Charlemagne and Roland and representations of the poetic events connected with them from around the middle of the 12th century. The latter was depicted in the cathedral of Vercelli around 1148 and in Brindisi in 1178, while Arthur appears, rather as in the Ghirlandina at Fig. 59. Modena, riding an underworld he-goat in Ontranto cathedral between 1163–66. [293]

Illustrations of Arthur in Southern Italy and other literary traces in Sicily may be explained by the rule of the Normans which lasted until 1189. The traditions survived under the Hohenstaufs (especially during the reign of Friedrich II in 1215–1250) and underwent a vigorous surge in popularity at the Anjou court of Naples at the turn of the 13th–14th centuries. [294]

I do not consider that the very early appearance in Modena is explained by the crossing of the first crusade through Lombardy and its brief sojourn there, even if we assume that tradesmen had accompanied the army and had remained behind for the building of the cathedral. It seems much more realistic to consider the effect of oral transmission by the "Scotti peregrini" who settled in Bobbio from the 7th century onwards and later in Nonatola, Ivrea, Vercelli, Pavia and Milan. At the same time a large number of the figurative floor mosaics found in these Northerm Italian towns in the 12th century may have been linked to the Irish, Scottish and Anglo-Saxon Benedictine itinerant monks, referred to until very recently as Scotsmen. [295]

From as early as the end of the 12th century, these monks were visited, particularly in Pavia and the border province of Treviso, by wandering minstrels from the South of France who were known there as "giullari" and had perhaps fled in connection with the persecutions of the Albigensian, Cathar and Waldensian heretics. [296] Boncompagno da Signa (1165–1240) is cited as giving news societies of young men, such as the company of eagles, of lions, or the Round Table. The first to deal with Breton tales in Italy was Gotfrid of Viterbo, Barbarossa's secretary in his *Pantheon* of 1186–91. In Zorzi in the second half of the 13th century and in Dante's *Vita nuova*, the earliest influence of some poems by Chrètien de Troys has been recognised. At the turn of the 14th century Rustichello da Pisa, contemporary and prison mate of Marco Polo, was a compiler of French courtly epics. Apart from the details already mentioned (sword names), we shall not elaborate further on the evolution of the Charlemagne cycle of legends in Italy, since it is only in part a separate line of development, and one which is already intermingled in Rustichello's work. This development had an especially strong basis in history in Lombardy. Of Leonardo's books, no. 45 *Attila, Flagellum Dei* by Niccolo da Casola from the middle of the 14th century—per volgare—makes a delibarate attempt to link up with the Carolingian theme and thereby antedated Luigi Pulci's (1432–1484) *Morgante Maggiore*, which was also in Leonardo's first library, with its semi-humorous attitude to the chosen topic, Bojardo (1441–1494), and the huge *Orlando* poem by Ariosto, still working in the

third decade of the 16th century. The latter himself does not believe in the events in his own writings and his irony is sometimes obvious.

It is considered characteristic of the development of the Arthurian theme in Italy that it is not the legendary king who is the hero but mostly "Tristano" and "Lancilotto", although other, second-generation heroes of the Round Table also have a prominent role. Antonio Pucci's (d. 1388) Gismirante liberates Rome from the "porco troncassino". This is the equivalent of the "grimmly boar" in Malory, Arthur's ancient northern enemy "Trwch Trwych", or the "Bruto di Bretagna", also from A. Pucci and with later associations with Leonardo, snatching the "sparvier sovrano" from Arthur's court in a victorious sword–fight (Cantare unico 39–44), which in Chretien de Troyes Erec von for King Arthur in a victorious conquest before his exogamous marriage.[297]

Fig. 62.

Two levels can be distinguished in the audience for the mythical tales in Italy: in the aristocratic social strata " . . . quel giorno piu non vi leggemmo avante" Dante (Inf. V. 138), that is, written creations went from hand to hand, as it is clear from the illustrated codices favoured by ruling classes at the court of Naples and somewhat later in the North-Italian city-states. The other, lower social classes "favoleggiarono", listened to the performances of the minstrels in the city streets, which consisted of only as much as could be comprehended on one occasion. This is why there are *cantari* with two, or even several parts, which by Leonardo's time were dying out.[298] He, however, was not averse to them unlike Poliziano.[299] The two versions of the courtly tales, however, were not sharply distinguished and the popular version found its way into court circles by way of Luigi Pulci's *Morgante*. As we have mentioned, one copy of this was in Leonardo's library and in fact it was possibly at his suggestion that Lorenzo de Medici gave Lodovico il Moro a copy of it.[300] Apart from this Leonardo knew the whole story well—he had adopted from it the nick-name for G. G. Caprotti, a young pupil of his, of Salai or Salaino (devil, little devil). We shall now deal with the traces of these influences which can be found in his drawings.

In his often-quoted *Trattato* (Lib. VI, cap. XIX, p. 336) Lomazzo writes the following " . . . Con la medesima via riferi Francesco Melzo, che Leonardo fece un drago, che combatteva con un leone . . ." and (Lib. II, cap. XIX, p. 178) " . . . un drago in zuffa con un leone, con arte . . . Della qual pittura io ne hebbi gia un disegno, che molto m'era caro . . ." We may identify these with drawing no. 435 E in the Uffizi in Florence, which has not been spared some re-drawing and with the lion alone, from the same composition, in the Louvre in Paris.[301] In this desperate struggle Chrétien de Troyes' Yvain intervened on the side of the lion. This is why, in his later adventures in search of the Grail, he obtains the help of the lion's vigilant protection on the dangerous bed, as can been seen in many fourteenth-century ivory carvings.[302] As it has long been known at the beginning of L. Pulci's *Morgante* (Vol. I from p. 97, Canto IV from strophe 7) the interference in the struggle between the lion and the dragon is repeated in its entirety as Rinaldo's adventure and he adopts the pround title of Cavalier di Lione.[303] In Windsor drawing no. 12329 Leonardo depicted as a detail a closed basinet helmet held in the open jaws of a lion with a fluffy mane, a totally benevolent symbol with the role and origin of a "totem". In all probability he drew this

Fig. 67.

Fig. 69.

65

Fig. 68.     for one of the heroes of the *Morgante* or his personification. An actual lion helmet of this type is known in Florence in the Bargello's 15th-century Carand Collection. Much less lively than Leonardo's sketch it has merely the conventional half-figure of a lion on the top with apotropaic lions' heads on both sides holding a ring between their teeth and acanthus leaves fitting over the helmet in the manner of a cabbage. Therefore, the artist used a version of the literary motif which had reached Italy from origins in Brittany, having acquired poetic from among the French.

Fig. 70.     Sheet no. 15630 in Torino is registered as Heracles,[304] altough Kenneth Clark was struck by the fact that the lion lying at the feet of the huge man had "too docile" a countenance, inappropriate to an enemy.[305] Precisely on account of this I would denote it as the giant wild man
Fig. 71.     of Chrétien, Yvain as the master of wild beasts.[306] However, there is a pair to this in Windsor Anat. B. 26. 19043/r, again heavily redrawn, but in Pedretti's view numbered in Leonardo's own hand. Instead of the wooden club of the "Heracles" in Torino, this man holds a proper beam in his hand and therefore A. Pucci's *Bruto di Bretagna*, already mentioned, comes to mind as a possible source:

"Disse il giogante, di niquizia pregno:
—Io te ne paghero, se Dio mi vaglia!—
col baston del metallo e non di legno,
che lo menava come fil di paglia."[307]

In this case, therefore, the popular Italian *cantare* is the direct source. Leonardo has a whole group of related motifs in drawings of the male nude stating astride. For this he drew anatomical muscular studies, at sufficient depth to reach the vascular system. He made several versions himself but perhaps some were by one of his pupils: the man's head is depicted bald, then with locks of hair but shaven face and finally adorned with a luxuriant beard while sometimes the end
Fig. 72.     of a stick can be seen in his hands, or it appears as if he were leaning on one (Windsor nos 12593–97, 12629–34, etc.). This might again depict Chrétien's Yvain who, for breaking his
Fig. 73.     promise and out of fear of losing his wife, goes mad and lives naked like a beast "la barbe a plein poing sor la face" (ed. cit. pp. 130–139, lines 2810–3045, p. 143, line 3131). In Malory, Tristan and Lancelot go mad, turn into wild men and are then found and cared for by bountiful ladies,[308] which reminds us of Odysseus, worn out by the cruelty of nature, appearing before Nausikaá. But what clear reason and refinement are revealed by.

"And with these words King Odysseus crept out from the underwood; but first his powerful arm he tore a leafy bough from the tangled growth to go across his body and hide his nakedness as a man....."*

* Homer: The Odyssey. Translated by W. Shewring. Oxford. Univ. Press. 1980. The World's Classics. p. 70. VI.

When Tristan breaks the branch and throws away his weapon in Malory, however, it is really an act of insanity, of mindless delirium. This later intensifies to a wild frenzy in Ariosto with Orlando's famous mad scene (Cante XXIII, strophe 131–134).[309] If this was in the first version which appeared in 1516, the question is, would it have reached Leonardo, who was probably preparing to go to France? In the event that he got to know Chrétien's composition, then we should have to assume that his information was obtained from Francis I or supplied to him by Malory. In any case, Ariosto made an impact on the Italians which lasted centuries, for Orlando's madness continued to be a favorite scene even in the 19th century. It was also popular in carnival puppet shows.[310] In the Anat. B. f. 21/r Leonardo gives a draft of the contents of his new work and it has been concluded from this that he had intended giving not merely the anatomy of the human body but a whole encyclopedia of man.[311]

One of titles he gave was the following: "Dove di per le malattie il farnetico". It is as if literary themes had helped him towards his interest in certain aspects of natural science.

The case may be similar in respect of drawing no. 2247 in the Louvre in Paris. On the page a young man is sitting in a square among ruined buildings and using a concave shield to gather the sun's rays and project most of them to a quarrelling group of mythical animals. The dragon, bear, lion, unicorn and the boar appearing from a gap in the ruins may be taken as ancient totem animals. Their squabbling can be explained by the breaking up of the company of the Round Table or of the feudalistic order.[312] The anonymous Italian *Cantari di Carduino*, dated to around 1375, is regarded as one which has preserved many archaic elements and itsFrench equivalent *Bohort* or *Bors,* is seen in the Italian Gorone.[313] In the Cardunio, at the time of early bourgeois capitalism, the author is in a certain sense passing judgement on the leaders of the town's society: the duty of a hero "... leoni dragoni orsi e leopardi a ta'cagioni..." but "E non son draghi, anzi son baroni... poi troverai di lioni, tutti son cavalier d'arme portare. E gli orsi e cinghiar, che son si felli, giudici e notai s'apellan elli". Later a dwarf gives advice to the hero "nonne entrare dentro del palazo che in uno fuoco faresti tramazo".[314] By using the power of the sun in the manner seen in the drawing, Leonardo gives a rational, scientific explanation for the apparently magic origin of the ancient knight Sir Gawain's revered strength: "li avoil tos iors crute a heure de miedi... car itant est il amendes de ma proier que tos iors entor heure de miedi a cele heure meisme quil rechut baptesme amendera sa force e sa vertu en quel que lieu que il soit... Et ce estoit la chose par quoi plusor chevalier duotoient plusa entrer en champ encontre lui se ne fust apres heure de miedi...[315] This is why a good 150 years later in a 14th century text, we find the following description of his helmet in *Sir Gawain and the Green Knight*:

"Thenne hentes he te helme, and hastily hit kysses,
That watz stapled stifly and stoffed wythinne.
Hit watz highe on his hede, hasped bihynde,
Wyth a *lightly vrysonn* ouer the auen tayle..."

Fig. 75.

But on his shield and clothing:

"Forthy the *pentangel* nwe,
He ber in schelde and cote,
As tulk of tale most trwe
And gentylest knyght of lote."[316]

    The knight roaming under the protection of the real sun was likewise known in Italy. In connection with the illustration of the rearing horses attached to the carriage, we mentioned the codex in Florence, Bibl. Naz. Cod. Palat. 556, which is filed with the title *Storia di Lancilotto del Lago*, with the completion of the text dated to 1446.[317] In reality it appears with a history of the search for the Grail as well.—The illustrations attributed to Bonifacio Bembo, active in the second half of the 15th century in Lombardy.—The different dangerous trials of the fortress of the Grail are undertaken by several knights but not every one can satisfy them. Finally three are successful: Galahad (Italian Galasso), Perceval (Italian Percevalo) and the third, Bohort (Italian Goron, in Malory Bors). Fol. CLI and CXLVII shows an angel on Galahad's helmet, Bohort was given Sir Gawain's sun-ornamented helmet because when one of his endeavours failed, he was punished by being placed on a cart of dishonour. He was released from this only by Sir Gawain who took his place. This exchange of symbols may be found elsewhere in the Italian versions when Re Meliadus, Tristan's father, went to Uther Pendragon's May tournament "a guisa di dragone". As we suggested, he must have done this in honour of his host. Elsewhere, however, in the *Roman de la Table Ronde* (Vienna, Nat. Bibl. Cod 2537 in f. 99/v and 279),[318] Tristan was probably given Arthur's three-crowned coat of arms on his robe for having freed the king. Because of this multivalent use of symbols it is later hard to find the direct literary source for the individual phenomena.

    The "pentangel" on Sir Gawain's shield, consisting of triangles drawn on the sides of a pentagon, can be found on a Leonardo manuscript (Ms L. f. 4/r)[319] which almost totally corresponds to the description of Gawain's dress. In connection with f. 2/r, however, we can read in the Gawain section of Chrétien's *Contes del Graal, Percevaus li galois* and a continuation by a pupil of his[320] about "pucel as petites manches" who gives a "vermoil samit bien longe e les" dress sleeve to Gawain for him to wear in the tournament the next day. In Malory this scene takes place between Lancelot and his fair of Astolat.[321] The "pentagel" also had a lasting role among the symbols of the free-masons.

    The way the hero makes use of the sun's power in overcoming the beats, derived from Gawain-Bohort-Carduino, is very typical of Leonardo. V. Zubov quoted from Ms F and G his comments on the sun's own heat warms the concave mirror. With this he contradicts Albert of Saxony (episcopus Halberstadiensis, +1390), whose writings are identified with item no. 46 in Leonardo's library—had claimed that heat belonged not to the sun itself but to its light.[322] Here Leonardo's interest in natural science and his experience of technical experimentation influenced the way he illustrated a scene from a fairy-tale.

Fig. 74.

Fig. 77.

Fig. 76.

68

According to Dionisotti, Leonardo's quotations from literary works, such as A. Pucci's *Reina d'oriente*, were not taken from the complete work but indirectly from selected anthologies and it is likely that he intended to compile for himself a so-called "zibaldone", which was so fashionable at the time. At the same time he used many details and quotations from bestiaries,[323] which were later medieval translations of the late antique *Physiologus*. Their impact is reflected by the illustration of the unicorn, for example, among his drawings.[324] Their antecedents can be found once again in the reliefs on 14th century ivory caskets, characteristically with certain scenes from the Breton lays.[325] I also believe that Leonardo's numerous drawings of dragons and dragon fights are related to the Breton lays, as I elaborated when discussing the wearing of a shirt by the rider on the Budapest statuette.[326] Finally the death of the remnants of an army is depicted in the lower right corner of the page on Windsor no. 12376, which Leonardo himself provided with a written description.[327] It may therefore be the remains of Arthur's army, destroyed in his last battle.[328]

Fig. 80.

Fig. 83.

Piece no. 12332 in Windsor, the so-called "pazzia bestialissima", may perhaps be identified with the battle of Alexander the Great although in classical history the use of elephants is mentioned on more than one occasion.[329] Nevertheless, in the Middle Ages it was perhaps Alexander the Great who was most commonly linked with this mode of battle, where indiscriminate slaughter went on from behind a plank fixed to the back of the huge animal. It can be seen, for example, in Paris on f. 108 of Bibl. Nat. Ms. fr. 9342 dated to the end of the 15th century, an illustrated copy of the *Roman d'Alexandre,* and also in one of the codices of the Bodley Ms., already mentioned, Alexander the Great is also connected, albeit through the passive role of his teacher Aristotle, with Leonardo's *Aristotle and Phyllis* drawing in Hamburg.[330] The theme is considered to be of Eastern origin. It appeared in France in the first half of the 13th century but Phyllis' name does not occur until around 1300. One of the ivory carvings, intended for mass production, shows the scene which it proceeds: the philosopher with his already crowned young pupil, then the scholar suffering under the yoke of a woman followed by the so-called "Fountain of Youth" illustration, which also became very popular. We shall elaborate somewhat further on this.

Fig. 82.

Fig. 81.

This motif, which also originated in the East, appeared in Europe around 1170–1180. One of the first works to spread its fame was the *Roman d'Alexandre* by A. de Bernay and Lambett li Tors, which connects the theme with at least the name of the Breton King Arthur, making a point of searching for his "colonies".[331] Later in Jean de Mandeville's (1322–1356) *Le Livre des Merveilles* which contains an itinerary based on Marco Polo, the "Fountain of Youth" appears again. An incunabulum copy was in Leonardo's first library, but he may have got to know an elaborately illustrated codex of it in the library of Francis I. This was commissioned by Jean Sans Peur in 1413 for his uncle, Jean de Berry, for the New Year.[332] Later the volume came into the possession of Jaques d'Armagnac, Due de Nemours. Well after the death of his son Jacques in 1528 Francis I donated the province of Nemours to his mother's brother, Philippe de Savoi. The book, however, may have been acquired by Francis I earlier. In one of the miniatures in the French illuminated manuscript (f. 186), an Indian pepper harvest can be seen. On one side there

is a fertile hillside, on the other a bare rocky hill top, while in the valley between the two an elderly throng can be seen advancing towards the "Fountain of Youth", visible in the background. Just like almost every folk tale theme so far, "favole", this one appears in fourteenth-century ivory reliefs. One of its versions is cited above. On the early 15th-century murals of La Manta Saluzzo castle, among the "Neuf Preux" and "Preuses" already discussed, the pilgrimages to the famous fountain and the wonderful, joyful regeneration of those bathing in it are depicted in rich detail.[333] If we consider that in the Milan Castello, the scene in the Sala delle Asse is crowned with a canopy of trees rooted wild in the cliffs as a "locus amoenus" and if, in Ms H³ f. 130/r,[334]

Fig. 79.

Fig. 78. Leonardo depicted a carriage carrying old people resembling that on the La Manta fresco, we may cautiously ask ourselves whether he might not have intended to draw the "Fountain of Youth" himself? Can we ever find an answer to the questions raised here? It is unlikely to be possible to distinguish between the sketches based on his memories of Italian literature and those drawn directly from French influence. According to the publisher E. Levi, behind the Italian *cantari cavallereschi* which were written and published, there was an immeasurably larger store of fable material which was performed but not published. This is why it is possible that many more French details may have crossed into Italy than we know of nowadays.

From the point of view of our main problem, the subject of the equestrian statue, this condensed survey has merely served to show that this work of art was not unexpected in Leonardo's life, was not a surprising novelty. Its antecedents can be detected as formal elements in the earlier phases of his artistic development.

Today it is natural to give prominence to Leonardo's interest and achievements in natural science. The impression with which we are left from A. Warburg's characterization is his tremendous versatility. ". . . was a child of his time; the new and the old, theological concerns and a wordly acceptance of the joys of life, were battling against each other, but what is peculiar to his world-view is the fact that the Middle Ages and the Renaissance are not fighting fiercely for the soul of this Florentine but are both peacefully sharing it." Although this text originally referred to a Florentine chronicler, we can all the same cite it here and it is also characteristic of Leonardo.[335]

# Notes

Notes with an asterics give bibliographical data concerning the statuette in Budapest.

1. J. von Schlosser: Ein veronesisches Bilderbuch und die höfische Kunst des XIV. *Jhrb. d. Kunsthist. Samml. des allerhöchst. Kaiserh.* XVI. Vienna 1895, pp. 144-224.
2. S. Meller: Die Reiterdarstellungen Leonardo da Vincis und die Budapester Bronzestatuette. *Jhrb. d. K. Preuss. Kunstsamml.* XXXVII. Berlin 1916, pp. 213-250; S. Meller: Leonardo da Vinci lovasábrázolásai és a Szépművészeti Múzeum bronzlovasa (Leonardo da Vinci's depictions of horsemen and the bronze horseman of the Museum of Fine Arts). *Az O. M. Szépművészeti Múzeum Évkönyvei.* I. Budapest 1918, pp. 75-134. *idem:* Ferenczy István bronzgyűjteményének kiállítása. Budapest. 1917. No. 98. (Exhibition of the I. Ferenczy's bronze collection.); A közép- és újabbkori szobrászati gyűjtemény. Budapest. 1921. No 1. (Catalogue of the statues from Middle Ages and the Modern Era.).
3. A. Hildebrand: *Das Problem der Form in der bildenden Kunst.* Strassburg 1913, pp. 105ff. His description of the modelling of a clay statue helps us to reconstruct this process on a finished statue.
4. M. Jankovich: *Pferde, Reiter, Völkerstürme.* Munich s. a., pp. 97ff, 110ff.
5. F. Winzinger: Dürer und Leonardo. *Pantheon.* XXIX. Munich 1971, p. 20, note 49; Kenneth Clark: *A Catalogue of the Drawings of Leonardo da Vinci in the Collection of Her Majesty the Queen at Windsor Castle.* I—III. London 1969, I, pp. 14ff, 22ff, II, Plates. Inv. no. cit. All cited drawings are from this work.
6. H. Landais: *Les bronzes italiens de la renaissance.* Paris 1958, pp. 25ff; J. Montagu: *Bronzen.* Frankfurt a. M. 1963, pp. 11-15; A. Radcliffe: *European Bronze Statuettes.* London 1966, pp. 15-17; H. R. Weihrauch: *Europäische Bronzestatuetten.* Braunschweig 1967, pp. 14, 474ff, 482–3.
7. P. E. Schramm: *Herrschaftszeichen und Staatssymbolik. Beiträge zu ihrer Geschichte vom dritten bis zum sechzehnten Jhdt.* I—III. Stuttgart 1954—1956, I, p. 51.
8. G. Thomson: Marxism and Textual Criticism. *Wissenschaftl. Zeitschrift d. Humboldt Univ. zu Berlin. Gesch. und Sprachwiss. Reihe.* XII. Berlin 1963, pp. 43-51.
9. G. P. Lomazzo: *Trattato dell'Arte della Pittura.* First ed. Milan 1584; R. P. Ciardi (a cura di): *G. P. Lomazzo Scritti sulle Arti.* I—II. Florence 1973.
10. R. S. Loomis and L. H. Loomis: *Arthurian Legends in Medieval Art.* London—New York 1938.
11. J. P. Richter: *The Literary Works of Leonardo da Vinci.* Compiled and edited from original manuscripts. I—II. London 1970, I, pp. 93, 95, nos. 38 and 39: "... lo scultore nel fare una figura tonda fa solamente due figure, e non infinite per li infiniti aspetti, d'onde essa po essere veduta, e di queste due figure l'una a veduta dinanzi e l'altra di dietro... Ma il basso rilieu e di piu speculatione senza comparatione al tutto rileuo e s'accosta in grandezza di speculatione alquanto alla pittura, perche e obligato alla prospettiva e 'l tutto rileuo non s'impaccia niente in tal cognitione, perche egli adopra le semplice misure..."
12. Cod. Atl. f. 391/r; L. Beltrami: *Documenti e Memorie riguardanti la Vita e le opere di Leonardo da Vinci.* Milan 1919, pp. 10-11, no. 21.
13. L. Beltrami: *op. cit.* pp. 25-27, nos. 37, 39; p. 28, no. 41; p. 207, Poesie I; p. 209, Poesie V; p. 45, no. 79; p. 48, no. 82; pp. 68-69, no. 111; pp. 128-129, no. 203; p. 210, Poesie VI; pp. 161-163, no. 254; p. 166, no. 258; pp. 175, 178, 180, no. 260; p. 182, no. 261.

14. L. Dolce and Fr. Bocchi (ed.): P. Barocchi: *Trattati d'arte del Cinquecento fra Manierismo e Controriforma*. I—III. Bari 1960—1962, I, p. 198, III, p. 147.

15. L. Beltrami: *op. cit.* in note 12, pp. 68, 69, nos. 111, 112.

16. G. P. Lomazzo: *op. cit.* in note 9.

17. J. von Schlosser: Kunstliteratur. ed. I. Wien. 1924. pp. 352 f. J. von Schlosser and O. Kurz: *La letteratura artistica*. Florence–Vienna 1956, pp. 395-96.

18. E. Panofsky: *Idea. Ein Beitrag zur Begriffsgeschichte der älteren Kunsttheorie*. First ed. 1924. I used the Berlin 1960 edition. On the Trattato, pp. 97, 103, 111 he cites the *Idea del Tempio della Pittura* (1596) pp. 53, 100, 126ff.

19. A. M. Paris: Sistema e giudizi nell'Idea del Lomazzo. *Annali* II. 23. Pisa 1954, pp. 187-196.

20. E. Spina Barelli: Il Lomazzo e il ruolo delle personalita psicologiche nella estetica dell'ultimo manierismo Lombardo. *Arte Lombarda*. III. Milan 1958, pp. 119-124.

21. C. Pedretti: Sull'importanza delle notizie fornite dal Lomazzo, riguardo di Leonardo. *Studi Vinciani*. Geneva 1957.

22. R. Klein: Les sept gouverneurs de l'art selon Lomazzo. *Arte Lombarda*. IV/2. Milan 1959, pp. 227ff.

23. G. M. Ackermann: *The Structure of Lomazzo's Treatise on Painting*. Princeton 1964.

24. G. M. Ackermann: Lomazzo's Treatise on Painting. *The Art Bulletin*. XLIX. New York 1967, pp. 317ff.

25. R. P. Ciardi: Struttura e significato delle opere teoriche del Lomazzo. *La Critica d'Arte*. XII. Florence 1965, pp. 20-30 and XIII. Florence 1966, pp. 37-44.

26. J. B. Jr. Lynch: Lomazzo and the Accademia della Valle di Bregno. *The Art Bulletin*. XLVIII. New York 1966, pp. 210-211.

27. R. P. Ciardi (a cura di): Lomazzo: Scritti sulle arti. *op. cit.* in note 9.

28. E. McCurdy: *Leonardo da Vinci*. London 1904, p. 32; It must be mentioned, however, that he accepted our statuette completely as the work of Leonardo, first after Simon Meller in 1928, then after its display at the 1930 London exhibition; F. Malaguzzi-Valeri: *La corte di Lodovico il Moro*. II. Il Bramante e Leonardo da Vinci. Milan 1915, pp. 468, 594; A. Hekler: *Leonardo da Vinci*. Budapest 1927, p. 16.

29. We shall revert to the original reconstructed text later: A. Lopez Vieira and Ph. Lebesgue: *Le roman d'Amadis de Gaule* (reconstruction du XIII. siècle).

30. P. Barocchi: *op. cit.* in note 14. I, pp. 49ff. B. Varchi is cited for the variations on the relief: tutto-, mezzo- e basso-rilievo. p. 368, note 4; Leonardo: *Trattato*... Princeton 1956 edition, fol. 22: similar interpretation.

31. J. P. Richter: *op. cit.* in note 11. II, p. 4, no. 709.

32. F. Baldinucci: *Vocabolario toscano dell'arte del disegno*. Florence 1681, p. 126.

33. J. P. Richter: *op. cit.* in note 11. I, p. 95, no. 39.

34. G. P. Lomazzo: *Trattato*... First ed., p. 127.

35. C. Pedretti: Un ricordo di G. P. Lomazzo su Leonardo scultore. *L'Arte*. LVI. Milan 1957, pp. 15-22, Figs 1-2.

36. Ch. Jr. Seymour: "Fatto di sua mano". Another look at the Fonte Gaia Drawing Fragments in London and New York. In: *Festschrift U. Middeldorf*. Berlin 1968, pp. 93-105.

37. E. Plon: *Leone Leoni et Pompeo Leoni*. Paris 1887, pp. 55, 56.

38. J. B. de la Curne de Sainte Palaye: *Mémoires sur l'ancienne Chevalerie*. First ed. Paris 1759—1781, Vols I—III. New ed.: Introduction et notes historiques par Ch. Nodier. Vols I—II. Paris 1829.

39. L. Gossmann: *Medievalism and the Ideologies of the Enlightenment. The Work of Le Curne de Sainte Palaye*. Baltimore 1968, pp. 233, 244ff, 293, 357.

40. R. Truffi: *Giostre e Cantori di Giostre*. Milan 1911, pp. 35ff.

41. F. Lot: *Etude sur le Lancelot en Prose*. Paris 1918, p. 156 note.

42. J. Huizinga: *Herfsttij der Middeleeuwen*. Haarlem 1919 and 1921. I used the *Herbst des Mittelalters,* Munich 1931 edition.

43. J. Barbour and R. L. Graeme Ritchie (ed.): *The Buik of Alexander*. Vols I—IV. Edinburgh–London, 1925—1929, I, p. XLII, note 3.

44. J. Evans: *Art in Medieval France*. London 1948, p. 297.

45. R. D. Middleton: The Abbe de Cordemoy and the Graeco-Gothic Ideal. II. *Journal of the Warburg Inst.* XXVI. London 1963, p. 122.

46. A. von Reitzenstein: *Rittertum und Ritterschaft.* Nuremberg–Munich 1972, p. 144. It seemed most appropriate to use Sainte Palaye's work because it cites a number of texts not only from the golden age of feudal chivalry, but also from the very period most important to us, when the courtly customs were artificially kept alive or revived. Among others, e. g.: E. Deschamps (*c.* 1340–beginning of the 15th century), E. Monstrelet (*c.* 1390–1453), G. Chastellain (*c.* 1405–1475), J. du Bellay (1522–1560), Fr. de la Noue (1531–1591), P. Brantome de Bourdeilles (1535–1614), J. A. de Thou (1553–1617), Th. Godefroy (1580–1649), M. V. de la Colombier (end of the 16th century–1658). All these authors enable us to obtain a clear picture of 16th-century knowledge of the ancient chivalrous customs, of what they considered it worthwhile to keep and imitate. Thus we can fulfil the well-known requirement by P. E. Schramm (*op. cit.* in note 7), who advised us to gather information from contemporary authors.

47. J. P. Richter: *op. cit.* in note 11, vol. II, p. 2.

48. H. Landais: *op. cit.* in note 6, p. 14.

49. A. Ilg (ed.): Theophilus Presbyter: *Schedula diversarum artium.* Vienna 1874, pp. 263ff, 269-271, 272, 279, 281, 319ff, 325, 329.

50. A. Chastel and R. Klein (ed.): Pomponius Gauricus: *De sculptura.* 1504. Gineva–Paris 1969, pp. 230, 231.

51. G. Vasari and G. Milanesi: *Vite. . .* Vol. I. ed. Florence 1973. Della scultura. p. 163.

52. B. Cellini: *La vita di Benvenuto Cellini seguita dai Trattati dell'oreficeria e della scultura e dagli scritti sull'arte.* Preface and notes by A. J. Rusconi and A. Valeri. Rome 1901, pp. 448-455, 753-776.

53. J. P. Richter: *op. cit.* in note 11, II, p. 16, no. 740.

54. L. H. Heydenreich: Zum Madrider Leonardo Fund. *Pantheon.* XXV. Munich 1967, pp. 215-217; L. Reti: The two unpublished manuscripts of Leonardo da Vinci. *The Burlington Magazine.* CX. London 1968, pp. 14-15; Br. Bearzi: Leonardo da Vinci ed il monumento equestre allo Sforza. *Commentari.* XXI. Rome 1970, pp. 61-65.

55. L. Reti (ed.): *The Madrid codices of Leonardo da Vinci 1452—1519.* Vols 1-5, McGraw-Hill Book Comp. 1974 and Florence, Giunti–Barbera 1974.

56. J. P. Richter: *op. cit.* in note 11, II, p. 15, no. 739; My basic knowledge of metals is derived from the following works: L. Gillemot: *Szerkezeti anyagok technológiája (Technology of Structural Materials).* Fifth ed. Budapest *1966, pp. 273ff;* L. Gillemot: *Anyagszerkezettan és anyagvizsgálat* (Structure of Materials and Testing of Materials). Budapest 1967, pp. 270ff; J. Verő: *Fémtan* (Metallurgy). Budapest 1969, pp. 30, 159-161, 396ff.

57. H. R. Weihrauch: *op. cit.* in note 6, repr. p. 20, Figs 13, 14; J. P. Richter: *op. cit.* in note 11, II, p. 15, no. 739.

58. B. Cellini: *op. cit.* in note 52, p. 452.

59. J. P. Richter: *op. cit.* in note 11, I, p. 95, no. 39.

60. L. Reti (ed.): *The Unknown Leonardo. Leonardo Künstler, Forscher, Magier.* Frankfurt a/M. 1974 (1975), p. 97, Fig. 97/4; L. Reti: *op. cit.* in note 54, p. 21, Fig. 30.

61. J. P. Richter: *op. cit.* in note 11, II, p. 359, no. 1445; L. H. Heydenreich: Marc Aurel und Regisole. In: *Festschrift f. E. Meyer.* Hamburg 1957, pp. 146-159.

62. B. Degenhart and A. Schmitt: Gentile da Fabriano in Rom und die Anfänge des Antikenstudiums. *Münchener Jhb. f. Kunstgesch.* XI. Munich 1960, pp. 59ff; R. Stites: Un cavallo di bronzo di Leonardo da Vinci. *La Critica d'Arte.* XVII. Florence NS. fasc. 110. 1970, pp. 13-34; E. Pogány-Balás: Kolozsvári Márton és György szobrának antik előképéről (The antique prototype of the statue by Martin and George Kolozsvári). *Művészettörténeti Értesítő.* XXIV. Budapest 1975, p. 7. Fig. 13, Windsor no. 12333 drawing.

63. A. Hekler: Leonardo und die Antike Kunst. *Az O. M. Szépművészeti Múzeum Évkönyvei.* III. Budapest 1924, pp. 32-36, 125; G. Castelfranco: Mostra didattica Leonardesca. *Bollettino d'Arte.* Ser. IV. vol. XXXIX. Rome 1954, p. 88; J. Marcadé: *Au Musée de Délos.* Paris 1969, pp. 362-366. Planche LXXX. Torso di un gallo del II. sec. nell'isola de Delos. Trovato nel 1882; R. Lullies: *Griechische Plastik. Von den Anfangen bis zum Ausgang des Hellenismus.* Munich 1956, p. 66, no. 191. Dexileos. Attorno 394. Atene, Kerameikos. Trov. nel 1863; *ibid.*: p. 61, no. 177-179. Monumento Attico. Trov. Roma 1764. Villa Albani.

64. These very small statues were probably made after monumental ones still existing at the time. E. Müntz: *Léonard de Vinci, l'artiste, le penseur, le savant*. Paris 1898, p. 271, note 2; A. Hekler: *op. cit.* in Note 63; W. von Seidlitz: *Leonardo da Vinci, der Wendepunkt der Renaissance*. First ed. Berlin 1909, third ed. Vienna 1935, p. 462, Anm. 304 (136).

65. H. B. Siendentopf: *Das hellenistische Reiterdenkmal*. Waldsassen 1968, pp. 25, 65, 114. Cat. II. 76, pp. 64, 66ff, 141. Cat. II. 178, pp. 68, 121. Cat. II. 99.

66. A. Michaelis: Geschichte des Statuenhofes im Vatikanischen Belvedere. *Jhrb. des Kais. Deutsch. Arch. Inst*. V. Berlin 1890; 1891, pp. 5-72; H. H. Brummer: *The Statue Court in the Vatican Belvedere*. Stockholm 1970, pp. 154ff.

67. H. H. Brummer: *op. cit.* pp. 191ff.

68. S. Pressouyre: Les fontes de Primatice a Fontainebleau. *Bull. Monumental*. CXXVII. Paris 1969, pp. 230ff, note 3.

69. K. Clark: *Léonard de Vinci*. First ed. *1939*, second ed. *1952, Trad. franc*. Paris *1967, pp. 331ff; G. Guillaume: Léonard de Vinci, Dominique de Cortone et l'escalier du modele en bois de Chambord. Gaz. d. Beaux Arts*. VI. pér. LXXI. Paris 1968, pp. 93–108; G. Guillaume: Léonard de Vinci et l'architecture francaise. *La Revue de l'Art*. no. 25. Paris 1974, pp. 71–91.

70. E. Pogány–Balás: *op. cit.* in note 62; E. Pogány–Balás: L'influence des gravures de Mantegna sur quelques dessins de Léonard de Vinci. *Bulletin du Musée Hongr. d. Beaux Arts*. No. 37. Budapest 1971, pp. 25–32; E. Pogány–Balás: Observations a propos des têtes de guerriers de Léonard de Vinci et du portrait géant en bronze de Constantin. *Bulletin du Musée Hongr. d. Beaux Arts*. No. 42. 1974, pp. 41–54.

71. R. Koechlin: *Les ivoires gothiques francais*. I–III. Paris 1924, no. 478, tav. 90, no. 481, tav. 89; Ch. R. Morey: A group of Gothic ivoryes in the Walters Art Gallery. *The Art Bulletin. XVIII. New York 1936, p. 209*.

72. E. Pogány–Balás: *The Influence of Rome's Antique Monumental Sculptures on the Great Masters of the Renaissance*. Budapest 1980, pp. 40–41, 52.

73. G. Ring: *A Century of French Painting 1400–1500*. London 1949, p. 193, Cat. no. 15, Plate 16. Florence, Mus. Naz. Bargello. No. 3.

74. N. Hamilton: *Die Darstelung der Anbetung der Heiligen Drei Könige in der Toskanischen Malerei von Giotto bis Leonardo*. Strassburg 1901, p. 105.

75. Ch. de Tolnay: *H. Bosch*. Basel 1937, p. 44 and Baden-Baden 1965, I. p. 43, II. pp. 317–373.

76. L. Brand Philip: The Prado Epiphany by Jerome Bosch. *The Art Bulletin*. XXXV. New York 1953, pp. 284ff. R. Marijnissen and K. Block: *Hieronymus Bosch*. Bruxelles 1972, p. 44: cite W. Fraenger, according to whom the picture was commissioned by a family (Brenckhorst) that belonged to an occultist Jewish Messianic sect.

77. L. Beltrami: *op. et loc. cit.* in note 12. J. P. Richter: *op. cit.* in note 11. Vol. II. pp. 326–327, no. 1340.

78. E. Solmi: La festa del Paradiso de Leonardo da Vinci e B. Bellincioni. *Arch. Stor. Lombardo*. Milan 1904, pp. 78–89; L. Beltrami: *op. cit.* in note 12, pp. 27, 28, nos. 40, 41; Francis L. Finger: *Catalogue of the Incunabula in the Elmer Belt Library of Vinciana*. Los Angeles 1971, pp. 16, 18.

79. Tomo I. II. delle divine lettere del Gran Marsilio Ficino. Trad. per M. Felice Figliucci Senese. Venice 1563. Tomo II. pp. 63/b–66/b, 67/a. His letter to Federigo Duca d'Urbino on astronomy and astrology, the latter the subject of hostile criticism. Here reference is made to Abû Ma šar (Encyclopaedia Britannica: Albumazar), Manilius; A. Warburg: Italienische Kunst und internationale Astrologie im palazzo Schifanoia zu Ferrara. *X. Congr. Internat. C. I. H. A*. Rome 1912, pp. 179–193; C. Padovani: *La critica d'arte e la pittura ferrarese*. Rovigo 1954, pp. 208, 497ff; P. D'Ancona: *I Mesi di Schifanoia in Ferrara*. Milan 1954, pp. 7–9; The distinction between the Italian and above all Tuscan "umanesimo classico" and the more North-Italian, Franco-Venetian "umanesimo cavalleresco" is taken from Italian literary historians: Ruggiero M. Ruggieri: *L'umanesimo cavalleresco italiano da Dante al Pulci*. Roma 1962, with reference in part to the arguments of A. Gramsci; V. Branca (a cura di): *Umanesimo Europeo e umanesimo Veneziano*. Venice 1963; D. Branca: *I romanzi italiani di Tristano e la Tavola Ritonda*. Florence 1968.

80. L. Beltrami: *op. cit.* in note 12, p. 33, no. 52. J. P. Richter, op. cit. Vol II. p. 363. no. 1458.

81. R. Truffi: *op. cit. in note 40, pp. 62, note 3, 65, 67, 71ff; M. Wackernagel: Der Lebensraum des Künstlers in der Florentinischen Renaissance*. Leipzig 1938, pp. 205ff; R. Bernheimer: *Wild Men in the Middle Ages. A Study in Art, Sentiment and Demonology*. Cambridge 1952, pp. 13, 21, 23, 26, 30ff. On classical prototypes: pp. 85, 88, 103, 126; G. Fumagalli: Gli "omini salvatichi" di Leonardo. *Raccolta Vinciana*. XVIII. Milan 1960, pp. 129–157.

82. G. Paccagnini: *Pisanello e il ciclo cavalleresco di Mantova*. Milan 1972, pp. 7ff. According to him the fresco hall partly collapsed in 1480, but the realistic brutality of the fights, their "Leonardesqueness", is underlined on p. 235; B. Degenhart: Pisanello in Mantua. *Pantheon*. XXXI. Munich 1973, pp. 364–411.

83. Ch. de Tolnay: Remarques sur la Joconde. *La Revue des Arts. II. Paris 1952, p. 21.*

84. *H. Bodmer: Leonardo's zeichnerische Vorarbeiten zur Anghiarischlacht. Mitteil. d. Kunsthist. Inst. in Florenz.* III. Augsburg 1919–1932, pp. 463–491; J. Wilde: The Hall of the great Council of Florence. *Journal of the Warb. and Court. Inst.* VII. London 1948, pp. 65–81; C. Gould: Leonardo's Great Battle-Piece. . . *The Art Bulletin.* XXXVI. New York 1954, pp. 117–129, Figs 5–19; C. Pedretti: *Leonardo da Vinci inedito.* Nuovi documenti riguardanti la Battaglia d'Anghiari. Florence 1968, pp. 53ff.

85. Ch. A. Isermeyer: Die Arbeiten Leonardo's und Michelangelo's für den großen Ratsaal in Florenz. In: *Studien zur Toskanischen Kunst. Festschr. für L. H. Heyenreich.* Munich 1963, pp. 83–130.

86. A. Chastel: Les notes de Léonard de Vinci sur la peinture d'apres le nouveau manuscrit de Madrid. *La Revue de l'Art.* XV. 1972, pp. 9–28, Figs 1–37. Among other things: "Leonard ne tarit pas sur la nécéssité de la varieta dans l'aria dei volti et l'attitudine des figures". Besides the above counter-arguments and Lomazzo citations, I also regard the montage-like coupling of the Venetian drawings and the "middle group" of the battle-cartoon as incorrect because this changes the original concepts of the Anghiari and the Venetian drawings, which are depicted from different view-points and perspectives.

87. R. Truffi: *op. cit.* in note 40, pp. 67, 69ff.

88. J. B. de la Curne de Sainte Palaye: *op. cit.* in note 38, I, p. 224.

89. Bruxelles. Bibl. Roy. Ms. 9017. D. Aubert and J. Dreux: "Composition de la Sainte Ecriture'. Mission du l'apotre St. Thomas 1462. In: *Exp. Catal.* Amsterdam 1959, p. 142, no. 174, Pl. 55, Apokrif. A. Ap.

90. London. British Museum. Ms. Add. 24098. f. 20/v. From the codex once belonging to Francis I: a joust.

91. L. H. Heydenreich: *I disegni di Leonardo da Vinci nella Accademia di Venezia.* Florence 1949. Of the 39 sheets he regards 25 as authentic, the others as contemporary, but not autograph, or produced under his influence. These give us an idea of lost or merely planned works. The battle scenes are related by the author to the Battle of Anghiari. Only sheet no. 214 reveals the two foot-soldiers whom we have already seen in the central part of the copy of the Battle cartoon. One of them is already laid low and the other is ready to deliver the final blow; F. Valcanover (intr.) and L. Arano-Cogliati: *Disegni di Leonardo e la sua cerchia alle Gallerie dell'Academia.* Venice 1966.

92. K. Clark: *op. cit.* in note 69, p. 265, Fig. 103.

93. Anonimo Gaddiano. Cod. Magliab. XVII. 17. Florence, Bibl. Naz. cited: L. Beltrami: *op. cit.* in note 12, p. 163, no. 254; Ch. de Tolnay: *Michelangelo.* I. *The Youth of Michelangelo.* 1st ed. Princeton 1943, pp. 31, 106–109; II. ed. 1969. pp. 29–31., Ch. de Tolnay: *Michelangelo.* IV. *The Tomb of Julius II.* Princeton 1954, pp. 24–28, II. ed. 1970. pp. 24ff; for the iconography of the slaves; M. V. Brugnoli: notizie e ipotesi sulla scultura di Leonardo da Vinci. In: *Saggi e Ricerche.* ed. Rome 1954, p. 365; L. H. Heydenreich: Bemerkungen für das Grabmal des G. G. Trivulzio. Studien zur Geschichte der Europäischen Plastik. *Festschrift für Th. Müller.* Munich 1965, p. 189; Ch. de Tolnay: Quelques dessins inédits de Léonard de Vinci. *Raccolta Vinciana.* XIX. Milan 1962, pp. 95–114. With more recent data on the mutual influence the two artists exerted on each other.

94. Ch. Seymour Jr.: *Sculpture in Italy 1400–1500.* Hamondsworth 1966, p. 18, Fig. 120/a and b; V. L. Bush: Leonardo's Sforza Monument and Cinquecento Sculpture. *Arte Lombarda.* Nuova Serie. No. 50. Milan 1978, p. 57, Fig. 20.

95. P. Meller: Physiognomical theory in Renaissance heroic portraits. In: *Actes of 20th Internat. Congr. of the Hist. of Art.* New York. II The Renaissance and Manierism. Princeton 1963, pp. 53–69, Fig. XV, no. 14/a.

96. L. H. Heydenreich: *op. cit.* in note 91, p. 186.

97. M. Gaillard: *Histoire de Francois I. Roi de France.* I. Paris 1766, pp. 14–32; G. Guiffrey (ed): *Chronique du Roy Francoys premier de ce nom.* Paris 1860, pp. 5–116; Le Duc de Lévis Mirepoix, M. Andrieu: *Francois I.* Paris 1967, pp. 7–36, 106–112, 156, 222. 12, p. 156, no. 246; G. Nicodemi: Initiation aux recherches sur les activités de Leonardo de Vinci en France. In: *L'art et la pensée de Léonard de Vinci.* Paris-Alger 1953–54.c. p. 274; *ibid.* A. Dezarrois: La vie francaise de Léonard. pp. 85ff; L. Beltrami: *op. cit.* in note 12.

98. P. Meller: *op. cit.* in note 95.

99. R. Truffi: *op. cit.* in note 40, p. 71.

100. "Pseudo Boron": *"Queste de Graal". c.* 1386 Paris, B. Nat. Ms. fr. 343. f. 4–v. part of Louis XII's spoils from Pavia, where it found its way from the Carrara Library in Padua; Similar depictions are to be found in entertaining prose-tales from the turn of the 13–14th centuries at the Neapolitan Anjou court, which was under strong French influence at the time. B. Degenhart and A. Schmitt: Frühe angiovinische Buchkunst in Neapel. *Festschrift W. Braunfels.* Tübingen 1977, pp. 71–92, Fig. 13.

101. A. v. Reitzenstein:*op. cit.* in note 46, p. 47.

102. G. P. Lomazzo: *Trattato*... First ed. *op. cit.*in note 9, Lib. VII, Cap. XXV, pp. 621ff: Della forma de gl'Eroi, dei Santi... p. 632. Francesco Valesio.

103. P. Vitry and G. Brière: *Documents de sculpture francaise. Renaissance.* Paris 1911, Pl. XLII. Château Sansac; M. Barelli: *Milano e la Certosa di Pavia.* Novara 1928, p. 76, Fig. on p. 74. Agostino Busti detto il Bambaia (1480–1548): Relief portrait of Francis I. Museo Archeologico del Castello. The only relic of his Italian reign; M. Geisberg and H. Schmidt: *Einblatt Holzschnitten.* Munich 1930, no. 1286, p. 220. Erhard Schoen after 1491–1542: Francis I in profile, with the shell necklace of the Order of St. Michael; (Т. D. Kamenskaja) Т. Д. Каменская; Франнцуский рисунок XV–XVI. веков... Ермимаща. Leningrad 1969, no. 44, Pl. XXV. Unkown master, first quarter of 16th century: Le roy françoys premier du nom, or no. 26, Pl. XIV, J. Clouet (?): Le grand Roy François premier du nom. A somewhat later work, with wrinkles around nose and mouth; A. Chatelet, F. G. Pariset and R. de Broglie: *Inventaire des Collections Publiques Françaises. 16. Musée Condé. Chantilly. peinture de l'Ecole Français XV–XVII.* siecle. Paris 1970, no. 45. Probably after a lost J. Clouet drawing, between 1515 and 1520: François Ier; Corn. de Lyon (?): François I. Lyon. Musée. For the reproduction my thanks are due to Prof. L. Pálinkás; J. Clouet: François I. *c.* 1525 Paris. Louvre, no. 59. *Weltkunst XLI.* Munich no. 7, 1971, p. 325. Kunstauktion Bruxelles. Palais des Beaux Arts. Jean Clouet (?): St. John the Baptist with features of Francis I. My colleague, Mrs. Eva Benkő Gönczi, drew my attention to this piece. P. Wescher: New Light on Jean Clouet as a Portrait Painter. *Apollo.* CIII. London 1976, pp. 16–21, Fig. 3. St. John the Baptist. 1518. Ghent, Coll. J. Tijtgat.

104. M. Beaulieu: *Description raisonnée des sculptures du Musée de Louvre.* Vol. II. *Renaissance française.* Paris 1978, p. 68, Fig. 112. François Ier en armure. Inv. M. R. 1886 and N. 15058; The bronze is the 1756 copy by L. C. Vassé made after a mid-sixteenth century sand-stone piece from above the gate of the Cour Oval in Fontainebleau; H. E. Wethey: *The Paintings of Titian. II. The portraits. London 1971, pp. 24, 101ff, Pl. 79; P. Mellen: Jean Clouet.* London 1971, pp. 43ff, 237ff, frontspiece and Pl. 43.

105. G. Campori: *Raccolta di cataloghi ed inventari inediti.* Modena 1870, pp. 192, 195–196, 199.

106. O. Cartellieri: *Am Hofe der Herzöge von Burgund.* Basel 1926, p. 130.

107. J. Huizinga: *op. cit.* in note 42, pp. 123, 128; It was also Philipp Pot who asked Philip the Good to return to his court after wandering in the woods around Brussels, asking him politely whether he was playing the role of King Arthur or Lancelot. In note 46: G. Chastellain: *Chronique des choses de ce temps.* Brussels 1863–66, Vol. III, p. 279; On the grave-stone of Ph. Pot (Paris, Louvre), the reverence for the Knights of the Round Table is well reflected. It represents a funeral procession: monks in mourning are carrying an armoured figure lying on a simple marble slab. The monks are wearing the coat-of-arms of the deceased. Of the nine coats-of-arms, seven are family ones and two are known as those of Lancelot and Palamedes. Cf. M. Prinet: Armoiries familiales et armoiries au XV. Siécle. *Romania.* 58. Paris 1932, pp. 569–573.

108. J. de Baisieux: *Des trois chevaliers et del chainse.* (ed. Scheler: Trouveres belges. I. 1876); J. B. de la Curne de Sainte Palaye: *op. cit.* in note 38, new ed. II, pp. 112–132; B. Degenhart: *op. cit.* in note 82 on Meldon l'Envoisié; Sir Th. Malory (ca. 1400–1471): *Morte d'Arthur.* First ed. London, Caxton, 1485. Ed. by E. Rhys. I–II. Everyman's Library no. 45. London 1906–1935, vol. I, Book VI, ch. 17, p. 178, vol. II, Book XII, ch. 11–12, pp. 158–160.

109. C. Pedretti: Leonardo. *A Study in Chronology and Style. Berkeley, Los Angeles and London 1973, p. 174, Figs 174, 175, 176.*

110. *J. Huizinga:op. cit.* in note 42, p. 96.

111. A. L. Millin: *Antiquités nationales.* Paris 1790–98, vol. II, p. 289.

112. Reproduction of the etching: Le Duc de Lévis Mirepoix... etc., *op. cit.* in note 97, p. 156.

113. V. Oberhammer: *Die Bronzestandbilder des Maximiliangrabes in der Hofkirche zu Innsbruck*. Innsbruck, Vienna 1935, pp. 14–15, 130–133; *1471 Albrecht Dürer 1971*. Ausstellung des Germ. Nat. Mus. Nürnberg 1971. Catalogue p. 382, No. 707.

114. G. P. Lomazzo: *Trattato*... First ed. I. Lib. VI. Cap. XXXX. pp. 378ff.

115. Th. Klauser: Aurum coronarium. *Mitteil. d. Deutsch*. Arch. Inst. Röm. Abt. LIX. Rome 1944, pp. 129–153.

116. P. E. Schramm:*op. cit.* in note 7, vol. II, pp. 422ff: J. Deer: Mittelalterliche Frauenkronen in Ost und West.

117. L. Vayer: Il Vasari e l'arte del Rinascimento in Ungheria. In: *Il Vasari storiografo e artista. Atti del Congr. Internaz. nel IV. cent. della morte*. Arezzo-Florence 1974, pp. 501–524, Fig. 83; Vienna Nat. Bibl. Ms. no. 4. repr. *Bull. de la Soc. Franc. de Repr. de Ms. á peint*. III. Paris 1913, Pl. XL.

118. E. Chmelarz: König René der gute und die Handschrift seines Romanes "Cuer d'Amours Espris" in der K. K. Hofbibl. *Jhb. d. Kunsthist. Samml. d. Allerhöchst. kaiserh*. XI. Vienna 1890, p. 124.

119. A. Lopez Vieira and Ph. Lebesque: *op. cit.* in note 29, pp. 159, 166.

120. P. E. Schramm:*op. cit.* in note 7, vol. III, p. 980; J. Deér: Kronenhelme; J. Pesina: Podoby a podobizny Karla IV. *Universitas Carolina Philosophica*. vol. I. Prague 1955, No. 1, H. P. Hilger: Eine Statue der Muttergottes. *Pantheon*. XXX. Munich 1972, pp. 95ff, Figs 11, 12. The statues are dated to *c*. 1385.

121. Th. Müller and E. Steingräber: Die französische Goldemailplastik um 1400. *Münchener JHB. F. Kunstgesch*. III. Folge. V. Munich 1954, p. 43, Fig. 17/b

122. Bruxelles, Mus. Roy. d. B. A. Inv. no 2405, 2406. *Expos. Primit. Flam. Anonymes*. Bruges 1969, pp. 124–127, No. 59, Fig. on p. 126. Recently attributed to "Maitre de l'Abbaye d'Afflighem."

123. *Metropolitan Museum Bulletin*. NS. VII. 9. 1949, Fig. on p. 245; Boccaccio: *De casibus virorum illustrium*. Paris. Bibl. de l'Arsenal. Ms. 5193. f. 349 v. Ed. by. Martin 1911; P. E. Schramm: *op. cit.* in note 7. vol. III, p. 981: J. Deér: Kronenhelme. The coat-of-arms ornamented with three or more crowns was above all old Arthur's legal due.

124. Ch. de Tolnay: H. Bosch. Basel 1937 and Baden Baden 1965, vol. I, p. 300.

125. P. E. Schramm and J. Deér: *op. cit.* in note 123, pp. 986ff, Fig. 147.

126. L. Vayer: *op. cit.* in note 117, p. 520.

127. L. Schneider: Some Neoplatonic Elements in Donatello's Gattamelata and Judith and Holofernes. *Gaz. d. B. A*. VI. pér. LXXXVII. Paris 1976, pp. 41–48.

128. C. W. Scott-Giles: *The Romance of Heraldry*. First. ed. London, New York 1951, second ed. London 1965; W. N. Ferris: *Arthur's Golden Dragon. Romance Notes*. I. 1959, pp. 69–71; K. H. Göller: Die Wappen König Arthurs in der Hs. Lansdowne 882. *Anglia*. LXXIX. Halle 1961, pp. 253–266; O. Höfler: Zur Herkunft der Heraldik. *Festschr. f. H. Sedlmayr*. Munich 1962, pp. 134–200; G. J. Brault: *Early Blazon. Heraldic Terminology in the 12th and 13th Centuries with Special Reference to Arthurian Literature*. Oxford 1972, p. 44; L. Alcock: *Arthur's Britain. History and Archeology A. D. 367–634*. Harmondsworth 1971 and 1974, pp. 57, 70ff, 333ff; A. von Reitzenstein: *op. cit.* in note 46, p. 52.

129. Pauly's *Real-Encyclopädie* V. Stuttgart 1905, Sp. 1647; T. Livii Patavini Historiarum ab Urbe Condita... Basileae 1549, Dec. 3. Lib. 6. p. 404/a, Dec. 4. Lib. 8. p. 685/a.

130. G. P. Lomazzo op. cit. in note 9, Lib. VII. Cap. XXV, pp. 624–626, 628, 632.

131. Cit. in F. L. Polidori: *La Tavola ritonda o l'istoria di Tristano*. Bologna 1864, pp. LVI, 4.

132. *Arte Lombarda*. XVII. Milan 1972, p. 98; V. Pleister: *Der Münchener Boccaccio*. Munich 1965, p. 193.

133. V. Branca (ed.): *Studi sul Boccaccio*. III. Florence 1965, pp. 414ff; G. Ricci: Studi sulle opere latine e volgari del B. 2. (Le due redazioni del De Casibus...). *Rinascimento*. Ser. 2. II. Florence 1962, pp. 11–20.

134. J. Nauclerus: Chronicon... I had access to the 1564 Cologne edition. Tom. I, vol. 2. Chronographiae generatio XVII. Anno 492, p. 699. Arcturi insignia.

135. P. E. Schramm and Fl. Müterich: *Denkmale der deutschen Könige und Kaiser*. Munich 1962, P. 152; A. M. Cetto: Der Berner Traian- und Herkinbald—Teppich. *Jhb. d. Hist. Mus*. Jhg. 1963–64. Bern 1966, pp. 141, 150, 206; *1471 Albrecht Dürer 1971*. Ausstell. Katal. Munich 1971: G. Kaufmann: Umwelt, der Humanismus. pp. 152–154; H. Stafski: Dürer als Entwerfer von Skulpturen. pp. 379, 382, No. 707. Register p. 398; R. P. Ciardi (ed.): *G. P. Lomazzo Scritti sulle arti*. I. Florence 1973. intr. pp. X, XXXIX; V. Oberhammer, *op. cit.* in note 113. p. 26 ff 543.

136. J. Trithemius: Conpendium sive brevearium... de origine regum et gentis francorum. First ed. Inspurg 1515. The 46th "rex" of the Franks in Britain at the time of Hildericus was Utherpendragon with his son Arcturus.

137. H. Rupprich: Dürer und Pirckheimer. Geschichte einer Freundschaft. In: *A. Dürers Umwelt. Festschrift.* Nürnberg 1971, p. 85, Note 16; F. Winzinger: *op. cit.* in note 5, pp. 18–21.

138. D. Hay (ed.): *The Anglica Historia of Polydore Vergil. A. D. 1485–1537.* London 1950. Introd. pp. X—XIII, XXVIII, XXXIII. His most vehement opponent is J. Leland, in his *Assertio Inclitissimi Arturii.* London 1544. Similarly to the 16–17th century French writers already mentioned under Sainte Palaye, this was also a kind of "romantic" revival of the Middle Ages with the aim—according to its reviewer—"keeping of feudalism". Similarly, E. Spenser's (1552–1599) *Faerie Queen* was written *c.* 1580 in honour of Queen Elizabeth (R. Tuve: *Allegorical Imagery. Some Mediaeval Books and their Posterity.* Princeton 1966, pp. 340ff). In Shakespeare's *Love's Labour's Lost* (1595 or 1598) in Act V, Scene II the figures of the Neuf Preux are already parodied by strolling players to entertain members of the royal court.

139. San-Marte (ed.): Die Sagen von Merlin. (Prophetia Merlini v. G. Monmouth Vita Merlini. lat.) Gedichte d. XIII. Jhdt. Halle 1853, p. 262; E. Rhys (ed.): Sir Th. Malory: *op. cit.* in note 108. Introd. p. XI; L. Alcoock: *op. cit.* in note 128, p. 34.

140. J. Sommer (ed.): G. of Monmounth Historia Regum Britanniae. A variant version ed. from manuscripts. Cambridge (Mass.) 1951, pp. 105, 228.

141. J. Arnold (ed.): Paris. *Soc. d. Anciens textes franc.* 1938. vol. II.

142. J. S. P. Tatlock: The Legendary History of Britain. G. of Monmounth's Historia Regium Britanniae and its Vernacular Version. Berkeley-Los Angeles 1950, pp. 474ff.

143. M. Roques (ed.), Paris 1958, p. 176.

144. O. Sommer (ed.): *"Vulgata Cycle".* vol. II. *Lestoire de Merlin.* Washington 1908, p. 93.

145. Paris. Bibl. Nat. Nouv. Aqu. Fr. 5243; F. Bogdanov: Recension of R. Lathuilliere: Guiron le Courtois. Étude de la tradition manuscrite et analyse ctitique. Geneve 1966. In: *Cahiers de la Civ. Méd.* XI. Poitiers 1968, pp. 76–79. In the above codex "Artu" is represented for the first time with a dragon helmet. e. g. f. 7 and 7 v.

146. Vienna Nat. Bibl. Cod. 2577–2578. In: *Bull. de la Soc. Franc. de Repr. de Ms. à* peint. II. Paris 1912, p. 30, Pl. XVIII. Illustrations dated to 1482–86.

147. I had access only to the Italian translation ed. R. de Visiani. Bologna 1869, Cap. XXVII, p. 93.

148. M. Meiss: *French Painting in the Time of Jean de Berry. The Boucicaut Master.* London 1968, p. 108, Fig. 418, Paris, Bibl. Arsenal. Ms. 5077, fol. 298.

149. J. Arnold: *op. cit.* in note 141, I, p. 437.

150. R. L. Wyss: Die Neun Helden. Eine ikonographische Studie. *Ztschr. f. Schweiz. Arch. u. Kunstgesch.* 17. Basel 1957, pp. 79, 81.

151. K. J. Höltgen: Die "Nine Worthies". *Anglia.* 77. Halle 1959, pp. 179–308; G. Troescher: *Burgundische Malerei. Maler und Malwerke, um 1400...* Berlin 1966, pp. 286–288, Pl. 158, Fig. 487–488; B. Degenhart and A. Schmitt: *Corpus der italienischen Zeichnungen 1300–1450.* I. *Süd- und Mittelitalien.* Berlin 1968, I/2, pp. 594, 595, 619, notes 22, 25, p. 620.

152. Vienna Nat. Bibl. Cod. 2578. f. 33/v. Text 1466. Illustrations 1482–86 J. Colombe (?).

153. Sir Th. Malory: *op. cit.* in note 108, I, book V, ch. 4, King Arthur's marvellous dream, pp. 134–135.

154. P. E. Schramm: *op. cit.* in note 7, III: J. Deér: *Kronenhelme.* pp. 938, 984, Fig. 144.

155. M. Fossi Todorow: *I disegni dei maestri d'Italia delle origini a Pisanello.* Milan 1970, Pl. XXXVIII. Paris, Louvre Cab. d. Dessins. No. 2306. 1448, p. 92, 165 × 142 mm.

156. Vienna Nat. Bibl. Cod. 4. In: *Bull. de la Soc. Franc. de Repr. de Ms. à* peint. III. Paris 1913, Pl. XL.

157. L. Goldscheider: *Leonardo da Vinci. The Artist.* London, fourth ed. 1951, p. 24, Fig. 45; A. Lensi: Il Museo Bardini. II. Le armi. *Dedalo.* VI/1, Milan-Rome 1925–26, pp. 181–183, Fig. on p. 182.

158. Divi Caroli V. Imperatoris Optimi, Maximi Victorie ex multis Precipue. Anvers. H. Cock. 1556; L. de Pauw-de Veen: *Jérome Cock, éditeur d'estampes et graveur. Exp. á la Bibl. Roy. Albert* I. Bruxelles 1970, p. 57, No. 139, p. VIII; L. Preibis: *Martin van Heemskerck.* Leipzig 1911, p. 52; Schéle Sune: *Cornelis Bos. A Study of the Origins of*

*the Netherland Grotesque.* Stockholm—Uppsala 1965, pp. 20, 24, 37, 107; M. Mignet: *Rivalité de François I. et Charles Quint.* Paris, third ed. 1886, vol. II, pp. 48, 51, 53, 56.

159. A. Wauters: *Bernard van Orley.* Paris 1892, p. 71. One of the seven tapestry cartoons depicting the battle at Pavia. Paris, Louvre. The tapestries from the possession of Marchese del Vasto, Naples, Pinacoteca.

160. P. Wescher: *op. cit.* in note 103, in *Apollo* CIII. London 1976, pp. 17, 21.

161. Fr. Hackett: *Francis the I—Franz der Erste.* Berlin 1936, pp. 110–112.

162. P. Wescher: *op. cit.* in notes 103 and 160, Fig. 3.

163. Nach Rosso Fiorentino before 1535. The unity of the state. Francis I as Vercingetorix. Vienna, Gobelinsamml. CV. 6.

164. Cl. G. Dubois: *Celtes et Gaulois au XVI. siècle.* Le dévelopment littéraire d'un mythe natonaliste. Paris 1972. In note 164 Philippo Camerarius (1537–1624): Opera horarum subcisivarum, sive meditationes historicae... (ed. Paris 1610), vol. I, p. 411: The trying-on of Roland's armour.

165. A. Chastel and R. Klein: *L'Europe de la Renaissance. L'âge de l'humanisme.* Paris 1963, p. 334, Fig. 235.

166. S. Béguin: *L'école de Fontainebleau.* Paris 1960, pp. 9–14; E. Panofsky: *Tomb Sculpture.* New York 1964, p. 78, Figs. 325 and 380; J. Shearmam: *Andrea del Sarto.* I, II. Oxford 1965, I. pp. 3ff, II. p. 57.

167. K. Clark: *op. cit.* in note 69, pp. 332–333; C. Pedretti: The Burlington House Cartoon. *The Burlington Magazine.* CX. London 1968, pp. 22ff.

168. G. Guillaume: *op. cit.* in note 69, 2, pp. 71–91.

169. G. Vasari and G. Milanesi: *Vite...* Ultima Impressione. Florence 1973, VI, pp. 619–620.

170. E. Plon: *op. cit.* in note 37. pp. 55–56. note 1.

171. L. de Laborde: *Les Comptes des batiments du Roi.* Paris 1880, vol. II, pp. 200ff.

172. M. Philippson: *Ein Ministerium unter Philipp II. Kardinal Granvella am Spanischen Hofe. 1579–1586.* Paris 1895, pp. 3–15.

173. G. Vasari and G. Milanesi: *Vite... op. et loc. cit.* in note 169.

174. G. P. Lomazzo: *Trattato...* Fist ed. Liber II, cap. 19, p. 177.

175. J. B. de la Curne de Sainte Palaye: *op. cit.* in note 38, vol. I, pp. 358ff, p. 412, note 28.

176. B. Thomas: Die münchener Harnischvorzeichnungen im Stil François I. *Jhb. d. Kunsthist. Samml. in Wien.* N. F. XIX. Vienna 1959, p. 63, Figs. 67, 68; On the basis of the report published in our museum's Bulletin (no. 36, 1971) he felt it necessary to change the dating of our statuette: C. Pedretti: *Leonardo. A Study in Chronology and Style.* London 1973, p. 174, Figs 174, 175.

177. W. R. Valentiner: *Rustici in France. Studies in the Histori of Art.* Dedicated to W. E. Suida. London 1959, p. 216.

178. An engraving of it: Ch. Terrasse: *Le chateau d'Écouen.* Paris 1925, p. 19; A. Lenoir: *Historie des Arts en France Prouvée par les Monuments* (1973) cites J. Bullant's opinion on the bronze equestrian statue above the entrance gate "d'un prince étranger, qui ,'est inconnu".—In the preface of his 1805 edition of Baltard's etchings of historical monumenst, A. Duval regards the rider as a representation of the connétable Montmorency cited by M. Hall: Reconsiderations of sculpture by Leonardo da Vinci... *J. B. Speed Art Museum Bulletin.* XXIX. Luisville 1973, p. 56.

179. E. Plon: *op. cit.* in note 37, p. 55.

180. M. Wackernagel: *op. cit.* in note 81, p. 228.

181. E. Pogány-Balás: *op. cit.* in note 70 (1972), p. 52ff.

182. *Federici Cardinalis Borromaei Archiep. Mediolani Museum.* 1625. New ed. 1909, pp. 71–72. B. Boucher: "Leone and Primaticcio's moulds of antique sculpture", *Burlington Magazine,* CXXIII. London, 1981, p. 24.

183. E. Plon: *op. cit.* in note 37, pp. 48–49.

184. C. Casati: *Leone Leoni d'Arezzo scultore e G. P. Lomazzo pittore Milanese.* Milan 1884, pp. 26–27; J. v. Schlosser: *Kunst- und Wunderkammer der Spätrenaissance.* Leipzig 1908, p. 123.

185. Information kindly supplied by C. Pedroni-Alcsuti (Milan).

186. C. Amoretti: *Memorie storiche... di Leonardo da Vinci.* Milan 1804, p. 133.

187. A. Castan: *Monographie de Palais Granvelle a Besancon.* Paris 1867, p. 18.

188. Marguerit de Navarre: *Heptameron*. Paris, Garnier 1964.

189. R. de Broglie: Les Clouet de Chantilly. *Gaz. d. B. A.* VI. pér. 74. Paris 1971, pp. 257–336, p. 257, no. 35, p. 315, no. 268, p. 318, no. 282.

190. C. Pedretti: *Leonardo da Vinci—Fragments at Windsor Castle from the Codex Atlanticus.* London 1957, p. 11; A. Corbeau: *Les manuscrits de Leonardo da Vinci.* I. Examen crtitique et historique de leurs éléments externes. II. de la Bibliothèque Nationale de Madrid. Caen 1968, note 20, pp. 117–124, note 23, pp. 135–141.

191. C. Pedretti: The Burlington House Cartoon. *The Burlington Magazine.* CX. London 1968, p. 22ff.

192. E. Plon: *op. cit.* in note 37, pp. 242–245; C. Pedretti: *Studi Vinciani. Documenti, Analisi e Inediti Leonardeschi.* Geneve 1957, from p. 264 on: Saggio di una cronologia di fogli del Codice Atlantico; A. Corbeau: *op. cit.* in note 190, pp. 88, 148, 150; K. Clark and C. Pedretti: *op. cit.* in note 5, ed. 1969, vol. II, p. XLVIII, Appendix C.

193. C. Pedretti: *op. cit.* in note 192.

194. X. de Salas: Poussin and Leonardo. *The Burlington Magazine.* CX. London 1968, pp. 633, 639.

195. Exhib. Cat. Buffalo—New York 1937. Master bronzes selected from Mus. and Collect. in America. No. 135; The Metrop. Mus. of Art Bull. V. New York 1946, p. 86;P. Jeannerat: publ. in Apollo. XIX. London 1934, pp. 312–316; de Agostini (ed.) *Leonardo da Vinci.* Novara 1956, vols I–II.: A. Visconti: Leonardo in Mailand und in der Lombardei. p. 124. The picture of the London horse, the copy of the Budapest piece (with and without rider) and the small, bronze crouching soldier of the Trivulzio collection from the Milanese Poldi Pezzoli Museum. Exhib. Cat. Italian Bronze Statuettes. London, Vict. and Alb. Mus. 1961. The London piece: No. 20; Amsterdam, Rijksmus. 1961/62, no. 19; Florence, Pal. Strozzi, 1962, no. 18; Size and technical data: M. G. Agghàzy In: *Bull. du Musée d. B. A.* 36. Budapest 1971, pp. 77–78 and 168–169.

196. J. B. de la Curne de Sainte Palaye: *op. cit.* in note 38, vol. I, p. 42, note 36.

197. R. W.: A symbol of Platonic love in a portrait bust by Donatello. *Journ. of the Warburg Inst.* I. London 1937/38, pp. 26off, Pl. 34/d.

198. Florence, Bibl. Naz. Cod. Pal. 556: Cosidetto "Storia di Lancilotto del Lago", 1446. We shall have to return later to another detail from this codex.

199. W. Bode: Die italienschen Bronzestatuetten der Renaissance. Berlin 1907. Vol. II. p. 15. Plate 132.—W. Bode: ibidem Vol. III. Plate 257.

200. L. Planiscig: Bronzi minori di Leone Leoni. Dedalo. VII/3; Milano-Roma 1926/27, pp. 554–556. Fig. on pp. 55off; L. Planiscig: Piccoli bronzi italiani del Rinascimento. Milan 1930, p. 45. Figs. 337, 338.

201. L. Planiscig: Vienna, Kunsthist. Mus. Die Bronzeplastikan. Publ. aus den Kunsthist. Samml. in Wien Bd. IV. Vienna 1924, pp. 131ff, Figs. 228, 229.; *idem et ibidem* p. 128. Fig. 222; E. Plon: *op. cit.* in Note 37. Pl. V.

202. J. Walker: Washington Nat. Gal. of Art. Painting and Sculpture from the Widener Coll. Washington 1948, Fig. 149. Inv. No. A-131; H. R. Weihrauch: *op. cit.* in Note 6. p. 249.

203. A. Santangelo: Le collezione Auriti. Palazzo Venezia. Roma 1964.

204. S. O. Androssow: *op. cit.* in Note 278. and *idem:* Bemerkungen zu Kleinplastiken zweier Ausstellungen Leningrad 1977—Budapest 1978. AHA. Budapest 1980 Tom. XXVI. p. 148. Fig. 14.

205. M. Leithe-Jasper: Ausstellung Schloss Schallaburg. 1976 Italienische Kleinplastik der Renaissance. p. 91. *Idem.* Exp. Cat. in Washington, 1986.

206. A. F. Radcliffe: Exp. Catalogue of Sculpture from the D. Daniels Coll. Minneapolis. 1979–80. pp. 24–27.

207. J. Gelli: Tra Benvenuto Cellini e Filippo Negroli. *Rassegna d'Arte.* II. Milan 1902, p. 84; E. Plon: *op. cit.* in note 37, vol. II, Pl. XXXIV. pp. vol. I. 20, 52, 64.

208. H. W. Kaufmann: Art for the Wedding of Cosimo de Medici and Eleonora of Toledo. 1539. *Paragone.* No. 243. Florence 1970, p. 53, Pl. 48/b. Paris, Louvre, Cab. d. Dessins. Inv. No. 50.

209. Armour: Lombardic-French: Helmet, *c.* 1555. Paris, Musée de l'Armée. No. H. 155; E. Libaerts von Antwerpen: Detail of a shield, *c.* 1560. Copenhagen, Nationalmuseet. No. D. 174. The central relief on this latter item was made after a drawing, Windsor 12339/r, by Leonardo. B. Thomas: Die Münchner Harnischvorzeichnungen mit Rankendekor des É. Delaune. *Jhb. d. Kunsthist. Samml. in Wien.* NF. XXV. Vienna 1965, p. 45, Fig. 34; B. Thomas: Die Münchner Waffenvorzeichnungen des É. Delaune. *Ibidem.* NF. XXII. Vienna 1962, p. 132, Fig. 112; An

excellent series of other arms and armours, among them a gilded helmet in the shape of a lion's head: *The Metrop. Mus. of Art. Bulletin.* XXXII. New York 1973–74, pp. 58ff. Department of Arms and Armor. H. Nickel Curator.

210. A. E. Popham and J. Wilde: *The Italian Drawings of the XV and XVI Centuries in the Collection of Her Majesty the Queen at Windsor Castle.* London 1949, p. 187, Fig. 21, no. 0463. Attr. to Fr. Ubertini Bachiacca (1494–1557); Dom. Campagnola (*c.* after 1500–1562): Warrior in wire mail armour and dragon helmet. c. 1539–1540. Padova, Liviano. Sala dei Giganti; R. Pallucchini: *Tiziano.* I–II. Florence 1969, vol. I. p. 207, vol. II, Pl. 633, Fig. 231. Florence, Uffizi, Tiziano: Fr. Maria della Rovere. Portrait of the Prince of Urbino, c. 1536–38.

211. J. Squilbeck: Une owuvre énigmatique "Les Trois Marie au Tombeau" du Mus. Boymans a Rotterdam. *Revue Belge d'Arch. et d'Hist. de l'Art.* XXVIII. Anvers 1959, pp. 53–77, Fig. 2.

212. E. Schroter: Raffaels Parnassfresco in der Sala della Segnature des Vatikan. Eine ikonographische und ikonologische Untersuchung. *XXIII Congreso Internacional de Historia del Arte C. I. H. A.* Granada 1973, *Ponencias...* pp. 232–3.

213. O. Larsson: *Adrian de Vries. 1545–1626.* Vienna-Munich 1967, p. 63, note 65, (Fig. 176.)

214. The Stradanus-Cort depiction has already been discussed by Simon Meller, cf. note 2. and J. Balogh: Studi sulla collezione... VI. Parte II. Bronzetti Italiani. *AHA.* XII, Budapest 1966, p. 294, Fig. 125.

215. L. Dimier: *Le Primatice.* Paris 1928, p. 15, Pl. VI.

216. E. Panofsky: *op. cit.* in note 166, pp. 75, 83–84, Figs. 381, 385, 387, 388.

217. U. Keller: Reitermonumente absolutistischer Fürsten. *Münchener Kunsthist. Abhandlungen.* II. Munich-Zürich 1971.

218. A. E. Popham: *The drawings of Parmigianino.* London ed. 1971, vol. I, pp. 110ff, vol. II, Pl. 19, no. 265.

219. R. Stites: *op. cit.* in note 62; M. Hall: *op. cit.* in note 178; there emerged a copy of the Louisville statue: London. Duveen and Walker. Early 17th Century French Bronze. *The Burlington Magazine.* CXVIII. London 1976, p. XCVI.

220. G. Busch and W. Sumowski: *Handzeichnungen alter Meister aus schweizer Privatbesitz.* Ausstellungen Bremen, Zürich 1967, p. 79, no. and Fig. 163. Zoltán Tóth from Frankfurt kindly drew my attention to this depiction.

221. F. Haskell and S. Rinehart: The dal Pozzo Collection. Some new evidence. *The Burlington Magazine.* CII. London 1960, pp. 318–26; Xavier de Salas: *op. cit.* in Note 194.

222. S. Meller: *Ferenczy István élete és művei* (The Life and Works of István Ferenczy). Budapest 1908; P. Cifka: *A pályakezdő Ferenczy István* (István Ferenczy at the start of his career). *Műv. Tört. Tanulmányok.* Budapest 1978, pp. 482ff.

223. G. Entz: I bronzetti della Collezione Marczibányi. *AHA* II, Budapest 1955, pp. 215–234.

224. Ph. Dengel, M. Dvořák and M. Egger: *Der Palazzo Venezia in Rom.* Vienna 1909; F. Hermanin: *Il Palazzo Venezia in Roma.* Bergamo 1931; *Palazzo Venezia.* Paolo II. e le fabriche di S. Marco. Roma, Palazzo Venezia 1980, maggio-ottobre.

225. L. Schudt: *Italenreisen im 17. und 18. Jahrhundert.* Vienna–Munich 1959, pp. 103ff, 401, 434; De Blainville: *Travels through Holland, Flamand, Germany, Switzerland and Italy.* I–III. London 1767, vol. III, pp. 76–79.

226. F. Sansovino: *Venezia citta nobilissima ...* Venezia 1581, p. 138/v ; J. Spon: *Italienische, Dalmatische und Orientalische Reisebescheribung.* ed. Nürnberg 1681, pp. 16, 94; S. Romanin: *Storia documentata di Venezia.* Second ed. Vol. VI, Venezia 1914, p.466. Vol. VII, 1925, pp. 316ff.

227. S. Romanin: *op. cit.* Vol VIII, 1925, pp. 73ff. Vol. X, 1921, pp. 279ff, 284; S. Savini-Branca: *Il Collezionismo Veneziano nel'600.* Padova 1965, p. 216. Famiglia Erizzo.

228. H. Landais: *op. cit.* in note 6, pp. 95ff; H. R. Weihrauch: *op. cit.* in note 6, pp. 416–458; J. Fischer and F. J. B. Watson: *The French Bronze. 1500–1800.* Catal. New York 1968. Foreword.

⋆ 229. L. v. Baldass: Neuerwerbungen des Budapester Museums der Bild. Künste. *Kunst u. Kunsthandwerk.* XX. Vienna 1917, pp. 395, 398.

⋆ 230. E. Tietze-Conrat: Das Rossdenkmal auf G. M. Crespi's "Kindermord". *Mitt. D. Gesellsch. für vervielfält. Kunst.* XL. Vienna 1917, p. 13; eadem: Kleinbronzen. *Die Bildenden Künste.* III. Vienna 1920, p. 49.

* 231. Fr. Schottmüller: *Bronze-Statuetten und Geräte. Berlin 1918, p. 81; eadem: An equestrian statuette of the Renaissance. Art in America.* XIII, New York 1925, pp. 64–67, Fig. 1.

* 232. W. Suida: Leonardo da Vinci und seine Schule in Mailand. *Monatschefte f. Kunstwissenschaft.* XIII. Leipzig 1920, p. 289.

* 233. E. Maclagan: Leonardo as sculptor. *The Burlington Magazine.* XLIII. London 1923, p. 67.

* 234. B. Kramer: Un bronzo di Leonardo da Vinci. *Emporium. LIV. Bergamo 1921, no. 323, p. 278.*

* 235. Fr. Malaguzzi-Valeri: Un bronzo di Leonardo. *Il Marsyas.* I. New York (?) 1921, p. 23; idem: Leonardo da Vinci e la scultura. Bologna 1922, pp. 84–88, Figs 64, 65.

* 236. A. M. Brizio: Recensione del articolo di Schottmüller. *L'Arte.* XXVIII. Rome 1925, p. 134.

* 237. A. Venturi: Leonardiana. *ibidem.* p. 146.

* 238. O. Sirèn: *Leonardo de Vinci.* I. Paris–Bruxelles 1928, p. 72, Pl. 93/A. B.

* 239. W. Suida: *Leonardo und sein Kreis.* Munich 1929, p. 71, Fig. 76.

* 240. W. Suida: Lenardo lovasábrázolásai – Zu Leonardo's Reiterdarstellungen. *Arch. Ért./*Arch. Anzeiger. XLIII. Budapest 1929, p. 182.

* 241. W. Suida: Zum Werke des Palma Vecchio. *Belvedere.* X. Vienna 1931, p. 142.

* 242. G. J. Hoogewerff: Leonardo e Raffaello. *Commentari.* III. Rome 1952, p. 178, Pl. IV, Fig. 2.

* 243. J. Müller-Hofstede: Rubens' St. Georg und seine früheren Reiterbildnisse. *Zeitschr. f. Kunstgesch.* XXVIII. Leipzig–Munich 1965, p. 73, Fig. 4.

* 244. X. de Salas: Poussin and Leonardo. *The Burlington Magazine.* CX/II. London 1968, pp. 633, 639, Fig.30.

* 245. A. E. Popham: The Drawings of Parmigianino. First ed. 1953, second ed. London 1971, vol. I, pp. 110, 111, vol. II, Pl. 19, no. 265. Cf. note 218.

* 246. E. Hildebrandt: *Leonardo da Vinci.* Berlin 1927, pp. 161–167.

* 247. E. Hildebrandt: Neue Leonardo-Literatur. *Repertorium f. Kunstwiss.* LI. Stuttgart–Berlin 1930, pp. 256, 257.

* 248. Kenneth Clark: A Catalogue of the Drawings of Leonardo da Vinci in the Collection of His Majesty the King at Windsor Castle. Cambridge 1935, new ed. 1969, I–III. I. p. 28. Col. 1, no. 12. 328; idem: Leonardo da Vinci, new ed. Baltimore 1958, p. 132; French transl. Paris 1967, p. 271, Fig. 105.

* 249. J. Pope Henessy: *Exhibition Catalogue Italian Bronze Statuettes.* London Victoria and Albert Museum 1961, no. 20; Amsterdam, Rijksmuseum 1961–62, no. 19; Florence, Palazzo Strozzi 1962, no. 18; *Italian High Renaissance and Baroque Sculpture.* London 1963, I–III, I. p. 98, Fig. 127.

* 250. J. Montagu: *Bronzen.* Frankfurt a/M. 1963, p. 26.

* 251. A. Radcliffe: *European Bronze Statuettes.* London 1966, pp. 71, 72, Pl. 44.

* 252. Ch. Avery: *Florentine Reneaissance Sculpture.* London–New York 1970, p. 148.

* 253. G. B. Armenini: *De'veri precetti della pittura.* First ed. Ravenna 1587, pp. 98ff.

* 254. *Exhibition of Italian Art. 1200–1900.* London, Royal Academy of Arts 1930, p. 444.

* 255. Kenneth Clark: *op. cit.* in notes 5 and 248, vol. I. p. 43, no. 12.354

* 256. E. McCurdy: Leonardo's bronze statuette at Burlington House. *The Burlington Magazine.* LVI. London 1930, p. 141; M. H. Longhurst: *ibidem.* p. 10.

* 257. H. Bodmer: *Leonardo.* Stuttgart–Berlin 1931, pp. 105, 377.

* 258. L. Planiscig: *Piccoli bronzi italiani del rinascimento.* Milan 1930, p. 24, Pl. CXIV, Fig. 199.

* 259. G. Nicodemi: Bronzi minori del rinascimento Italiano. Milan 1933, p. 74.

* 260. W. von Seidlitz: *Leonardo da Vinci, der Wendepunkt der Renaissance.* Ed. Leipzig–Vienna 1935, pp. 462, Fig. 73.

* 261. G. Nicodemi: *Leonardo da Vinci.* Second ed. Leipzig 1940, p. XLIV, Fig. 143.

* 262. A Venturi: *Storia . . .* vol. X/1. Milan 1935, pp. 58–60, Fig. 53.

* 263. G. Delogu: *Italienische Bildhauerei.* Zürich 1942, p. 169.

* 264. M. Salmi: *L'Arte Italiana.* I–II. First ed. Florence 1953, vol. II, p. 686, Fig. 1017.

* 265. L. Goldscheider: *Leonardo da Vinci.* Fourth ed. London 1951, p. 40; ed. 1959, p. 180, Pl. 114. ". . . it is clearly the most Leonardesque of all bronzes attributed to the master . . ."; Similarly: L. D. Ettlinger (intr.)—A. Ottino della Chiesa: *The Complete Paintings of Leonardo da Vinci.* London 1967 and 1969, p. 116. Appendix I. Leonardo as a

sculptor. Among others a picture of the Budapest piece and: "... it is the most wideley attributed to Leonardo..."

* 266. R. S. Stites: Leonardo da Vinci sculptor. *Art. Studies*. IV. Cambridge (Mass.) 1926, p. 103; idem: The bronzes of Leonardo da Vinci. *The Art Bulletin*. XII. New York 1930, p. 260, Figs. 9, 10. idem: Un cavallo di bronzo di Leonardo da Vinci. *La Critica d'Arte*. XVII. Nr. fasc. 110. Florence 1970, pp. 22, 29, 30, 31, Fig. 23/a-b.

* 267. W. R. Valentiner: Rustici in France. In: *Studies in the History of Art, Dedicated to W. E. Suida*, London 1959, p. 217.

* 268. M. Hall: Reconsiderations of sculpture by Leonardo da Vinci. *J. B. Speed Art Mus. Bulletin*. XXIX. Louisville 1973, pp. 7–59.

* 269. J. R. Spencer: Sources of Leonardo da Vinci's Sforza Monument. *Actes du XXIIe Congress International d'Histoire de l'Art, Budapest, 1969*. Budapest 1972, II. p. 741; idem: Il progetto per il cavallo di bronzo per Francesco Sforza. *Arte Lombarda*. 38–39. Milan 1973, pp. 23–35.

* 270. V. L. Bush: Leonardo's Sforza Monument and cinquecento sculpture. *Arte Lombarda*. No. 50. Milan 1978, pp. 47–68, Figs 11–13.

* 271. H. Friis: *Rytterstatuens historie i Europa*. Copenhagen 1933, pp. 174, 184.

* 272. Fr. Knapp: *Leonardo da Vinci*. Bielefeld–Leipzig 1938, p. 59.

* 273. L. H. Heydenreich: *Leonardo da Vinci*. Basel 1954, vol. I, p. 74, vol. II, Fig. 105.

* 274. H. R. Weihrauch: *Die Bildwerke in Bronze und anderen Metallen*. Katalog des Bayerischen Nationalmuseums, vol. XIII. Munich 1959, p. 80; idem: *Europäische Bronzestatuetten, 15–18. Jhdt*. Braunschweig 1967, pp. 46, 94, Figs 38, 96.

* 275. Th. Müller: *Il Cavallo*. Stuttgart 1963, pp. 19–21, Figs 1–3, 5.

* 276. A. Chastel: *Le grand atelier d'Italie*. Paris 1965, p. 131, Fig. 141; We can only enumerate the literature subsequent to the above mentioned studies pointing out that these recently published titles do not bring further results on the solution of problems. M. Rosci: The Hidden Leonarde. Sydney. 1978. p. 98, pp. 121. and sequ., p. 183. fig. 24.; E. Ullmann: Leonardo da Vinci. Leipzig. 1980. pp. 96–97., pp. 189–191. Taf. 78.; G. Scaglia: Leonardo's non inverted writing and Verrocchio's measured drawing of a horse. The Art Bulletin. vol. 65. 1983. pp. 34–50. 16 figs. By the drawing Windsor No. 12319. cited: "gianecto grosso di Messer Galeazzo", but the statuette of Budapest is not mentioned. Pečirka, J.: Leonardo da Vinci, Prague, 1975. III. 18. 1506–1508. Sonino, M. ed.: G. Vasari: The Great Masters: Giotto, Botticelli. Leonardo... etc, New York, 1986. Ill. p. 89. origin around 1485. In his recent catalogue to the exhibition *Renaissance Master Bronzes* from the Kunsthistorisches Museum, Vienna. (Washington 1986. pp. 160–162 and pp. 163–165.) Leithe Jasper also proceeds with dividing the groups of small warriors presumed previously to belong together. Accepting his argumentation to a certain extent, I still cannot consider his results as final. He does not take into consideration the small warrior on his hunkers at the Poldi Pezzoli Museum in Milan bearing a very close resemblance to the less detailed figures of warriors.

* 277. V. N. Lazarev: *Leonardo da Vinci*. Moscow 1952, p. 66, XXVII; (V. R. Vipper) В. Р. Виппер: Лионардо и скульптура *Сообщения Инст. Истории Искусств*. 3. Живом Скульм. АН СССРА Moscow 1953, pp. 105–114, Fig. on p. 113.

* 278. С. О. Андроссов: *Катал. Художественная бронза Итальянского Возрождения* Leningrad 1977, p. 24ff, No. 26, Figs. 13, 26. idem: Italienische Bronzen der Renaissance. Aus der Samml. der Staal. Ermitage in Leningrad. Katal. der Ausstell. Berlin 1979, pp. 38–40, Fig. 24, Cat. no. 24. idem: Бро нзовая статуетка всадника К вопросам изучения скульптурый Лионардо да Винчи. *Искусство* Moscow 1979, no. 8, pp. 58–61. E. Eszláry— E. Koroknay: *Kisplasztikai kiállítás*. (Exhibition of small statuettes) Budapest. Museum of Fine Ars. Cat. No. 53. pp. 21–22. Fig. 53.; S. O. Androssow: Bemerkungen zu Kleinplastiken zweier Ausstellungen. Leningrad 1977— Budapest 1978. AHA. vol. XXVI. 1980. pp. 148–149. Figs. 8–14.

* 279. M. V. Brugnoli: Documenti, notizie e ipotesi sulla scultura di Leonardo. In: *Leonardo, saggi e ricerche*. Publ. Rome 1954, pp. 574ff, Pl. CLVIII, Figs 20, 21.

* 280. C. Pedretti: *Leonardo. A Study in Chronology and Style*. London 1973, p. 174, Figs 174, 175.

281. L. Huszár and B. Procopius: *Medallien- und Plakettenkunst in Ungarn.* Budapest 1932, no. 2205, Pl. XXXIII; S. Salmann: An attempt at an analysis. Recension of H. R. Weihrauch: *op. cit.* in note 6. *Connoisseur.* CLXX. London 1969, p. 20, Fig. 5.

282. Exhibition of Italian art 1200–1900. Royal Academy of Arts. London. 1930. p. 444.

283. On April 1, 1939 handed over to the Italian Embassy. Budapest Museum of Fine Arts, Archives, File no. 137/1939; Budapest Museum of Fine Arts, Archives, File no. 110/1939.

284. M. Wackernagel: *op. cit.* in note 81, p. 336.

285. D. Covi: Four new documents concerning A. C. Verrocchio. *The Art Bulletin.* XLVIII.New York 1966, pp. 97–103, Note 18; J. P. Richter: *op. cit.* in note 11, vol. II, pp. 366–368, no. 1469. With G. d' Adda's explanations of titles. R. Reti: *op. cit.* in note 54, *ibidem,* Part II, 80–88. col; C. Maccagni: Leonardo's List of Books. *ibidem* 407–410. col; Fr. L. Finger: *Catalogue of the Incunabula in the Elmer Belt Library of Vinciana.* Los Angeles 1971.

286. T. Kardos: Leonardo humanizusa (Leonardo's Humanism). In: *Renaissance Tanulmányok (Renaissance Studies).* Budapest 1957, pp. 435–487.

287. P. Meller: Leonardo da Vinci's drawings to the Divine Comedy. *AHA.* II. Budapest 1955, pp. 135–166; B. Degenhart: Dante, Leonardo und Sangallo. *Röm. Jhb. f. Kunstgesch.* VII. Munich 1955, p. 287.

288. K. H. Göller: Die Wappen König Arthurs in der Hs. Lansdowne 882. *Anglia.* 79. Halle 1961, pp. 253–266.

289. J. Pokorny: Der Ursprung der Arthursage. 1908. In: K. Wais (ed.): *Wege der Forschung.* Vol. CLVII. Darmstadt 1970, pp. 22–44; L. Alcock: Arthur's Britain. *op. cit.* in note 128.

290. Chr. Brooke: *The Twelfth Century Renaissance.* London 1969.

291. W. A. Nitze: Problems des Arthurischen Romans. 1953. In: K. Wais (ed.) *op. cit.* in note 289, p. 99; Notker (*c.* 840–912): *Gesta Caroli Magni (886/87).* ed. Mon. Germ. Hist. Scrip. NS. Tom. XII. Berolini 1959; Sir Th. Malory: *op. cit.* in note 108, vol. I, V. 6, p. 237.

292. P. Deschamps: La Légende Arthurienne á la Cathédrale de Modene. *Monum. et Mém. Fond. E. Piot.* XXVIII. Paris 1925/26, pp. 67–94; J. Stiennon and R. Lejeune: La légende Arthurienne dans la sculpture de la Cathédrale de Modene. *Cahiers de la Civ. Méd.* VI. Poitiers 1963, pp. 281–296, Figs 1–27; R. Salvini: *Il Duomo di Modena.* 1966, pp. 137ff, Pls 144–147; R. Lejeune: La légende du Roi Arthur dans l'iconographie réligieuse médiévale. *Archaeologia.* No. 14, Paris 1967, pp. 51–55; A. Kingsley Porter: *Romanesque Sculpture of the Pilgrimage Roads.* I. New York 1969, pp. 64ff, 156.

293. For questions concerning early medieval floor mosaics: H. Kier: *Der mittelalterliche Schmuckfußboden.* Düsseldorf 1970, pp. 64–74, Fig. Otranto 366, 367, further: 378, 381ff, 408, etc.

294. B. Degenhart and A. Schmitt: *op. cit.* in note 100.

295. G. Micheli: *L'enluminure du haut moyen age et les influences Irlandaises.* Bruxelles 1939.

296. Details of Italian literary history are from the following works: F. L. Polidori (per cura di): *La Tavola ritonda o l'istoria di Tristanno.* Bologna 1864; E. Löseth: *Le roman en prose de Tristan, le roman de Palamede et la compilation de Rusticien de Pise. Analyse critique d'apres les manuscrits de Paris.* Paris 1890; R. Truffi: *op. cit.* in note 40; E. G. Gardner: *The Arthurian Legend in Italian Literature.* London 1930; A. M. Finoli: "Les Chansons de Geste sont dans l'air... " Ist. Lomb. di Scienze e Lettere. *Rendiconti.* Class. di Lett. vol. 89–90. XX. Della serie III. Milan 1956, pp. 623–638; A. Limentani: *Dal Roman de Palamedés ai Cantari di Febus el Forte.* Bologna 1962; Ruggiero M. Ruggieri: *op. cit.* in note 79; V. Branca: *op. cit.* in note 79; D. Branca: *op. cit.* in note 79; B. Degenhart and A. Schmitt: Mario Sanudo und Paolino Veneto. Zwei Literaten des XIV. Jhdts. *Röm. Jhb. für Kunstgesch.* XIV. Tübingen 1973, pp. 1–137; B. Degenhart and A. Schmitt: *op. cit.* in note 100, pp. 71–92.

297. E. Levi (ed.): *Fiore di Leggende. Cantari Leggendari.* Bari 1914, pp. 171–198, 201–211; J. Győri: Prolégomenes a une imagerie de Chrétien de Troyes. *Cahiers de la Civ. Méd. Poitiers.* X. 1967, pp. 361–384, XI. 1968, pp. 29–39.

298. Ruggiero M. Ruggieri: *op. cit.* in note 79 and 296, p. 87.

299. G. Fumagalli: Leonardo e le favole antiche. In: *Ist. Naz. di Studi sul Rinascimento. Atti del V. Conv. Internaz.* Florence 1956 (ed.: 1958), pp. 111–147; C. Dionisotti: Leonardo. Uomo di Lettere. In: *Italia Medioev. e Umanist.* V. Studi in onore di G. Madersteig. Padova 1962, pp. 182–216.

300. G. Fumagalli: *Leonardo ieri e oggi.* Pisa 1959, pp. 93ff, Leonardo e Policiano. P. 125, Lodovico il Moro's connections with L. Pulci. The question of the Morgante p. 142.

301. De Agostini (ed.): Leonardo da Vinci. Third ed. Novara 1956, vol. II, p. 314.

302. R. Koechlin: *op. cit.* in note 71, I. p. 439, II. p. 424, no. 1201. Musée Niort; Th. T. Hoopes: An ivory casket in the Metropolitan Museum of Art. *The Art Bulletin.* VIII. New York 1925–26, pp. 127–140. J. A. Ross: Allegory and romance on a mediaeval French marriage cascet. *Journal of the Warburg. Inst.* XI. London 1948, pp. 112–142, Fig. tav. 30/e.

303. U. Foscolo (ed.): L. Pulci: *Morgante maggiore.* vol. I–II. Classici italiani. Ser. II. vol. 43–44. Canto IV, from strof. 7, pp. 97ff.

304. C. Pedretti: L'Ercole di Leonardo. *L'Arte.* LVII. Milan 1958, pp. 163–170.

305. K. Clark: *Leonardo and the Antique. Leonardo's Legacy.* Berkeley–Los Angeles 1969, p. 21, Fig. 23.

306. In: W. L. Holland and A. Schulze, Third ed. Berlin 1902, pp. 16ff, 277, from lines 301.

307. E. Levi (ed.): *op. cit.* in note 297, p. 208, strof. 31.

308. Sir Th. Malory: *op. cit.* in note 108, vol. I. book XI. chapt. 17, pp. 325–326, vol. II, book XII, chapt. 1, p. 145, book XII, chapter 3, pp. 148–149.

309. L. Ariosto: *Orlando furioso.* Ed. Il Parnasso Italiano. II. S. L. Ed. Canto. XXIII, strof. 131–134, col. 310.

310. F. Gregorovius: *Wanderhajre in Italien.* Ed. Dresden 1925, pp. 222ff; E. Hoffmann: *A világirodalom remekei képekben. A Grafikai Osztály 78. kiállitása* (Masterpieces of World Literature in Pictures. 78th Exhibition of the Graphic Department). Catalogue. Budapest 1941, no. 35/2, p. 13, D. N. Chodowiecki's (1726–1801) engraving.

311. K. Clark: *op. cit.* in Note 5, vol. III, Anat. B, 21/r; J. Playfair-McMurrich: *Leonardo da Vinci. The Anatomist.* Washington-Baltimore 1930, pp. 74–76; S. Esche: *Leonardo da Vinci. Das Anatomische Werk. Basel 1954, pp. 28ff, 119.*

*312. J. Marx: La légende Arthurienne et le Graal. Paris 1952, p. 285.*

313. P. Rayna (ed.): *I Cantari di Carduino. 1375.* Bologna 1873; J. Marx: *op. cit.* in Note 312, p. 99.

314. In: P. Rayna (ed.) Canto II. 43–63.

315. H. O. Sommer (ed.): *The Vulgata Version of the Arthurian Romances.* Ed. from Ms. in the Brithis Mus. vol. VI. Les aventures ou La Queste del Saint Graal... Washington 1913, pp. 339–341.

316. J. R. R. Tolkien and E. V. Gordon (ed.): *Sir Gawain and the Green Knight.* Oxford 1967, 1968, from p. 17. 603 and p. 18. 619, also from 632.

317. Codex cited in note 198: Florence, Bibl. Naz. Cod. Pal. 556: Cosidetto"Storia di Lancilotto de Lago", 1446; F. Lot: *Etude sur le Lancelot en prose.* Paris 1918, pp. 400ff. Berti-Toesca, E.: Un romanzo illustrato del '400. L'Arte. Anno XLII, Milano, 1939. pp. 135–143. Salmi, M.: Note su Bonifazio Bembo. Commentari. Anno IV. Roma, 1953. p. 9. Tav. II. Fig. 6. Both in this 13th century writing and in R. Boron's 13th century work Gawain is sitting in punishment on the cart. J. Marx: *op. cit.* in note 312; p. 260; B. Degenhart-A. Schmitt: *op. cit.* in note 100. pp. 73 and 89. note 10.

318. J. H. Hermann: Beschreib. Verz. d. Illum. Hdschr. Öst. Bd. III. Franz. und Iber. der I. Hälfte des XV. Jhdts. Leipzig 1938, pp. 44ff.

319. Ch. Ravaissom-Mollien (ed.): Les Manuscrits de Leonardo da Vinci de la B. Inst. de France. Paris from 1881, Ms. L. f. 4/r.

320. After Chrétien de Troyas: Contes del Graal. éd. Paris. Ms. fr. 794. Freiburg i./Br.: 5400–5426; L. Polmann: *Chrétien de Troyas und der Conte del Graal.* Tübingen 1965.

321. Sir. Th. Malory: *op. cit.* in note 108, vol. II, Book XVIII, chapter 9, pp. 285ff.

322. V. Zubov: Le soleil dans l'oeuvre scientifique de Léonard de Vinci. A *"Le soleil a la Renaissance. Sciences et Mythes". Colloque International 1963.* Bruxelles–Paris, ed. 1965, pp. 179ff; Ms. F. and G. also Paris, Inst. de France, Fr. L. Finger: *op. cit.* in note 285, pp. 6–8., Hain 1925. I.

323. G. Fumagalli: *op. cit.* in note 299, p. 139; C. Dionisotti: *op. cit.* in note 299, p. 193.

324. A. E. Popham: *Les dessins de Léonard de Vinci.* Introduction, Notes er Catalogue. Bruxelles 1952, p. 106, Figs 27, 28/b.

325. J. A. Ross: *op. cit.* in note 302, and T. T. Hoopes: *op. cit. ibidem* Fig. 6.

326. My opinion concerning Windsor 12331 is supported by C. Pedretti: *op. cit.* in note 109, where the drawing is dated later.

327. Kenneth Clark: Exhibition Catalogue of Drawings by Leonardo da Vinci from the Royal Collection. London, Buckingham Palace 1969–70, p. no. 145.

328. J. Frappier (ed.): *La mort le Roi Artu. Roman du XIII. Siècle.* Geneve–Lille 1954, p. 250, 193 "... une pluie commença a cheoir moult grant e moult merveilleuse qui li dura jusqu'a un tertre..."

329. W. O. Hassal: Bestiaires d'Oxford. Ms. Bodley 764. f. 12. Éléfant et chateau. Les dossiers de l'archéologie. Paris, No. 16, 1976. Enluminure gothique, pp. 71–81, Fig. 17.

330. A. E. Popham: *op. cit.* in note 324, Fig. 110/b, W. Stammler: *Wort und Bild. Studien zu den Wechselbeziehungen zwischen Schrifttum und Bildkunst im Mittelalter.* Berlin 1962, I, pp. 12–44, Der Philosoph als Liebhaber; R. Koechlin: *op. cit.* in note 71. II, no. 1281, T. S. Hoopes: *op. cit.* in note 302. Figs 1, 3, 7.

331. L. Masson: La Fontaine de Jouvence. *Aesculap.* NS. 27. Paris 1937, pp. 244ff, pp. 245, 246; G. F. Hartlaub: *Lucas Cranach der Jüngere: Jungbrunnen.* Stuttgart 1958; R. Ginouvès: *Balaneutikè. Recherches sur le bain dans l'antiquité grêcque.* Paris 1962; A. Rapp: *Der Jungbrunnen in Literatur und Bildender Kunst des Mittelalters.* (Diss.) s. l., s. d.

332. M. Meiss: *French Painting in the Time of Jean de Berry. The Boucicaut Master.* London 1968, pp. 116–122. Paris Bibl. Nat. Ms. fr. 2810.

333. G. Troescher: *op. cit.* in note 151, p. 286.

334. Ch. Ravaisson-Mollien (ed.): *op. cit.* in note 319, Paris. Inst. de France. Ms. H³ f. 130r and ff 133r.

335. E. H. Gombrich: *Aby Warburg, an Intellectual Biography.* London 1970, pp. 96ff, VI. Return to Florentine researches. 1897–1904. Renaissance Art: Leonardo.

# Acknowledgement

Grateful appreciation is hereby expressed for their kind permission to reproduce material in this book:

*Windsor Castle, Royal Library*<sup>c</sup>, Her Majesty Queen Elizabeth II
*The British Museum*, London
*Ashmolean Museum*, Oxford
"All rights reserved, *The Metropolitan Museum of Art*", New York
*National Gallery of Art*, Washington
Service Photographique de la Réunion des Musées Nationaux, Paris
*Bibliothéque Nationale*, Paris
*Musée Condé*, Chantilly
"Photo Copyright *Musée de L'Armée*", Paris
*Bibliotheque Royale Albert*, Bruxelles
*Staatliche Graphische Sammlung*, Munich
*Österreichische Nationalbibliothek*, Vienna
*Kunsthistorisches Museum*, Vienna
"Firenze, *Museo Bardini*," Florence
*Hamburger Kunsthalle*, Hamburg
*Nationalmuseet*, Copenhagen
*Stiftskirche*, Altötting
*Gabinetto Disegni e Stampe degli Uffizi*, Florence
*Biblioteca Nazionale Centrale*, Florence
*Biblioteca Ambrosiana*, Milan
*Fondazione Artistica Poldi Pezzoli*, Milan
*Gallerie dell'Accademia*, Venice
*Biblioteca Nacional*, Madrid,     and to the
*Museum of Fine Arts*, Budapest

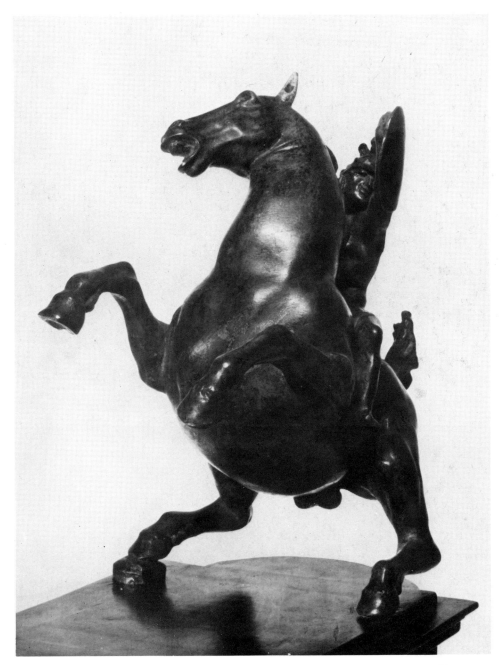

*Fig. 1*. Leonardo da Vinci: Triumphal rider on a rearing horse (1516—19). Bronze statuette. H. 24.3 cm
Budapest, Museum of Fine Arts, Inv. no. 5362.

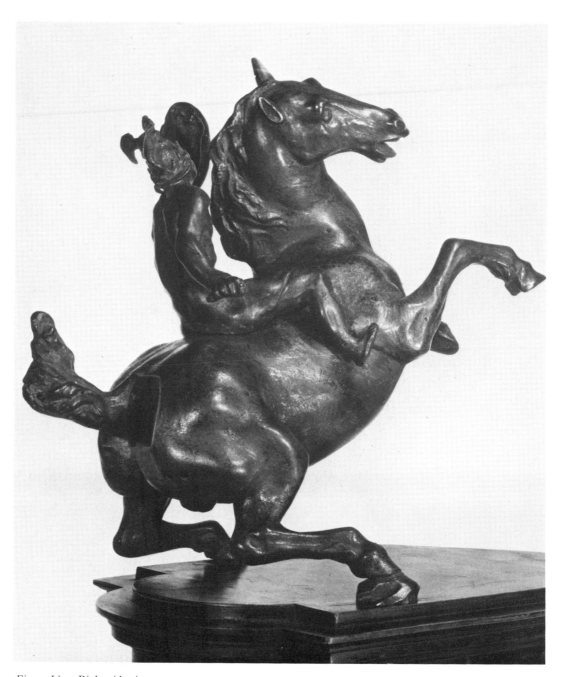

*Fig. 2. Idem.* Right-side view

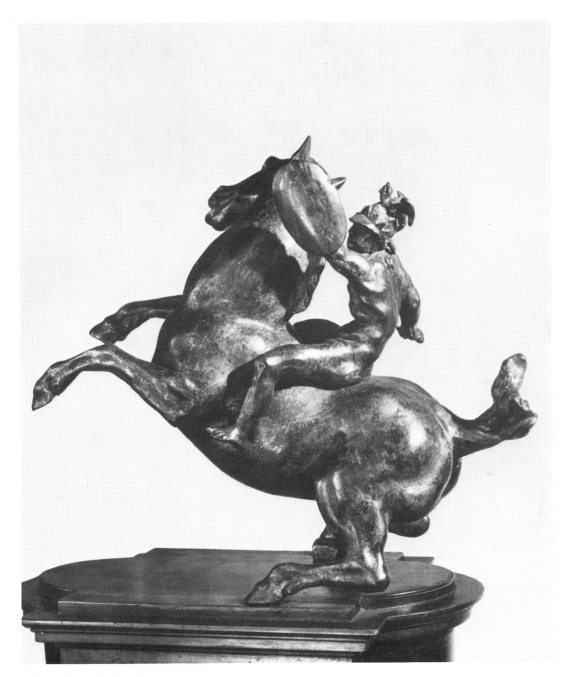

*Fig. 3. Idem.* Left-side view

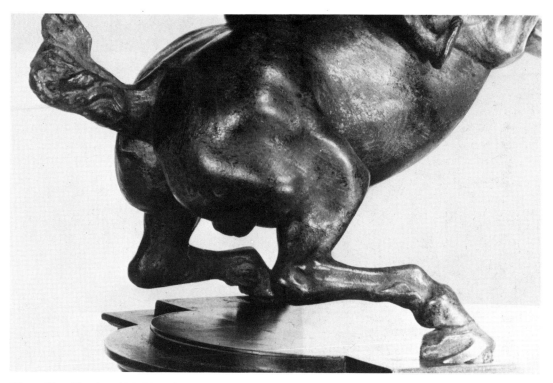

*Fig. 4. Idem.* Trunk and hind legs from the right side

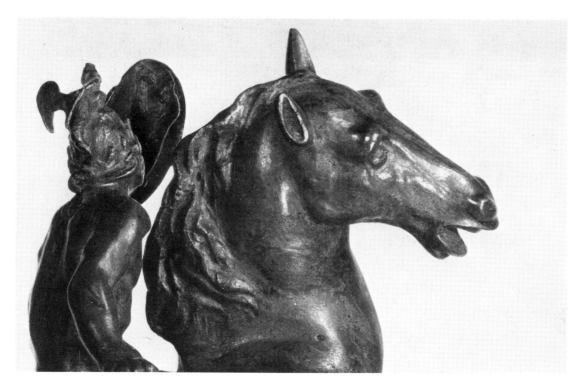

*Fig. 5. Idem.* Horse and rider, heads from the right side

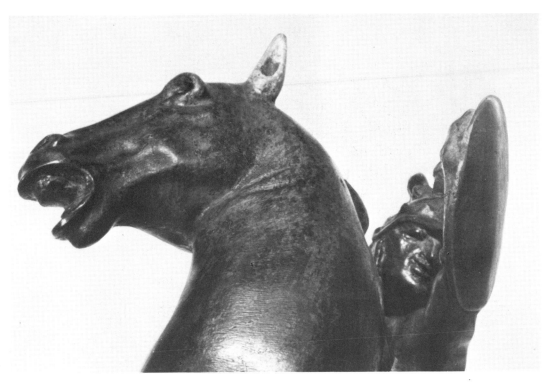

*Fig. 6. Idem.* Head of the horse and the rider, somewhat to the left, frontal view

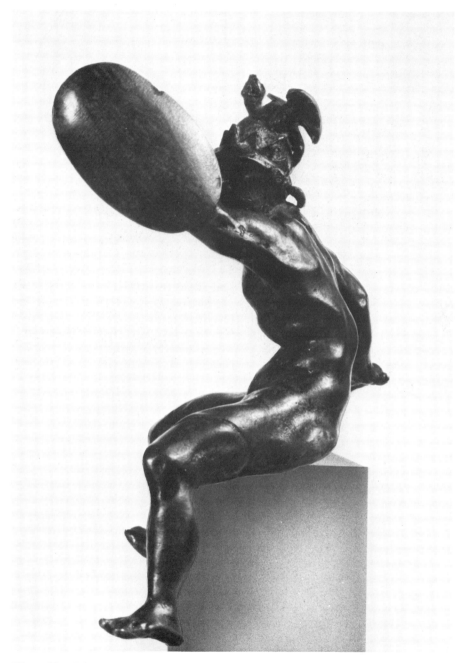

*Fig. 7. Idem.* The figure of the detached rider, from the left side

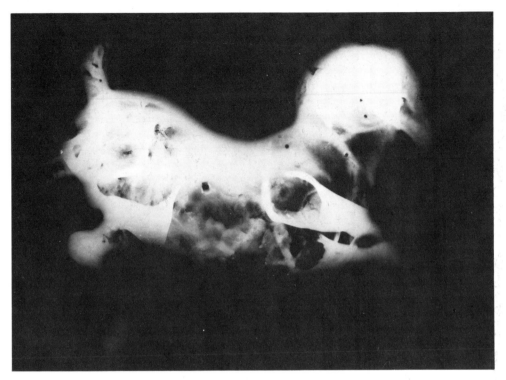

*Fig. 8*. An X-ray picture of the horse's right side

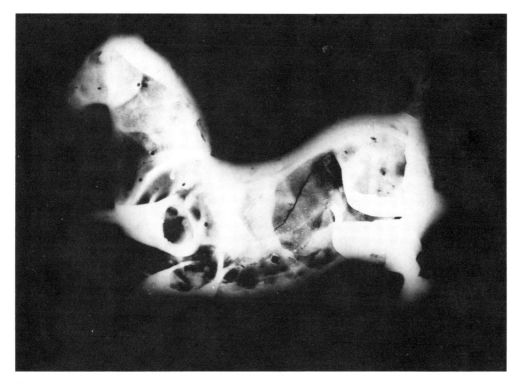

*Fig. 9.* An X-ray picture of the left side of the Budapest statuette

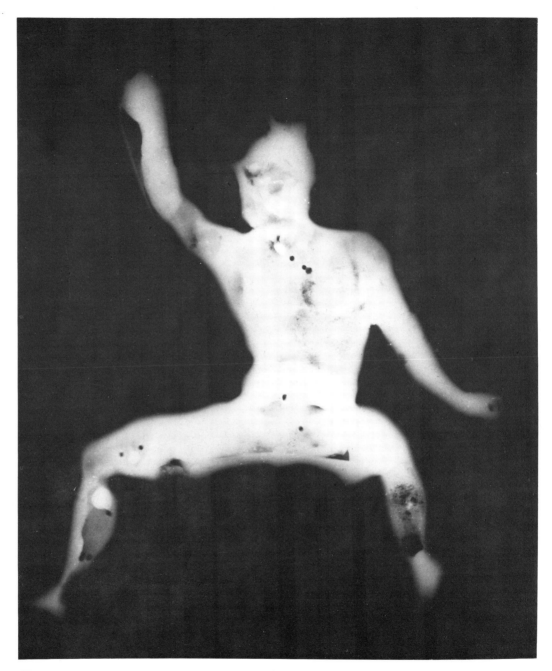

*Fig. 10.* An X-ray picture of the rider's back

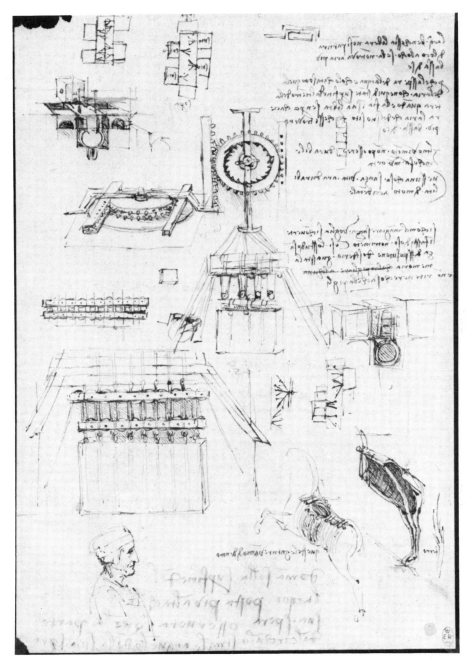

*Fig. 11.* Leonardo da Vinci: Sketches in preparation for casting the bronze horse. Enlarged detail. For the Sforza monument (1490—92). Windsor, 12349 r

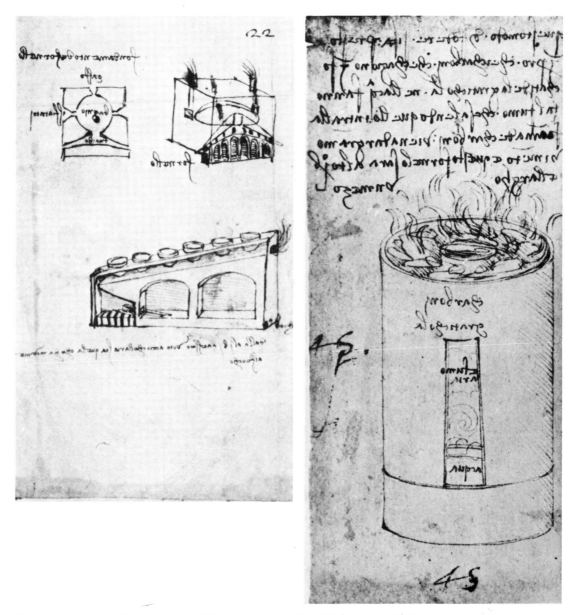

*Fig. 12.* Leonardo da Vinci: Furnaces. Milan, Ambrosiana Cod. Atl. f.32 r-a and f.306 r-c.

*Fig. 13.* Leonardo da Vinci: Sketches in preparation for casting the Sforza monument (1494). Detail. Windsor, 12348 r

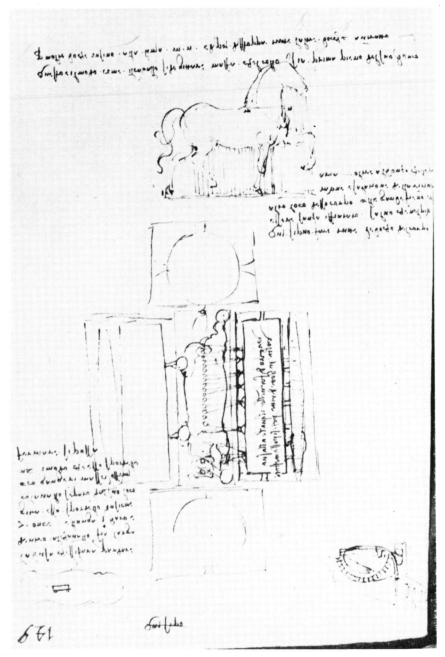

*Fig. 14*. Leonardo da Vinci: Sketch of mould for a walking horse, lying on its back. For the Sforza monument. Madrid, Bibl. Nac. Cod. 8936. II.f. 149 r

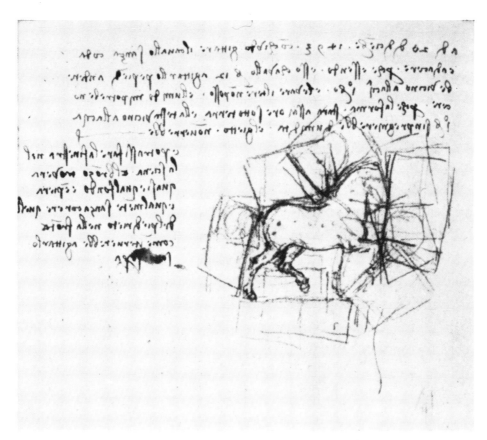

*Fig. 15.* Leonardo da Vinci: Sketch of mould for the Sforza monument. "a di 23 di dicembre 1493 Conchiudo gittare il cavallo sanza coda e adjacere...". Madrid, Bibl. Nac. Cod. 8936. II.f. 150 v

*Fig. 16.* Leonardo da Vinci: Sketches of moulds for the horse's hind legs. For the Sforza monument. (before November 1494). Windsor, 12352 r

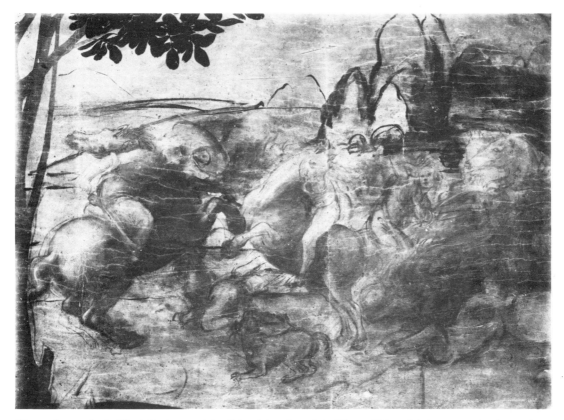

*Fig. 17*. Leonardo da Vinci: Background detail for Adoration of the Kings. Riders fighting on rearing horses (1481). Florence, Uffizi

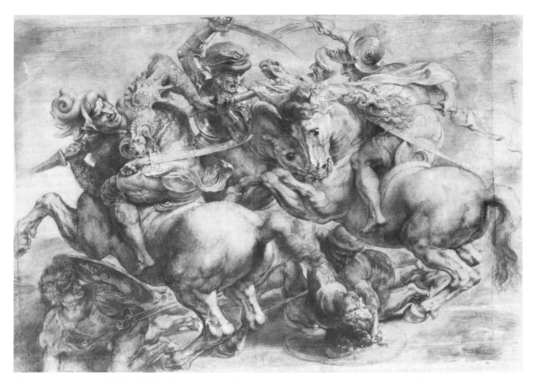

*Fig. 18*. Leonardo da Vinci: The Battle of Anghiari. Copy of the cartoon by Rubens. Paris, Louvre

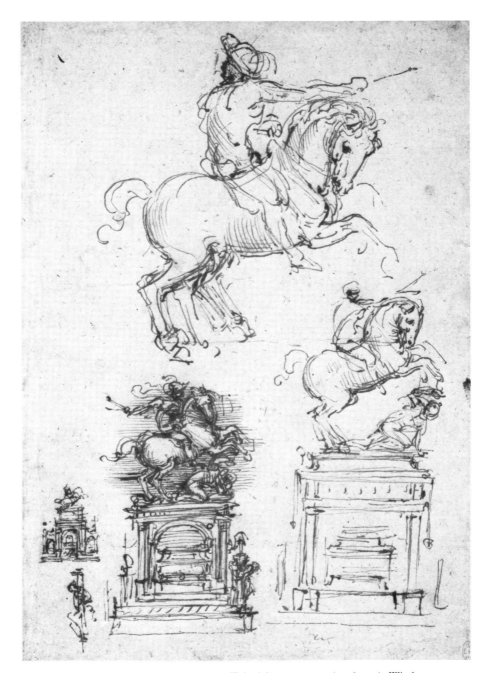

*Fig. 19.* Leonardo da Vinci: Studies for the Trivulzio monument (1508—11). Windsor, 12355.

*Fig. 20.* Leonardo da Vinci: Warrior on a rearing horse and other sketches. Detail of the Windsor No.12283. Dates uncertain

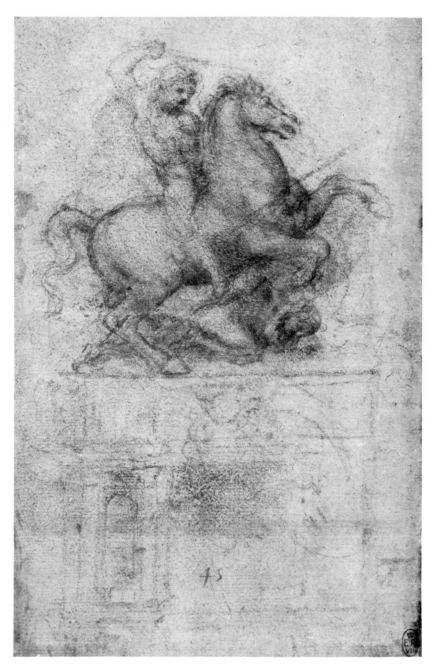

*Fig. 21.* Leonardo da Vinci: Study for an equestrian monument on a triumphal arch, representing a horseman fighting his enemy. Regarded as the most elaborated composition. Windsor 12354

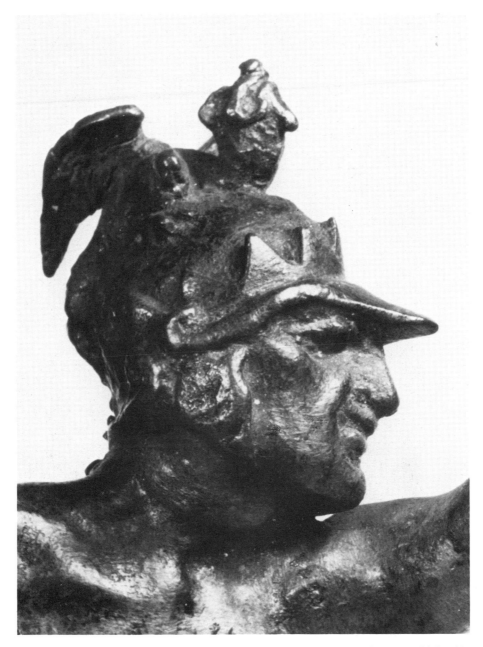

*Fig. 22.* Leonardo da Vinci: Head of the rider of the Equestrian Statuette in Budapest. Right-side profile

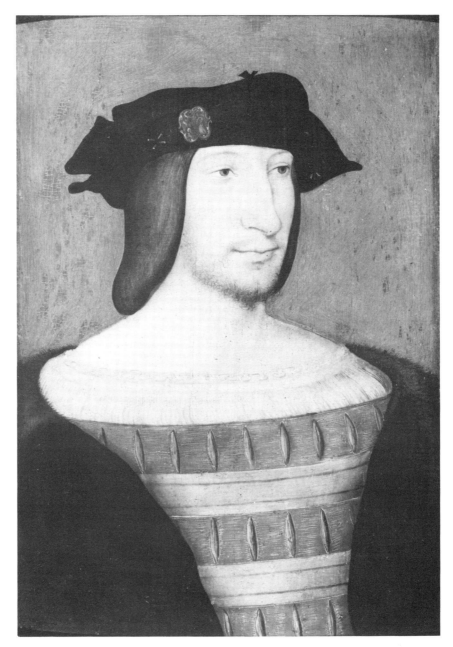

*Fig. 23.* Unknown French master: Portrait of Francis I (cca. 1515). Chantilly, Musée Condé

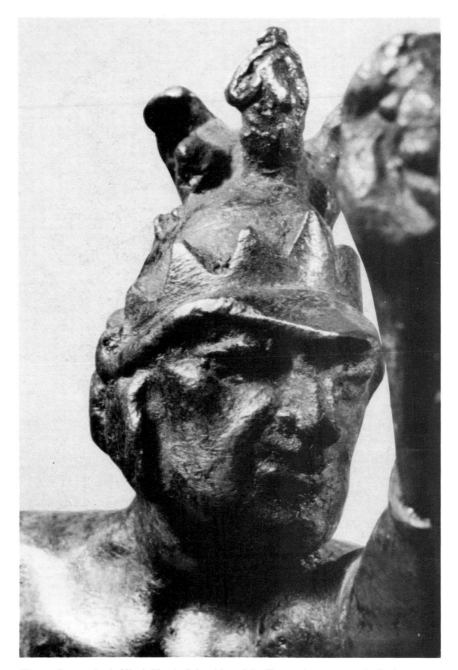

*Fig. 24.* Leonardo da Vinci: Head of the rider of the Equestrian statuette in Budapest

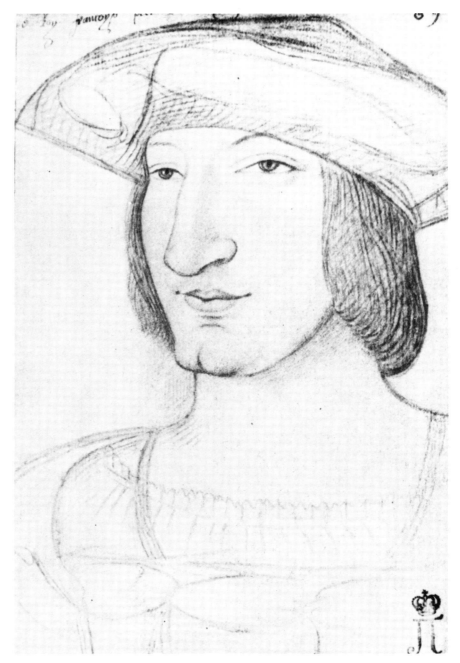

*Fig. 25*. French master: Le roy francoys premier du nom (cca 1515). Leningrad, Hermitage, No. 2862. Expos. Cat. 1969, No. 4

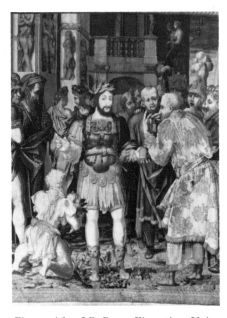

*Fig. 26.* Jean Clouet (?): St. John the Baptist with the features of Francis I (1518). Gent, Coll. Tijtgat (Apollo CIII, 1976)

*Fig. 27.* After J.B. Rosso Fiorentino: Unity of the state. Francis I as. Vercingetorix. Detail. Vienna, Gobelinsammlung, CV.6

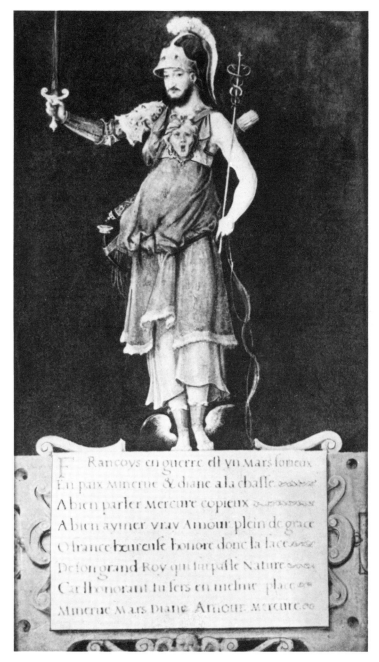

Francoys en guerre est vn Mars furieux
En paix Minerue & diane ala chasse
A bien parler Mercure copieux
A bien aymer vray Amour plein de grace
O france heureuse honore donc la face
De son grand Roy qui surpasse Nature
Car lhonorant tu sers en mesme place
Minerue Mars Diane Amour Mercure

*Fig. 28*. Nicolas Belin (da Modena): Francis I as Mars, Minerva, Diana,
Mercury, etc. (cca 1545). Paris, Bibl. Nat. (Chastel—Klein 1963)

*Fig. 29.* Pseudo Boron: "Queste de Graal" (cca 1386). Scene from a tournament. Lombard miniature. Paris, Bibl. Nat. Ms. fr. 343.f.4 v (Photo Bibl. Nat.)

*Fig. 30*. D. Aubert and J. Dreux: "Sainte Ecriture", more precisely Actum apokrif. Thomae Apostoli. (1462). Brussels, Bibl. Roy. Ms. 9017. f.240. Breaking of the lance at a princely wedding

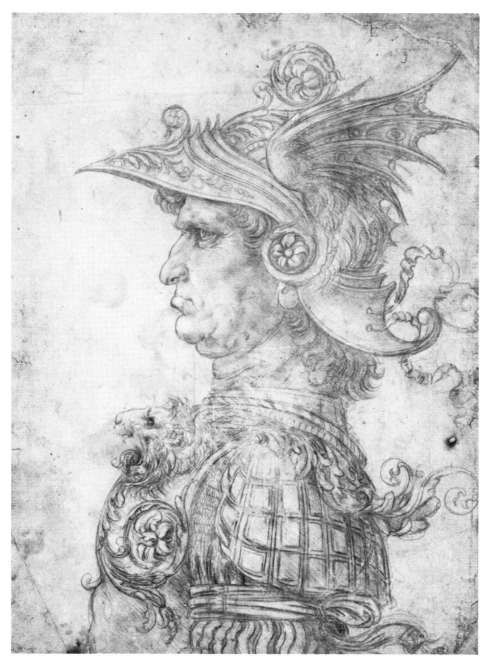

*Fig. 31.* Leonardo da Vinci: Antique warrior in fantastic armour (Colleoni, cca 1480). London, British Museum, No. 1895—9—15

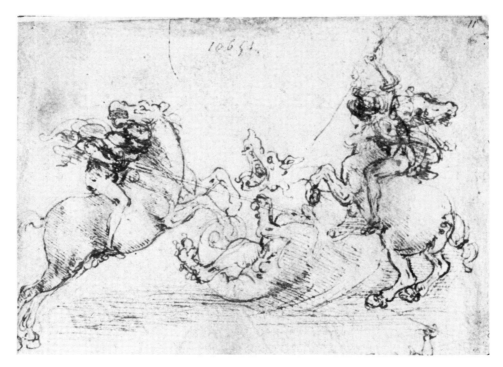

*Fig. 32.* Leonardo da Vinci: Two knights fighting a dragon. Paris, Louvre, Coll. Rotschild (J.P. Richter, 1970)

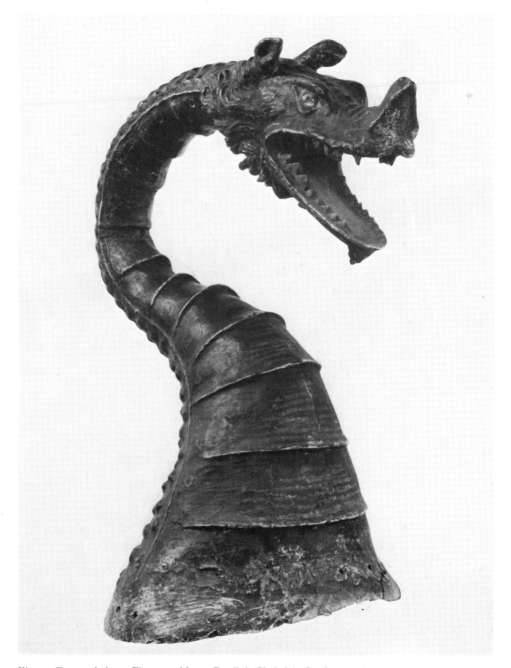

*Fig. 33*. Dragon helmet. Florence, Museo Bardini. Christie's Catalogue, 1899

*Fig. 34.* Leonardo da Vinci: Study of dragons (1480), Windsor, 12370

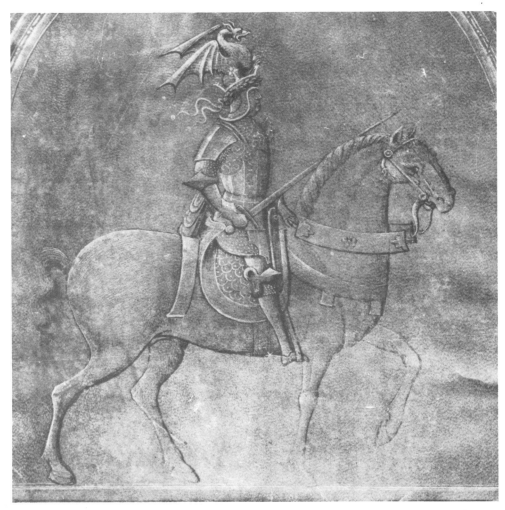

*Fig. 35.* Frontispiece of a codex containing the speeches of Cicero made for Ferdinand of Aragon (cca 1480—90). Vienna, Nat. Bibl. Ms 4 (Bull. de la Soc. Franc. 1913)

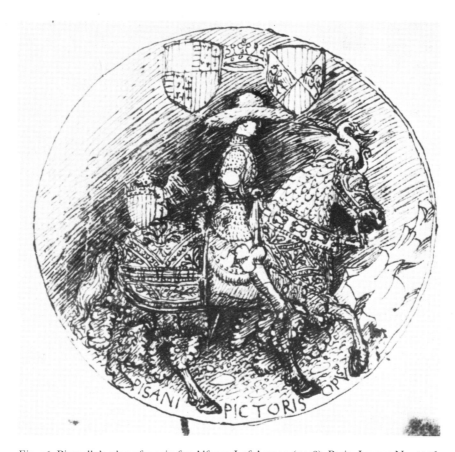

*Fig. 36.* Pisanello's plan of a coin for Alfonse I of Aragon (1448). Paris, Louvre No. 2306

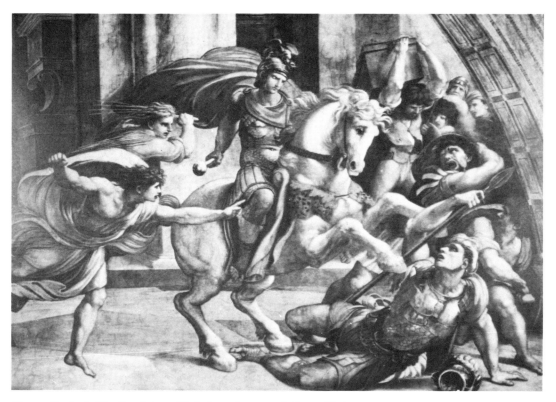

*Fig. 37.* Raphael: The Expulsion of Heliodoros (1512—14). Rome, Vatican

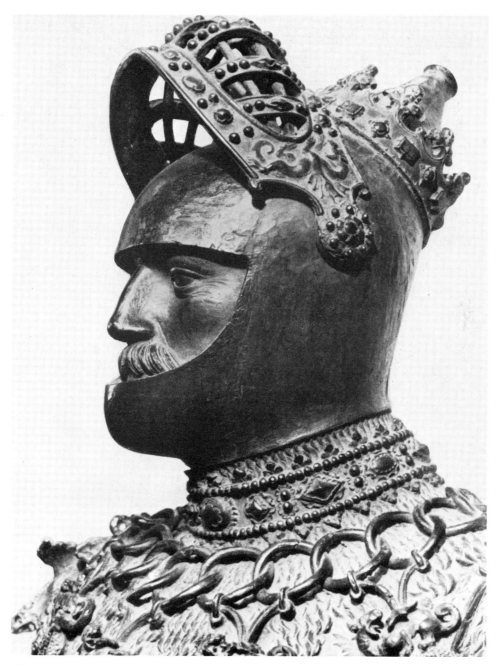

*Fig. 38*. Workshop of P. Vischer, after the plans of Dürer: King Arthur (1513). Innsbruck, Hofkirche

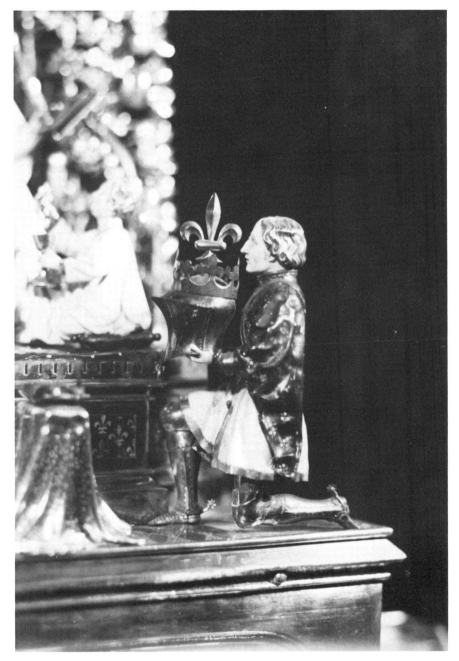

*Fig. 39*. Maréchal with the helmet of the king. Detail of the Goldenes Rössel. Early 15th century. Altötting

*Fig. 40*. M. van Heemskerck, C. Bos and H. Cock: Francis I in the battle of Pavia. Detail. (1556). Paris, Bibl. Nat.

*Fig. 41.* Master of the Fontainebleau workshop: Armour designed for the head of a horse (cca 1545).
Münich, Staatl. Graph. Samml. 14. 703

*Fig. 42*. Leone Leoni: Warrior on the defensive. Bronze statuette. Milan, Museo Poldi Pezzoli. No. FC. 77/68

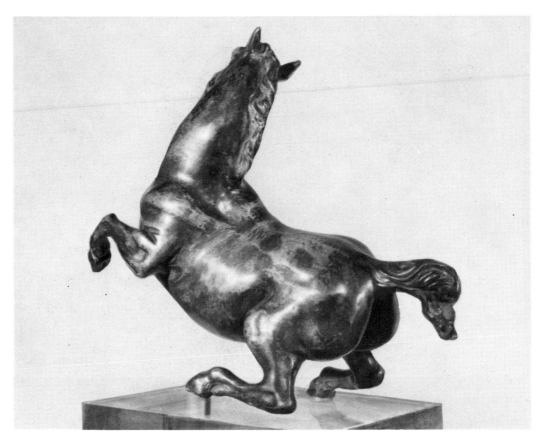

*Fig. 43.* Leone Leoni: Bronze statue of a rearing horse. Left-side view. Early 1550s. H. 23.1. cm. New York, Metropolitan Museum of Art, Acc. No. 2574. Photo, Budapest, Museum of Fine Arts

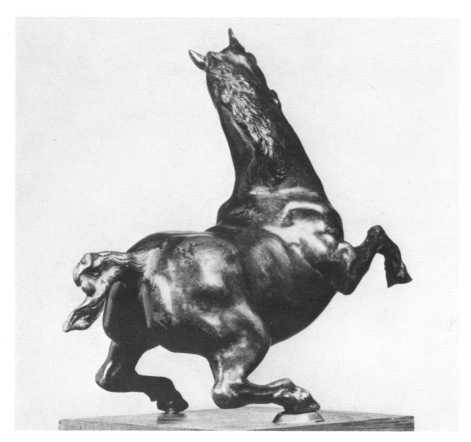

*Fig. 44*. Leone Leoni: Bronze statue of a rearing horse. Right-side view. Early 1550s. H: 24.2 cm. London, property of M.P. Jeannerat. (photo, from Prof. J. Pope-Henessy)

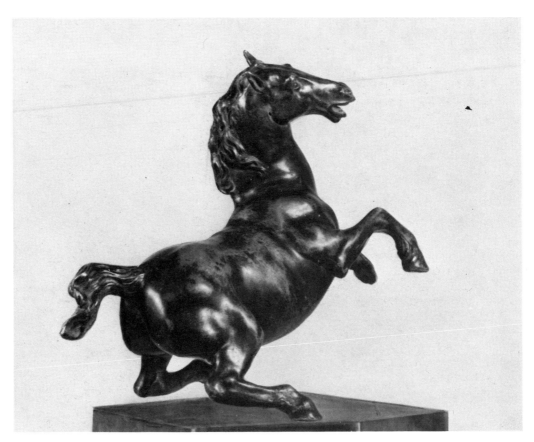

*Fig. 45.* The New York horse from the right side

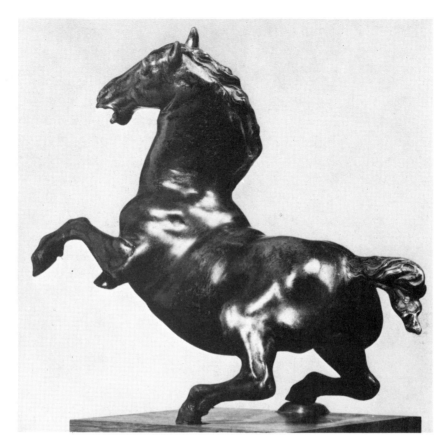

*Fig. 46*. The London horse from the left side

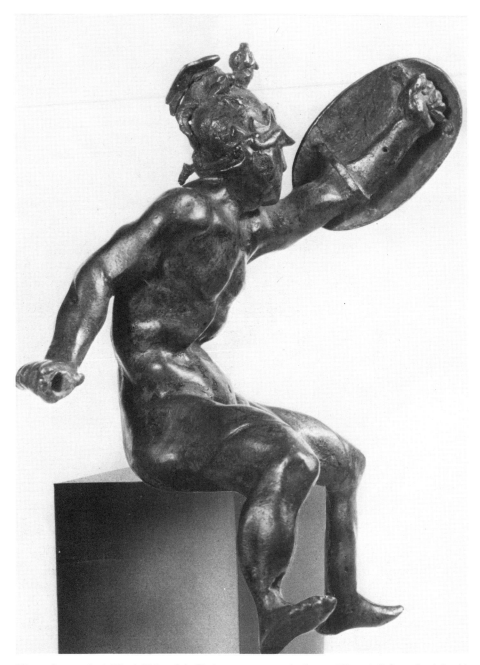

*Fig. 47*. Leonardo da Vinci: Rider of the Budapest statuette: the figure of Francis I. from the right side

*Fig. 48.* Leone or Pompeo Leoni: Small warrior, after 1551. Vienna, Kunsthistorisches Museum, Inv. No. 5819

*Fig. 49.* Leone Leoni: Helping warrior. Bronze statuette. H. 19.3 cm. Vienna, Kunsthistorisches
Museum. Inv. No. 5583

*Fig. 50.* Leone Leoni: The small warrior's bronze statuette (after 1551). H. 19,3 cm. Washington National Gallery of Art, formerly in the Widener Collection. Inv. No. A.—131

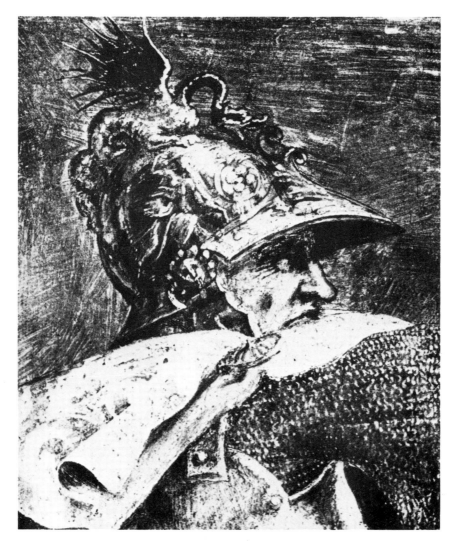

*Fig. 51*. D. Campagnola: Restoration of a 14th century fresco (1539). Detail. Padua, Liviano, Sala dei Giganti

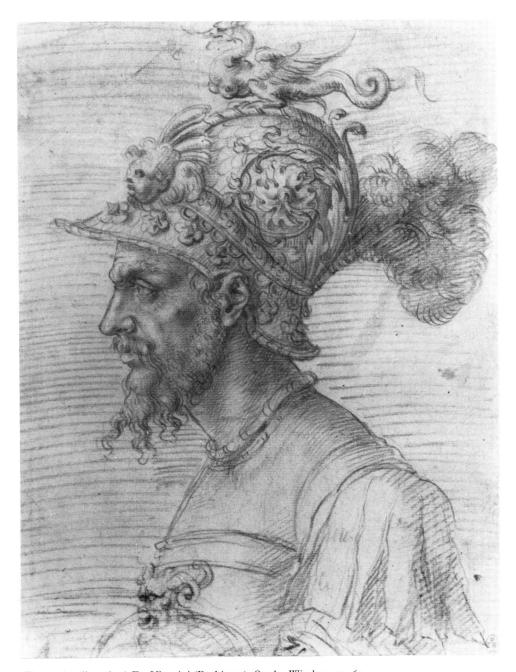

*Fig. 52.* (attributed to) Fr. Ubertini (Bachiacca): Study. Windsor 10.463

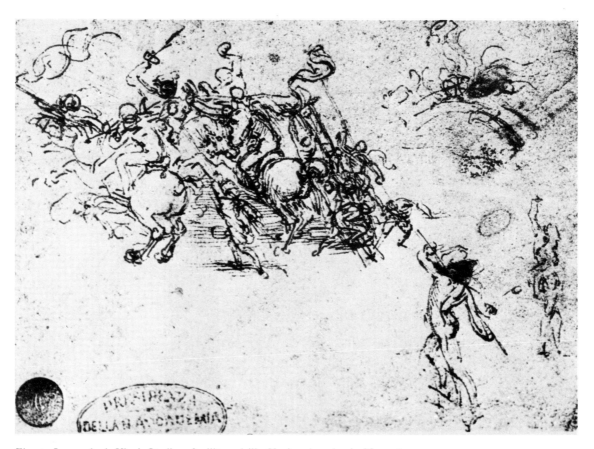

*Fig. 53.* Leonardo da Vinci: Studies of military drills. Venice, Accademia. No. 216

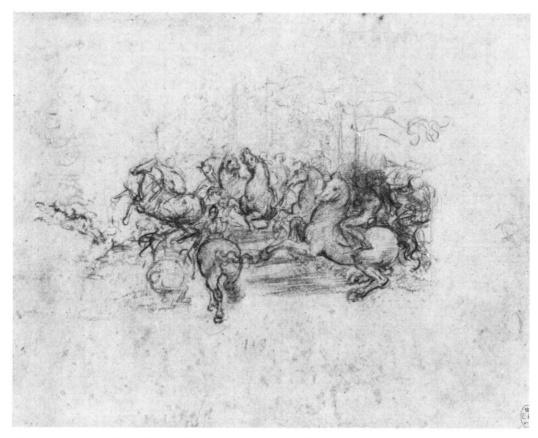

*Fig. 54.* Leonardo da Vinci: Group of horsemen. (cca 1504). Windsor 12339 r.l

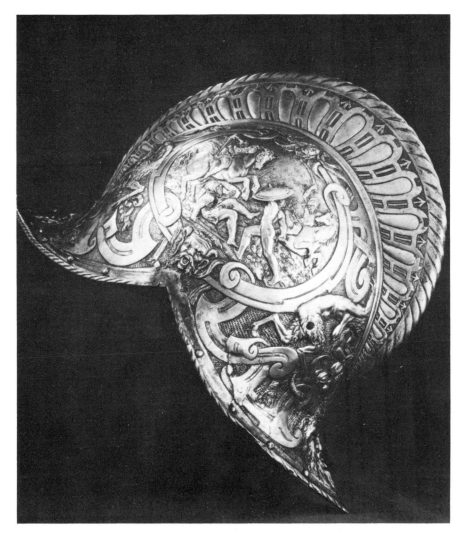

*Fig. 55.* French master: Ceremonial helmet (cca 1555). Paris, Musée de l'Armée. H.155

*Fig. 56* E. Libaerts von Antwerpen: Detail of a shield (cca 1560). Kopenhagen, Nationalmuseet. D. 174

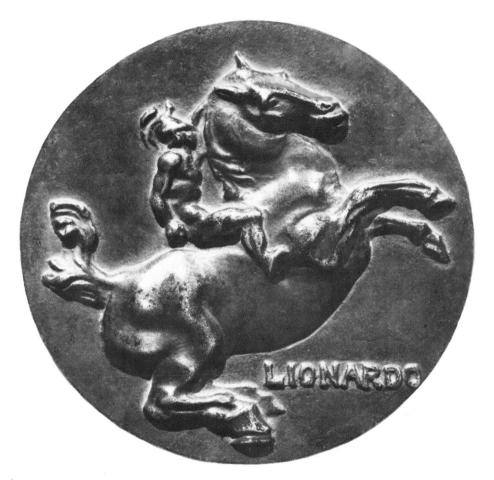

*Fig. 57*. Béni Ferenczy: Simon Meller commemorative medal. (1917). Diam. 119 mm. Budapest, Hungarian National Gallery Inv. No. 56.1463

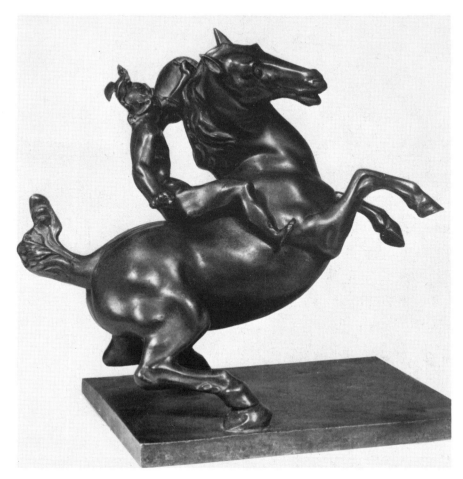

*Fig. 58*. Copies of the Budapest statuette made for the 1939 Leonardo Exhibition in Milan. Property of Gyula Gross, Budapest

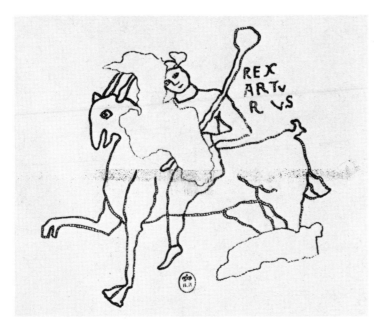

*Fig. 59.* Contour of King Arthur's figure from the detail of the pavement mosais (1163—66). Otranto Cathedral. *Rex quondam rexque futurus.* Paris, Bibl. Nat. Coll. A. L. Millin

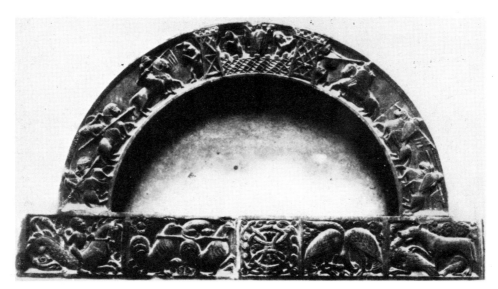

*Fig. 60.* Details of the "Porta della Pescheria". The story of King Athur (after 1106 or 1120—30). Modena Cathedral. Photo after Salvini

*Fig. 61.* King Arthur the tapestry series "Neuf Preux", made for Jean de Berry (cca 1400). New York, Metropolitan Museum of Art. The Cloisters

*Fig. 62.* The "Round Table" from Jean sans Peur's Boccaccio (cca. 1400). Paris, Bibl. de l'Arsen. Ms. 5193 f. 349.v

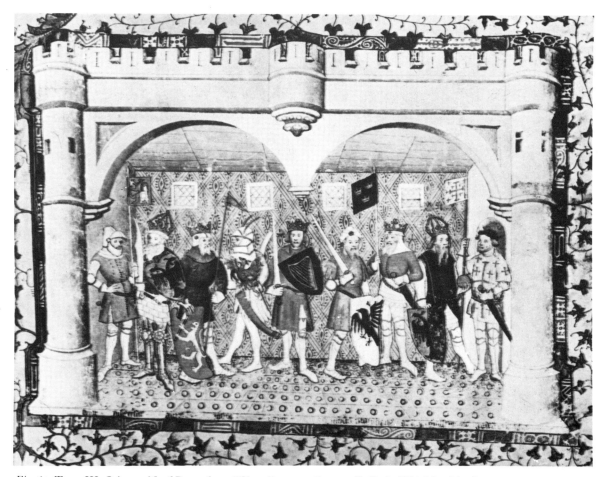

*Fig. 63*. Tom. III. Saluzzo: Neuf Preux from "Chevalier errant". 1394.f.l. Paris, Bibl. Nat. Ms. fr. 12559

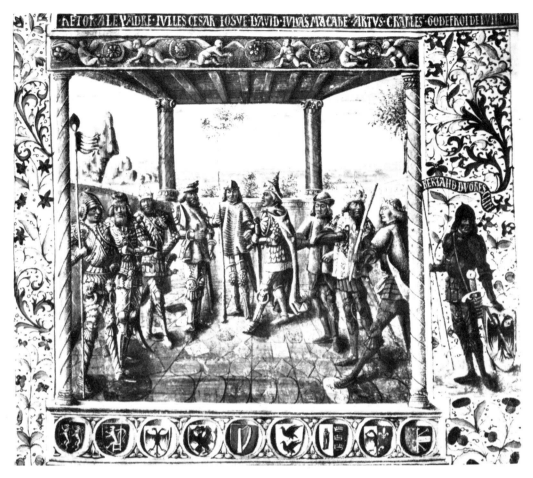

*Fig. 64.* Longuyon—Mamerot—Briart: Frontispiece of Neuf Preux (cca 1482—86). Vienna, Nat. Bibl. Ms. 2577

*Fig. 65.* After Nennius (end of 8th century): Battle of Breton and Angle dragons. Longuyon—Mamerot—Briart: Neuf Preux, Vienna, Nat. Bibl. Ms. 2578 f 38 v

*Fig. 66.* Leonardo da Vinci: Hilts of ceremonial swords. Milan, Ambrosiana, Cod. Atl. f. 133 r-a

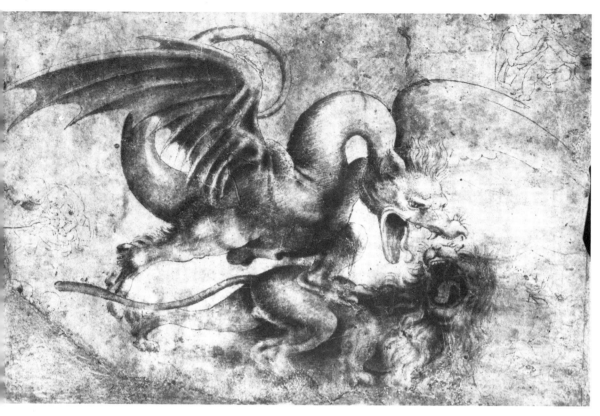

*Fig. 67.* Leonardo da Vinci: Battle of Lion and Dragon. Florence, Uffizi Gabinetto dei disegni. Inv. No.435[E]

*Fig. 68.* Closed helmet under the guard of a lion (15th century). Florence, Bargello. Carrand Collection. Catal. 1895

*Fig. 69.* Leonardo da Vinci: Closed helmet in the open mouth of a lion's head. Detail. Windsor 12.329

*Fig. 70.* Leonardo da Vinci: Giant as the master of the wild animal. Torino, Museo. No. 15630

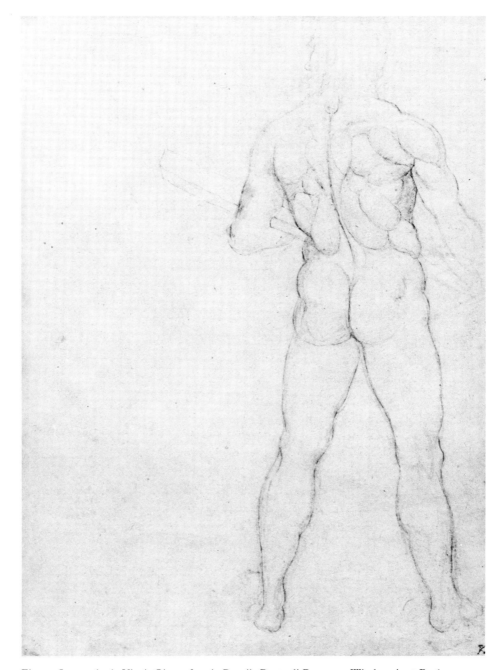

*Fig. 71.* Leonardo da Vinci: Giant after A. Pucci's Bruto di Bretagna. Windsor Anat.B.26.19043-r

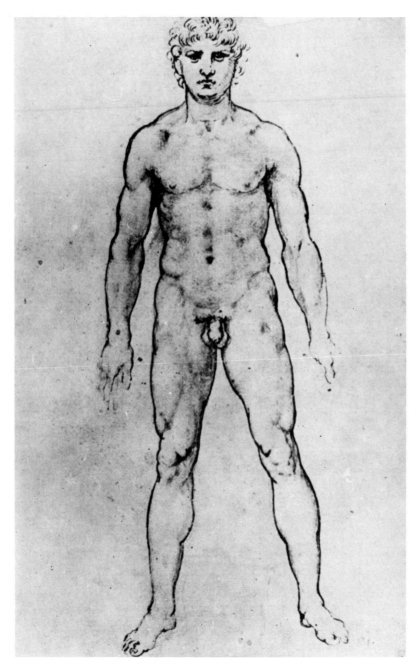

*Fig. 72—73.* Leonardo da Vinci: Studies of a nude man. Pieces from a series.
Windsor 13.593—97 and 12.629—34

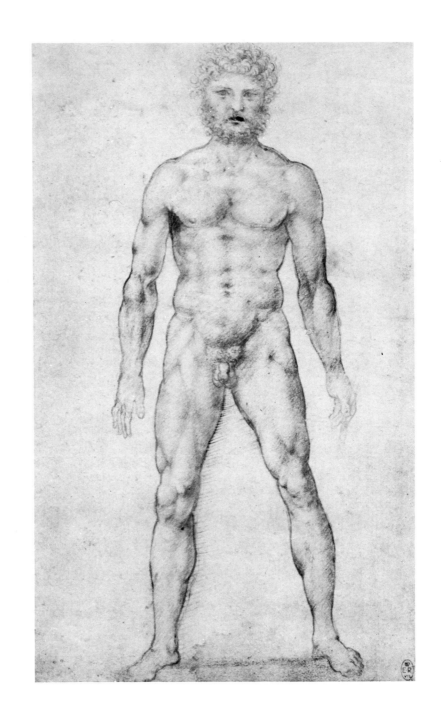

*Fig. 74.* Bonifazio Bembo: Illustration to the "Storia di Lancilotto". Episode from the quest of Graal. 1446. Florence, Bibl. Naz. Cod.Palat.556

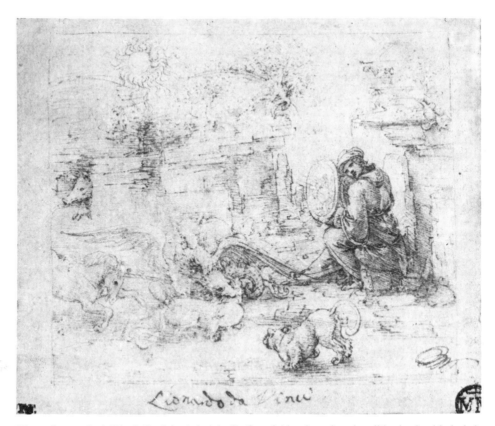

*Fig. 75*. Leonardo da Vinci: Carduino's (originally Gawain) battle against the wild animals with the help of the sun. Paris, Louvre. Cab.d.dess.No.2247

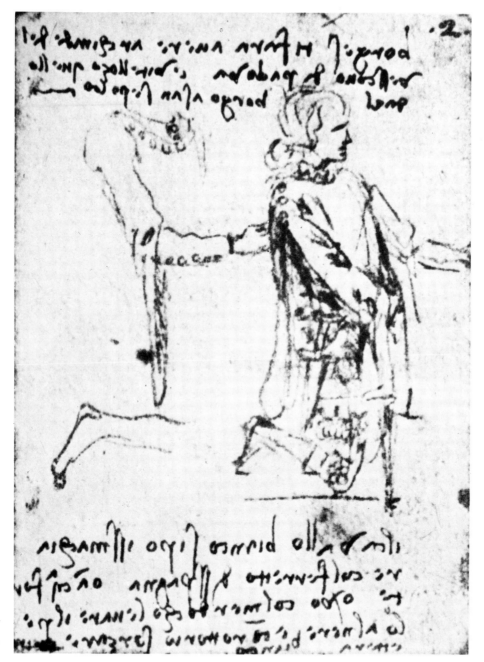

*Fig. 76.* Leonardo da Vinci: Knightly scene, Ms.L. f.2 r. Paris, Institut de France (Ravaisson—Mollien 1881)

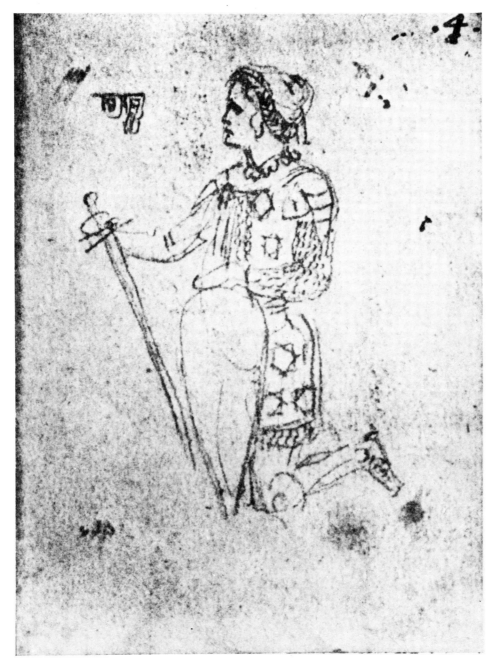

*Fig. 77.* Leonardo da Vinci: Dressing of Gawain. Ms.L. f.4 r. Paris. Institut de France (Ravaisson—Mollien 1881)

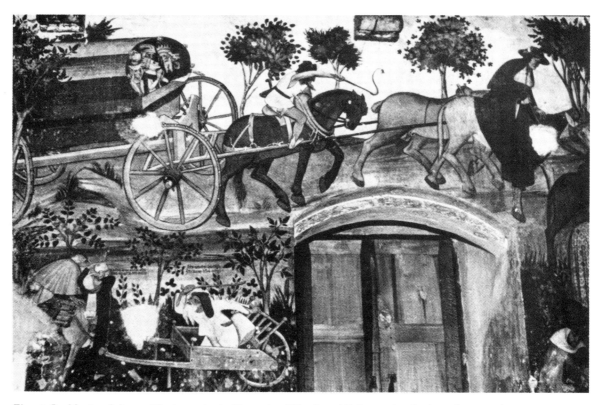

*Fig. 78.* La Manta—Saluzzo: Pilgrimage to the Fountain of Youth and Rejuvenation (early 15th century)

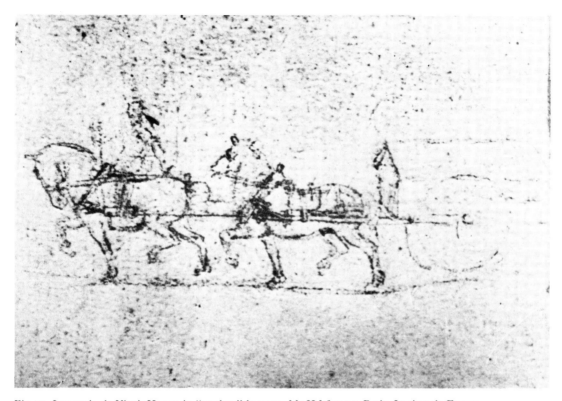

*Fig. 79.* Leonardo da Vinci: Horses in "tandem" harness. Ms.H.³ f.130 r. Paris. Institut de France

*Fig. 80.* Leonardo da Vinci: Unicorn with a Young Girl. Oxford,
Ashmolean Museum

*Fig. 81.* Leonardo da Vinci: Aristoteles and Phyllis. Hamburg, Kunsthalle. No.21987

*Fig. 83.* Leonardo da Vinci: Deluge. Detail. Windsor 12.376

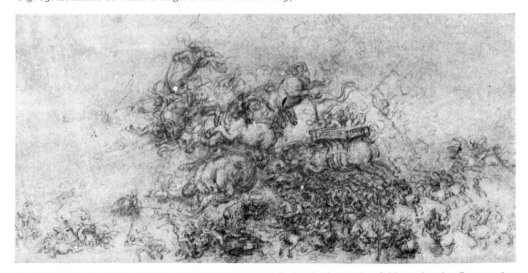

*Fig. 82.* Leonardo da Vinci: The socalled "pazzia bestialissima", the battle of Alexander the Great, using elephants. Detail. (cca 1511) Windsor 12.332